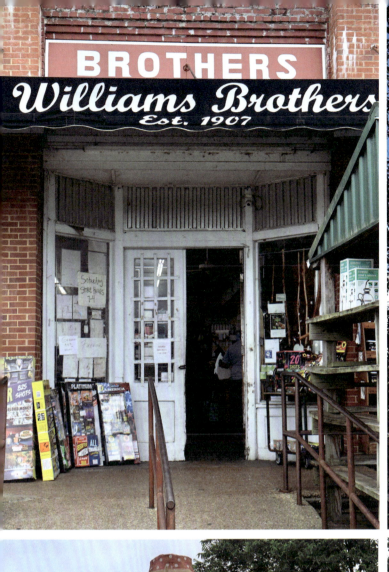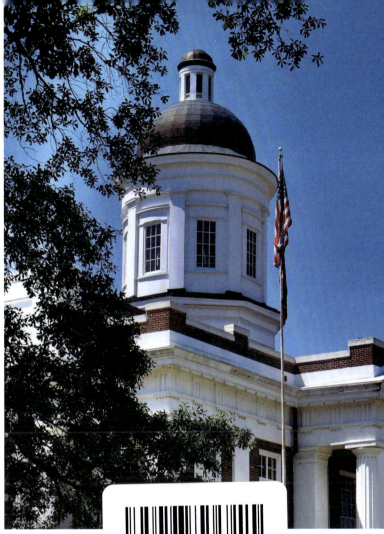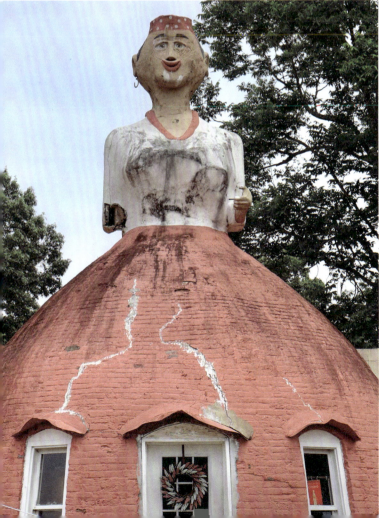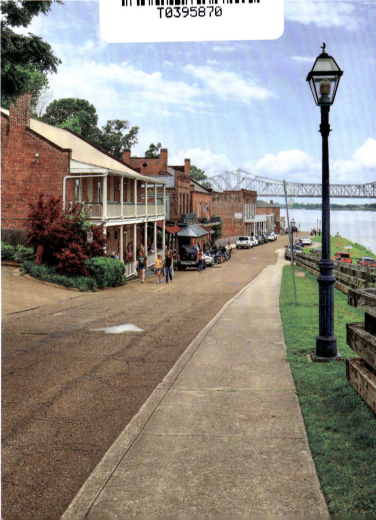

HOMETOWN
MISSISSIPPI

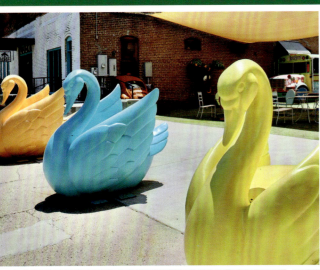

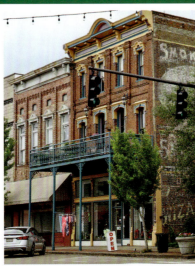
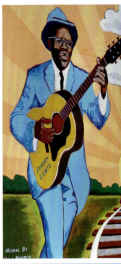
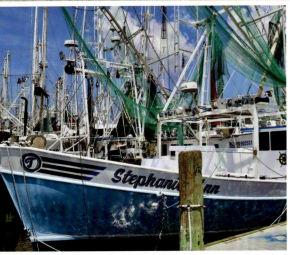
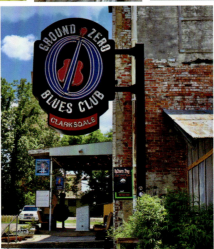
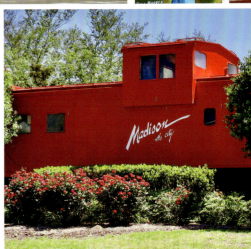

UNIVERSITY PRESS OF MISSISSIPPI / JACKSON

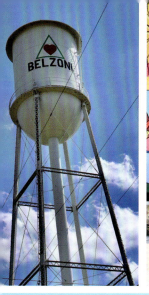

Hometown MISSISSIPPI
MELODY GOLDING

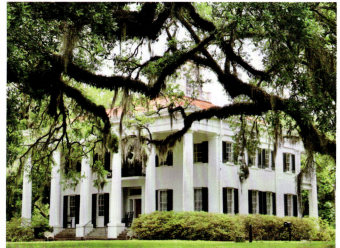
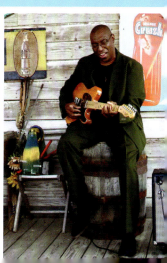

The University Press of Mississippi is the scholarly publishing agency of
the Mississippi Institutions of Higher Learning: Alcorn State University,
Delta State University, Jackson State University, Mississippi State University,
Mississippi University for Women, Mississippi Valley State University,
University of Mississippi, and University of Southern Mississippi.

www.upress.state.ms.us

Designed by Peter D. Halverson

The University Press of Mississippi is a member
of the Association of University Presses.

Text and photographs copyright © 2025 by Melody Golding
All rights reserved
Manufactured in China
∞

Publisher: University Press of Mississippi, Jackson, USA
Authorised GPSR Safety Representative: Easy Access System Europe -
Mustamäe tee 50, 10621 Tallinn, Estonia, gpsr.requests@easproject.com

Library of Congress Control Number: 2025937816

ISBN 9781496859990 (hardback)
ISBN 9781496860002 (EPUB single)
ISBN 9781496860019 (EPUB institutional)
ISBN 9781496860026 (PDF single)
ISBN 9781496859983 (PDF institutional)

British Library Cataloging-in-Publication Data available

JACOB'S LADDER

It is my honor to dedicate this book to Jacob's Ladder in Vicksburg, Mississippi. Their mission is "to provide adolescents and young adults who have intellectual disabilities a quality education in a nurturing Christian environment preparing them for success in adulthood."

The royalties from the sale of this book will go to Jacob's Ladder, a nonprofit organization, to help further their mission.
www.jacobsladderlearningcenter.com

"I grew up in a small Mississippi town. That upbringing echoes in my soul. It has never left me. As the world expands, divides, homogenizes, Melody Golding's photographs are a vivid reminder that quality life still exists on the quieter roads of the Magnolia State. That life where neighbors are truly neighbors, handshakes are more binding than any contract, and the better parts of ourselves are to be found in the company of those we truly love. The pictures in this book remind me to slow down, get in the hometown groove, and breathe . . ."

—**MARTY STUART,**

Congress of Country Music, Philadelphia, Mississippi

CONTENTS

INTRODUCTION 3

BELZONI	9	MADISON	89
BILOXI	13	MERIDIAN	93
BOLTON	19	NATCHEZ	99
CANTON	23	OCEAN SPRINGS	105
CHURCH HILL	27	OXFORD	111
CLARKSDALE	31	PASS CHRISTIAN	117
CLEVELAND	39	PHILADELPHIA	123
COLUMBUS	45	PORT GIBSON	131
FLORA	51	SENATOBIA	135
GREENWOOD	55	STARKVILLE	139
HATTIESBURG	61	TUPELO	145
HOLLY SPRINGS	67	VICKSBURG	151
JACKSON	73	WATER VALLEY	159
LAUREL	79	WEST POINT	163
LELAND	85	YAZOO CITY	167

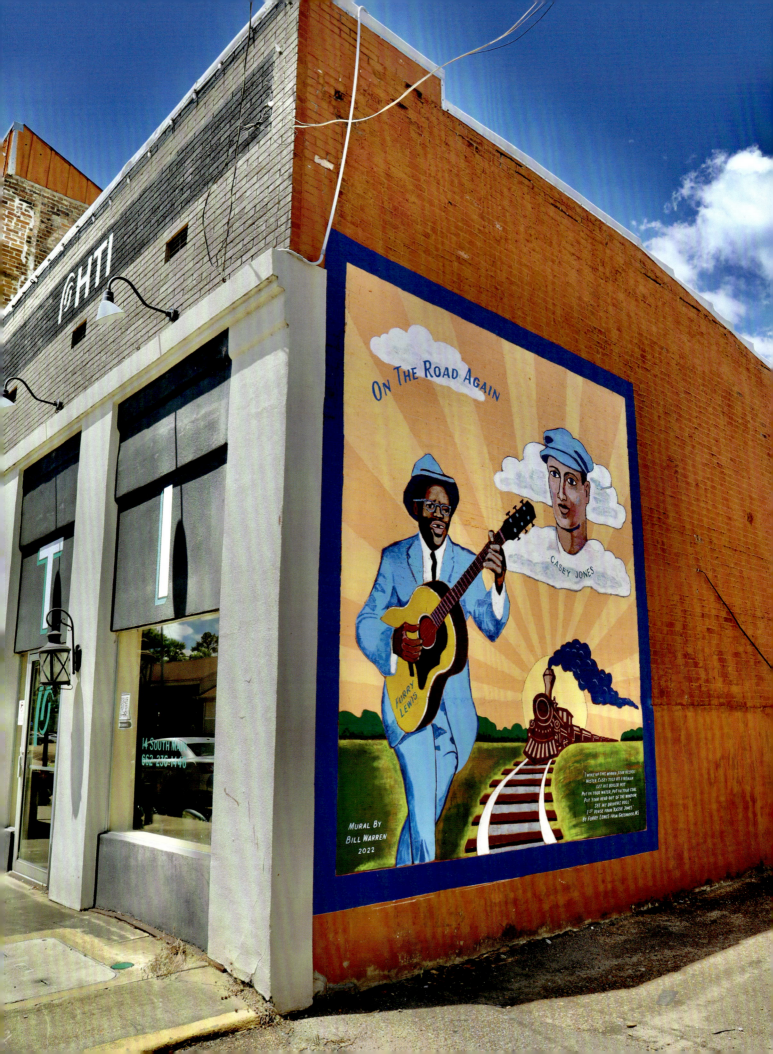

HOMETOWN
MISSISSIPPI

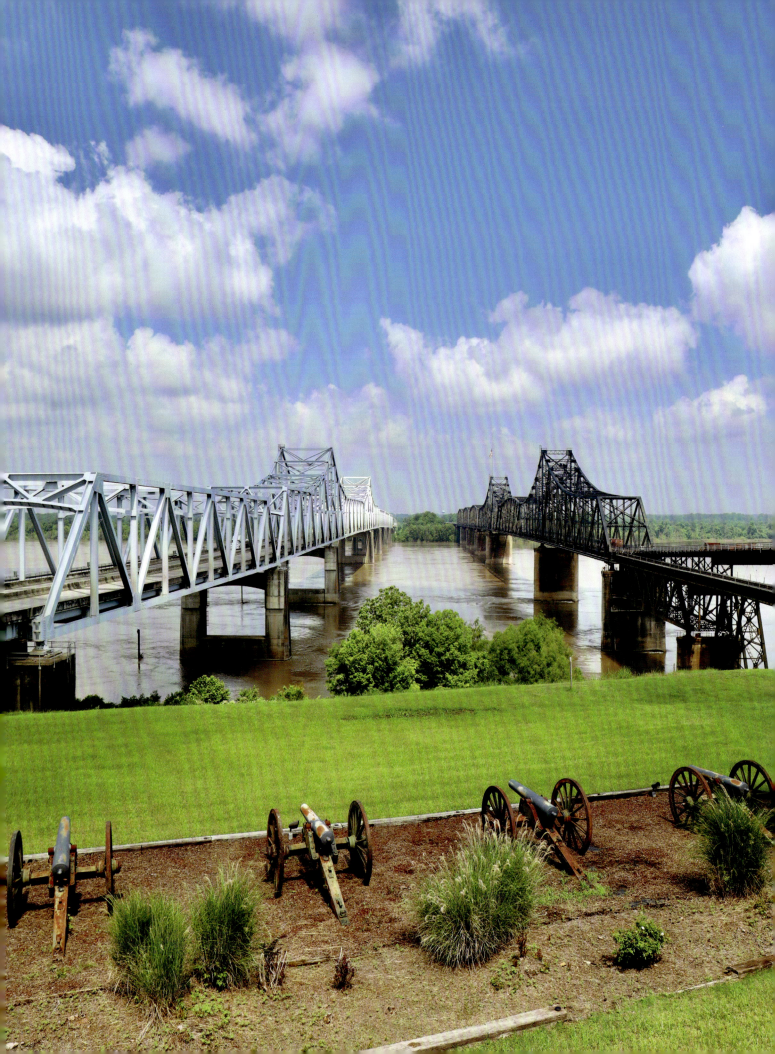

INTRODUCTION

This book is about Mississippi towns, and it is a documentation of my personal "walkabout" throughout the state covering thirty towns with my cameras in the early summer of 2024. According to Wikipedia and other online sources, the term "walkabout" has several meanings. The definition that I relate to the most is "a time of reflection, a return to one's roots and family ancestry, a joyous revisit to vistas . . . a time of balance to harmonize with the sounds and sights of the great land of Australia." Australia?! Well, of course this book is about the great land of Mississippi, not Australia! It is 100 percent pure Mississippi. But my journey to thirty towns was a surprising and joyous trek or "walkabout," and the term fits me and my summer of 2024. This book also contains quotes from a broad range of Mississippians who so graciously shared their reflections with a bounty of expression, on the positive aspects of their towns, experiences, and our state, and I thank them all for their generosity. It is a visual, present-day, and literal representation of Mississippi.

It all started when I asked my son Austin if he had any ideas for me about writing a new book. His immediate answer was, "Write a book about towns in Mississippi." His inspiration was that so many of his friends have moved back home. Home from college, home from working in big cities, home to raise their own families, home to have community with their lifelong friends, affordable housing, and all the other benefits of living here.

The idea struck a chord with me, and the next thing I knew, I was packing my cameras and equipment in my car. I got out a map of the state of Mississippi. My publisher had given me a list of towns to document, and I started circling and highlighting and figuring out where to go, how to go, and when to go. The two things that I always took with me besides my gear were a bag of Haribo Goldbears and a sixty-four-ounce fountain coke with lots of ice. No doubt that would get me through full days of working. My work turned out to be a summer of marvelous journeys. On most of the trips I travelled solo. My sons say that I am a camera ninja and people don't even know that I am there, so I am quick but thorough. You can imagine my delight as I came to each town. I am from Mississippi, and I live in Mississippi, but like

most people when I aim to go somewhere, I get on the interstate or highway and get from point A to point B as fast as I can. I quickly found out that I had missed a lot of stuff in my own state! My Mississippi Walkabout was a positive and eye-opening journey. In each town there was real progress and revitalization. I saw and spoke with people who took great pride in their town, and it showed. There is nothing stronger in a town than the pride the residents have in the place they call home. I'm not sure what I was expecting, but I sure wasn't expecting the plethora of color. With each town it was much like opening a jewelry box or new box of crayons or even a flower shop door. Of course, as an artist color is what I am drawn to, but I was amazed that it was so colorful from the very small towns to the very big towns. I swelled with pride and thought, Wow! Not only are my fellow Mississippians a bunch of colorful folks! Even the towns are colorful! The buildings were painted and so were the alleyways, storefronts, and railroad cars; and there were flags flying that promoted the name of the town and current events. I loved going to towns that I had heard of all my life but had never visited. In every town my goal was to find my way to Main Street or the central business district and the heart of town. Every town had its own attractions, whether historical in nature, or cultural offerings, recreational opportunities, colleges or universities, natural scenic beauty, tourism, industry, or being home to a celebrity. All are special in their own way. I can honestly say that every shoot was on a warm sunny day. I never ran into rain, and what a joy to cruise on those blue highways from town to town.

Every town I travelled to was different from the one before, and I remember them all individually. When I started this book, I was concerned that I would look at the photos and not remember where I took the image. Well, not true. I remember every single town, and out of thousands of images I can tell you where I was for each one. The memorable trip to Natchez was so much fun, but what made that trip different was my husband Steve and my son John Reid were with me. I was not travelling solo like I usually did. Sometimes it is easier when someone drives, so they offered to take me. I then could shoot out of the window when we were stopped or when I saw something interesting. Of course, one of the main topics of that trip while going down Highway 61 South was, "Where are we going to eat?" There are so many great places to eat in Natchez. I have been there many, many times, but seeing the magnificent

architecture never gets old. We pulled into the grounds of one antebellum home that was remodeled into a hotel. So, we knew that we could get out and look around the grounds. Snap, snap, snap went my camera. There is so much beauty to photograph. I looked up and couldn't find Steve or John Reid, so I started looking around for them. No Steve. No John Reid. I went towards the house, and as I looked up at the big house, there inside the window was John Reid holding his Jack Russell dog and waving at me through the window! And here comes Steve—he had been in the back of the house checking out the gardens. Anyway, we did get some delicious lunch, and Natchez is always fun as well as beautiful, and we got a good laugh.

Another memorable trip, when I was not solo, was my trek to the Choctaw Indian Fair. Our friend Keith Heard got us tickets, and I was really looking forward to going because I had never been. It was July 11, and that day fell on my regular babysitting day for our grandson Whit. Early that morning Steve and I loaded up the car with snacks and drinks and I threw my cameras in the back seat with the car seat, Whit, and his toys. And away we went. We listened to a lot of preschool songs and watched cartoons on my phone, while Steve drove. On the way we stopped at the Cypress Swamp on the Natchez Trace and walked the old wooden bridge. Several hours after we started this walkabout to Philadelphia, we were greeted at the fair by many smiling faces from the Mississippi Band of Choctaw Indians. If you haven't been to see this Mississippi treasure, I strongly urge you to go. The colorful clothes and dances were incredible. Whit had such a good time and was entranced with the songs, the people, the dancing, the ice cream, and the beautiful handmade Choctaw beaded bracelet just his size. He helped point out interesting things, and we really enjoyed getting to meet Chief Ben.

One thing I found was that the small towns were only small by population but enormous in spirit. Small towns are some of the most inviting places you will ever visit, and if you don't make eye contact and you don't speak, you are considered either rude or maybe just plain snooty. As I was driving and stopped at a traffic light or going down the street, people always gave me a quick wave. I didn't know them, and they didn't know me, but that wave made me feel welcome. When I asked a stranger where something was or where to go, I would leave feeling like I had just made a new friend and was given the directions I was looking for. They didn't have to be nice to me, but they

were, and usually in our conversation when we started peeling the onion, we would discover that we had a mutual acquaintance or two. My trips became something that I really looked forward to! Kindness has a ripple effect and goes such a long way. "No act of kindness is ever wasted"—I don't know who said that, but no truer words were ever spoken. Many of these people I will probably never see again, but what a warm and fuzzy feeling they left me with. And this was a universal truth in each town I went to across the state. Now, that is the epitome of a town in Mississippi. No state can compete with Mississippi's well-known Southern hospitality.

The opportunity to get away from a fast-paced way of big-city life, full of crowds and noise and people rushing from here to there, crime, pollution, long commutes to work, and a high cost of living, makes a town in Mississippi very appealing. I just kind of cruised along in each slow-paced town, got out of my car with my camera, and got to work. On several occasions I even had some people chase me down and ask that I "please oh please" take their photo. Those beautiful smiling faces were the gift of the day.

There are just so many positives about living in Mississippi. Not all towns I documented are small, but whether large or small, Mississippians have a reputation for being very friendly. I mean, if you are friendly to strangers, you can imagine the family of friends that you will develop or have in a Mississippi town and what that means. It means that your friends and family care for you and are there for you through good times and bad. Everywhere you go, whether it is the grocery, the post office, hardware store, or a school event, you are not a stranger. People know your name. A lot of times they know your family, your parents, and grandparents, and they watch out for your children. You will see your friends at church, at the park, or at the gym. Often you grew up together and share a lifetime of memories. You will shop local because your friends own the restaurants, the clothing stores, the sporting goods store, the bookstore, the donut shop, etc. These businesses have dedicated themselves to being a part of the community and they are supported by their community. In a small town you cross paths with people more often and you get to know all aspects of their lives, such as where they work, where they live, and what they like to do on weekends. Maybe it's their quirkiness and that's okay too—we brag about our characters. It gives a richness to your life and is a measure that is unique compared to big cities.

Living in a town in Mississippi, you create quality of life and a have a true sense of place. You have social spontaneity. You don't have to plan way in advance where you are going and how you are going to get there—you just get up and go! There is significant nostalgia for the people who live in Mississippi. We may root for different schools at athletic events or go to different churches or be in different political parties, but that's okay. In a town in Mississippi, when things happen you are going to know about it. In the end, we are all Mississippians, and we live in these exceptional towns that have a character all their own.

As in all towns, the youth will go away to college or go away for jobs or for adventure. But if you are from Mississippi, you almost always know that you can come home. Families are nearby with grandparents and aunts and uncles and dozens of cousins right up the street or just outside of town. Families stay close, and you find out how important that is when you have children of your own. But let me tell you, everywhere I went there were talented people. Talented people promoting the community and collectively revitalizing their towns. Young and old people are looking to live in a place that is unlike any other, that is unique, and a place that has attributes that they can call their own. Every town has its own character, and it has taken decades to develop. Small towns are coming back in style, no doubt. Every town I went to has its own individuality just like people have their own individualities. If you haven't been to all the towns in this book, let me strongly encourage you to get in your car and go! Go on your own walkabout!

There are many things that towns in Mississippi have to offer. A slower pace, a strong quality of life, and a lower cost of living, to mention just a few. I'm not poking fun at big cities in other states, but for me, "No Thank You" to living there. I love Mississippi and I love living here. I love my family and my friends, I love the people who live here, and I love the climate, the terrain, the river, the rich culture of writers and musicians and artists who have left their positive mark on the world—and Mississippi is full of those! The list goes on and on. We take great pride in those who have gone before us and nurture those who will go beyond us. We have an enormous share of homegrown success stories, and we are so very proud of those Mississippians who have achieved some degree of greatness. Our homegrown celebrities are a treasure and represent that achievement can no doubt spring from living in the

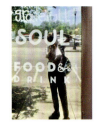

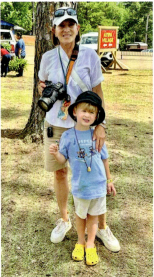

fertile grounds of Mississippi. Many people will never live in Mississippi—that is no problem. We love you anyway and will welcome you if you make the great choice to make Mississippi your home. Come to enchanting Vicksburg. That is where I am from, and we will welcome you here for sure! As a poet once said, "There are no strangers here; only friends you haven't met yet."

There truly is no place like home. And my home is in Mississippi.

<div style="text-align:center">

Melody Golding
www.melodygolding.com

</div>

INTRODUCTION

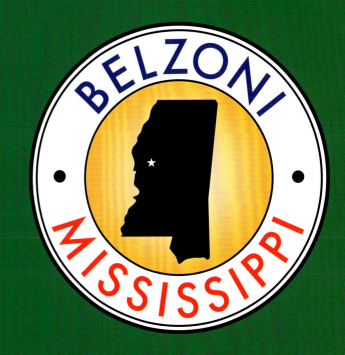

"I have lived in Belzoni nearly all my life. It is home to me and where I have brought up my family. Although there have been many changes and the population is declining, it is my home, and I plan to stay. My dad always said there is no place like Belzoni, Mississippi."

—HUEY TOWNSEND

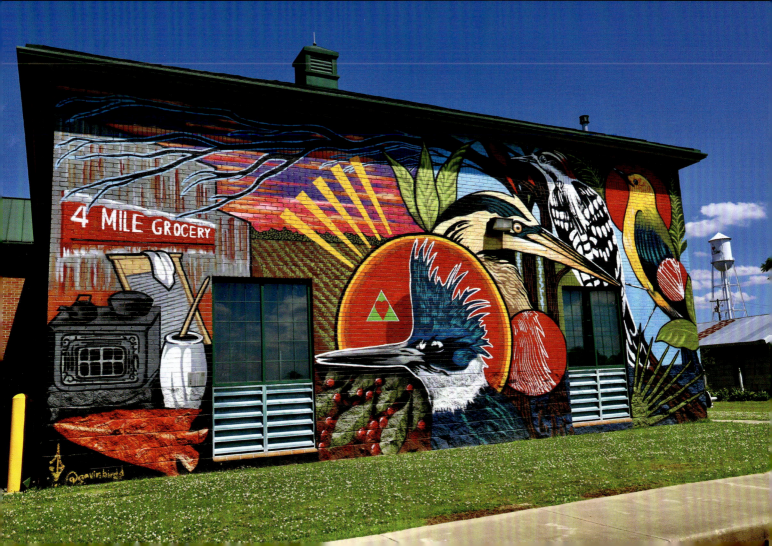

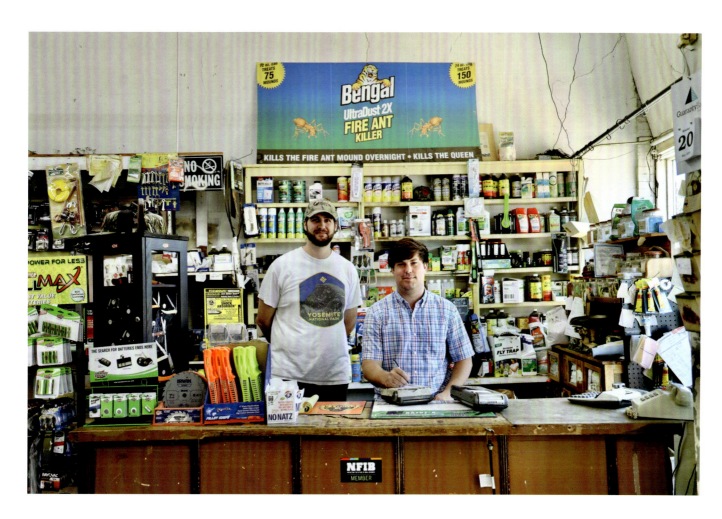

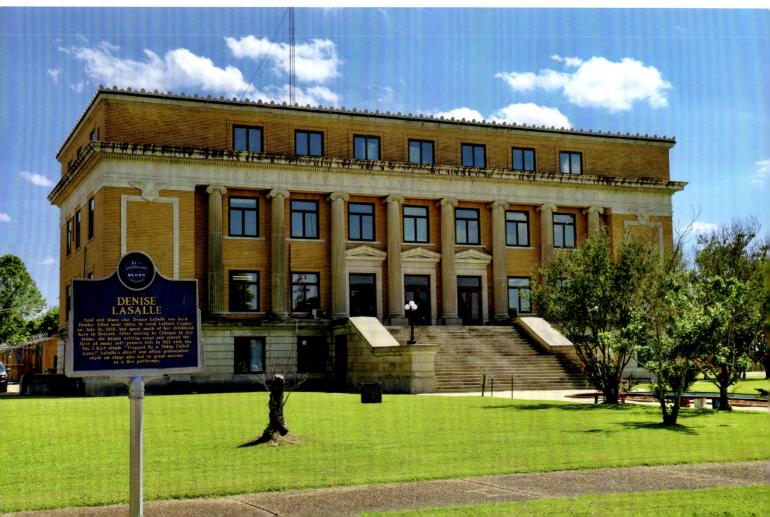

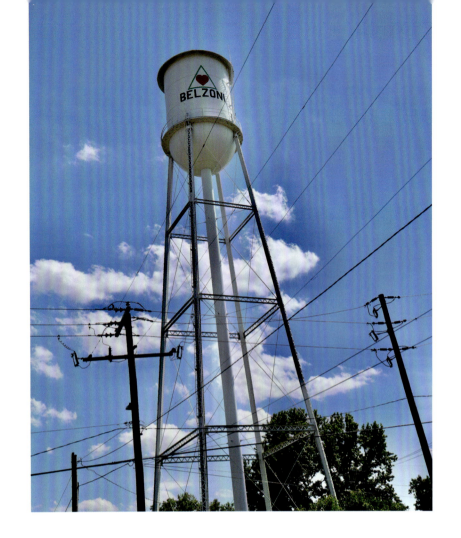

"I moved to the then-sleepy Gulf Coast over fifty-two years ago. The coast was still recovering from Hurricane Camille and would continue to struggle for twenty-five years. I did not know anyone other than family and was challenged to accept the much slower pace than in New Orleans.

"Mississippians are open, casual, accepting, genuine, and generous. Friendships were quick to develop and are still deeply meaningful."

—ANN GUICE

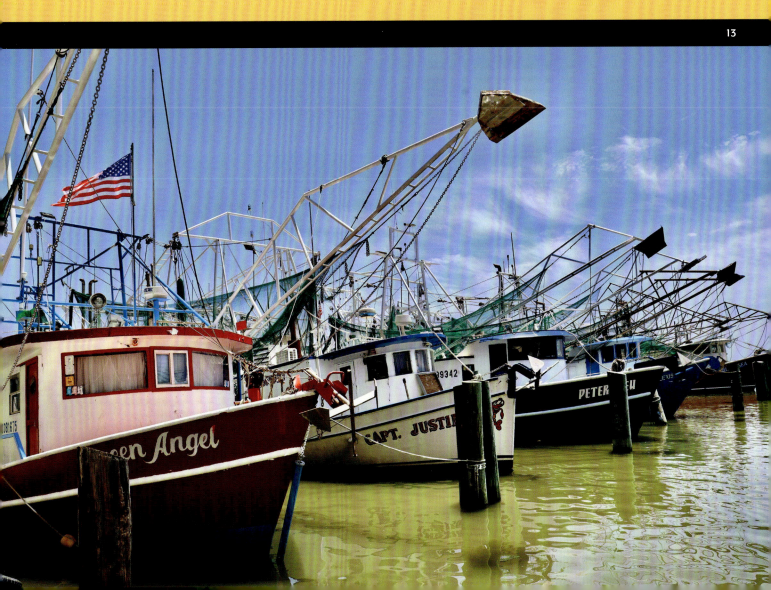

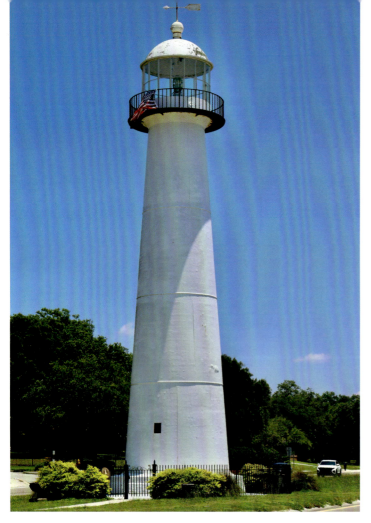

"Having lived in four states prior to my residence in Mississippi, I can state with conviction that small towns in our state have the most friendly, caring, generous people in the nation. Having completed thirty-five years as a physician/surgeon, I can also state that patients are very grateful for their care, now and then. Mississippi is a small community. I have learned that you never say anything negative about anyone, because everyone is related to someone."

—JOHN DAVID FAGAN, MD

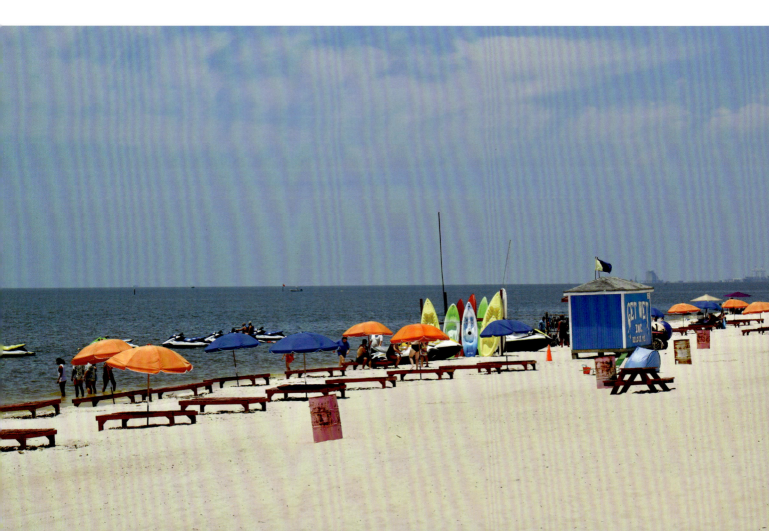

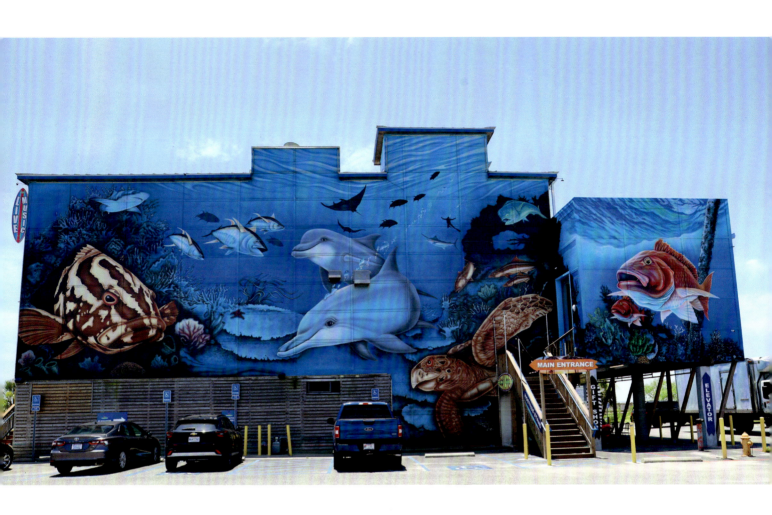

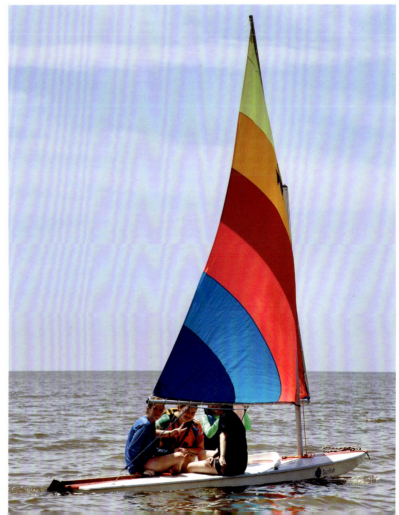

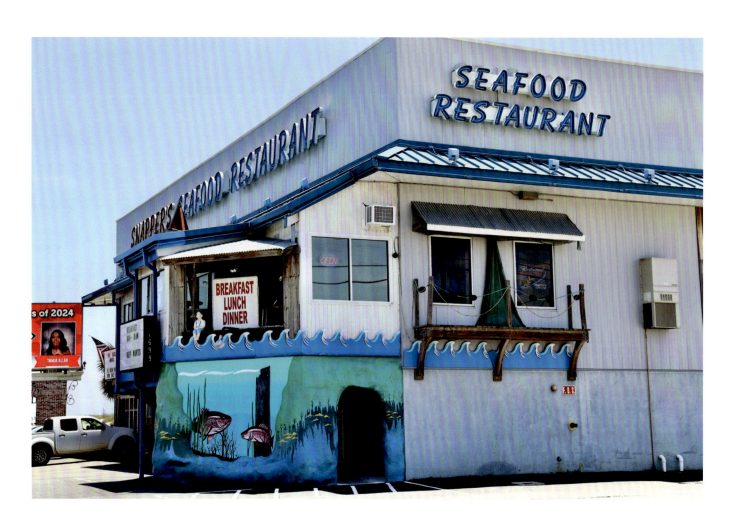

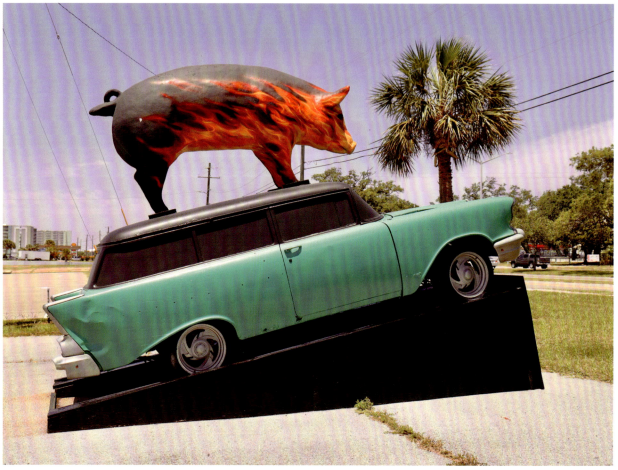

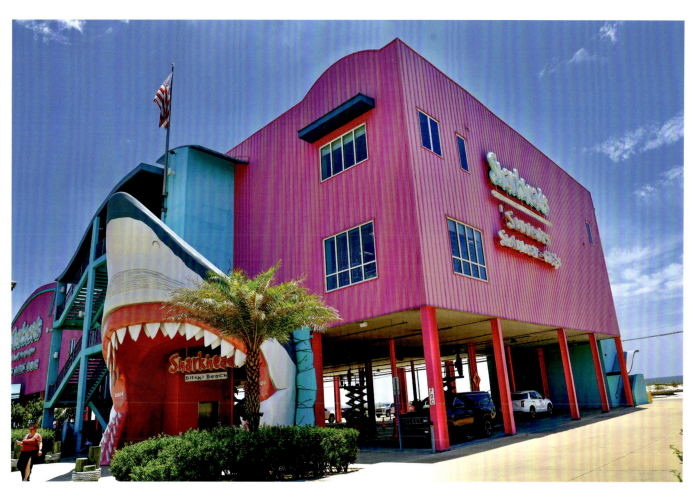

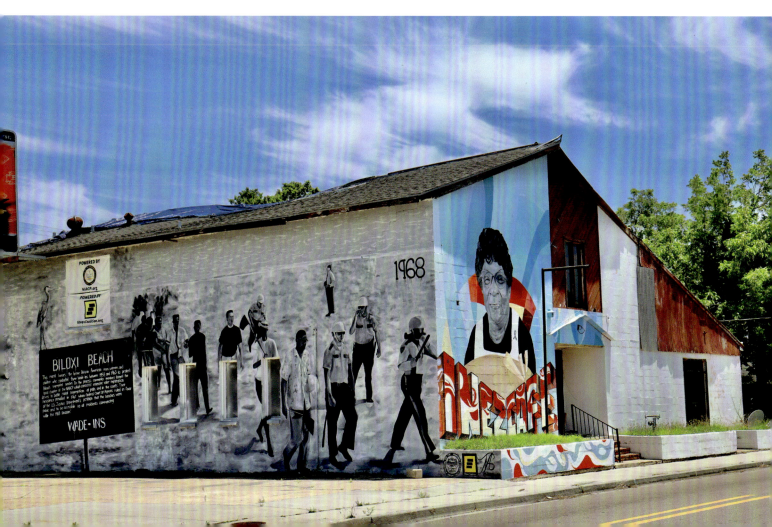

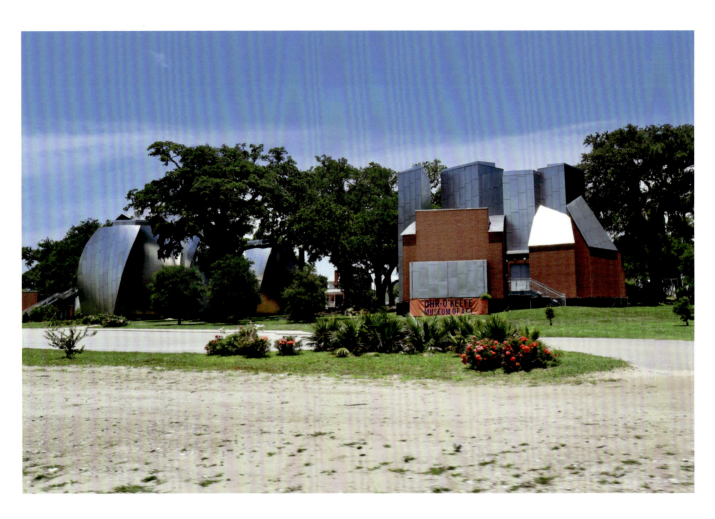

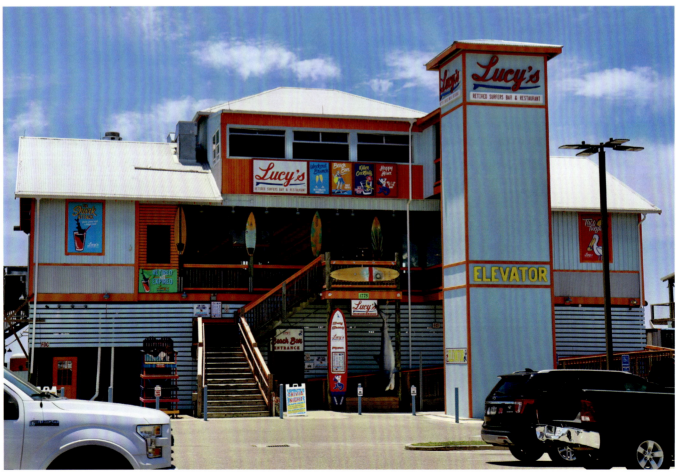

"There's nothing better than living in a community where you know all the people who live in it. Living in a community where you recognize everyone and where encounters prompt friendly greetings is truly unmatched."

—CONGRESSMAN BENNIE G. THOMPSON,
lifetime resident of Bolton, Mississippi

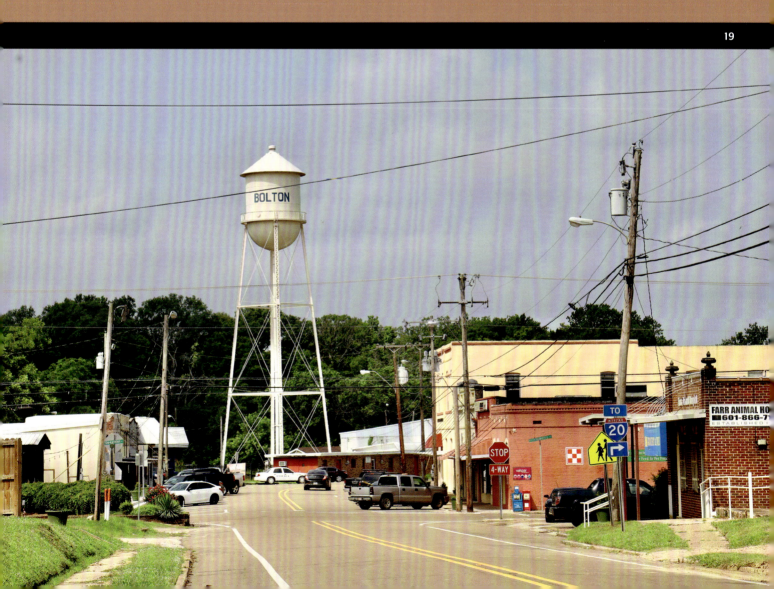

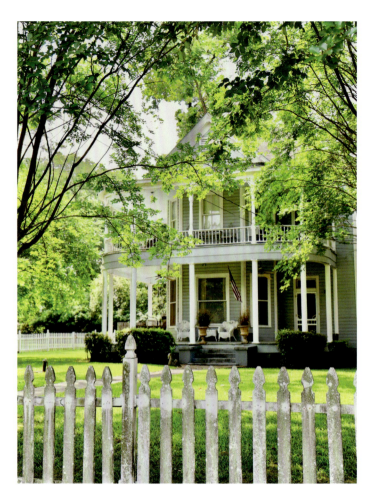
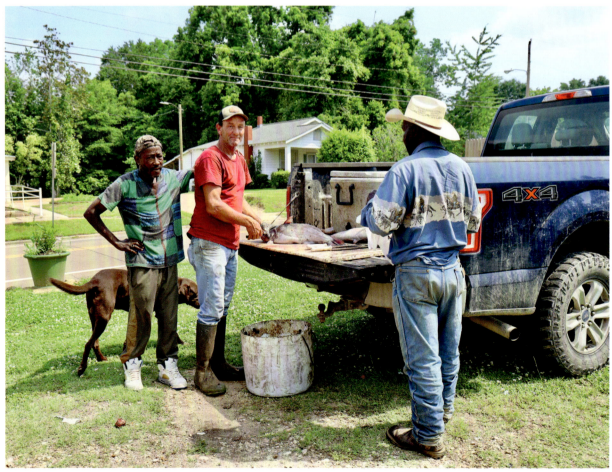

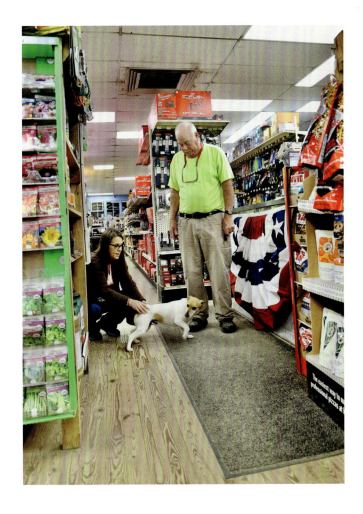
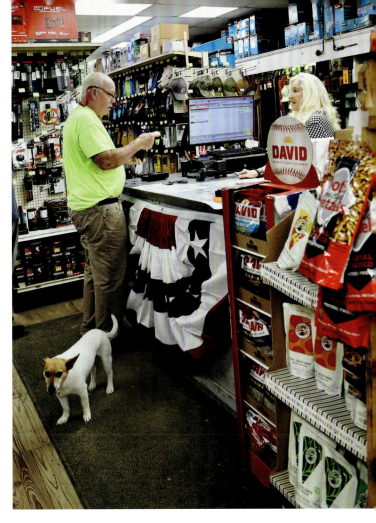
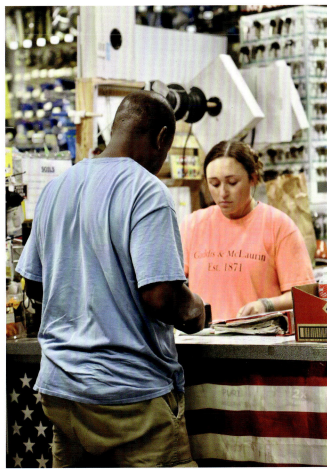

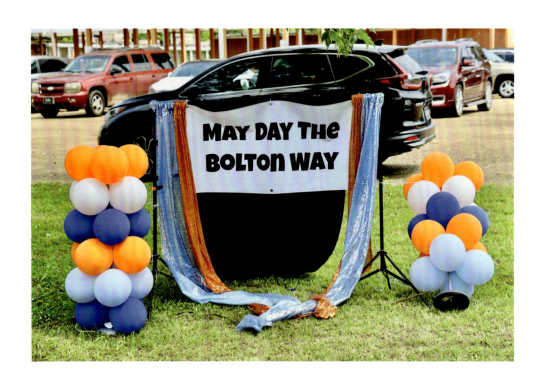
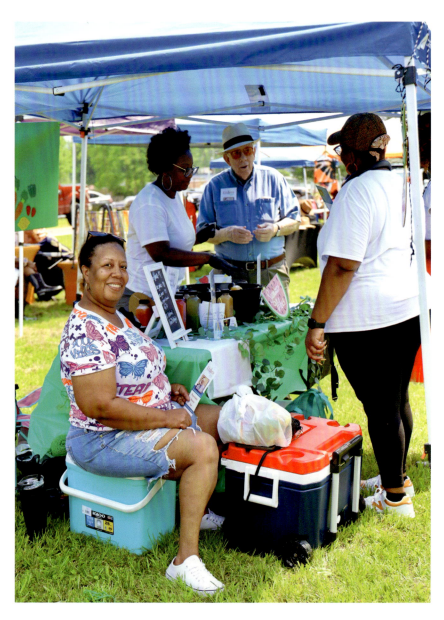

"Canton could not have been a better place for us to raise our boys. This community's loving souls nurtured roots that allowed them to reach for lofty educational, social, spiritual, and professional goals. One went from baseball to business and the other from ponies to pilot, and both continue to reach for their own stars."

—ALLISON CREWS

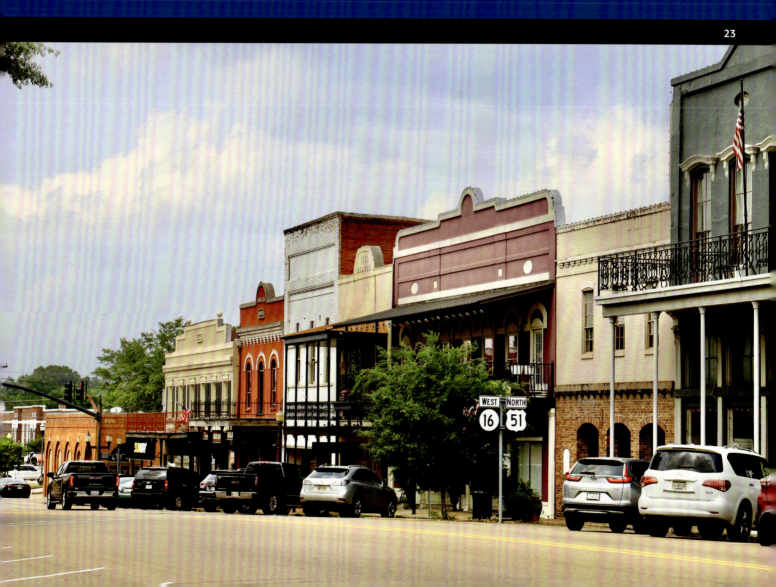

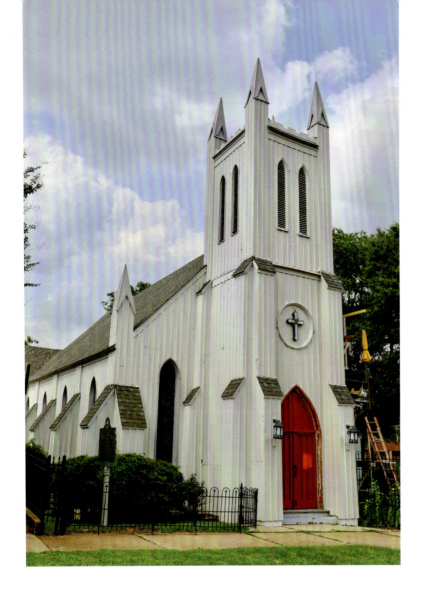

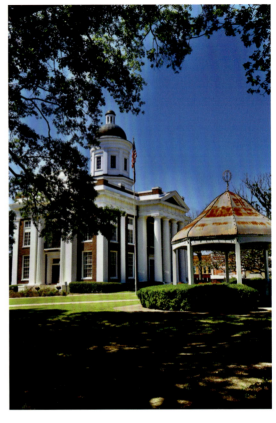

"When you were born, everyone was smiling, but you were crying. Live your life in such a way that when you die, you are smiling and everyone is crying."

—ROY KELLUM, MD

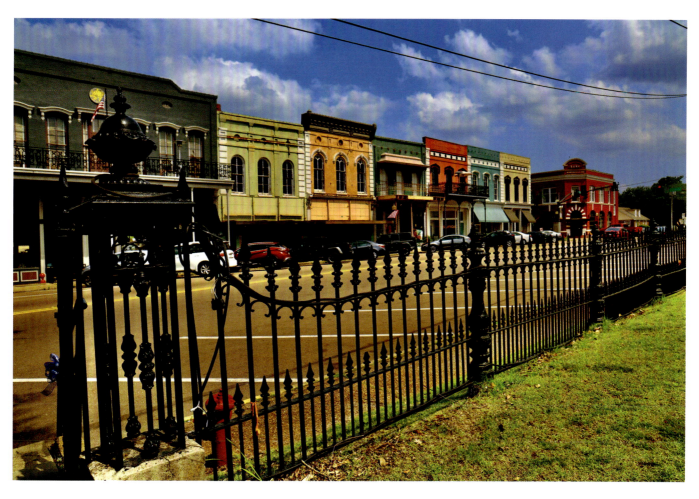

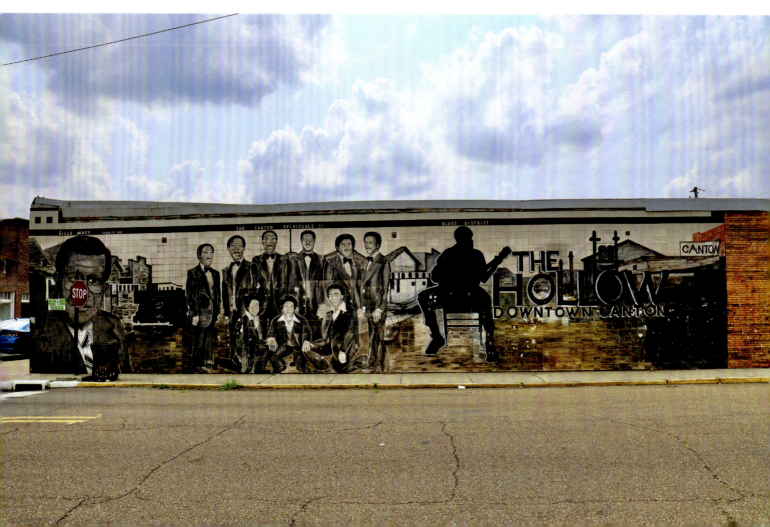

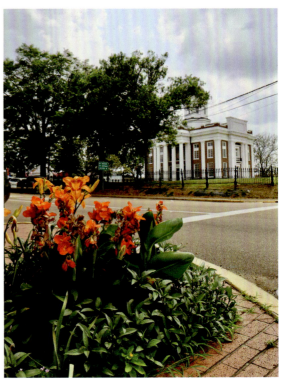
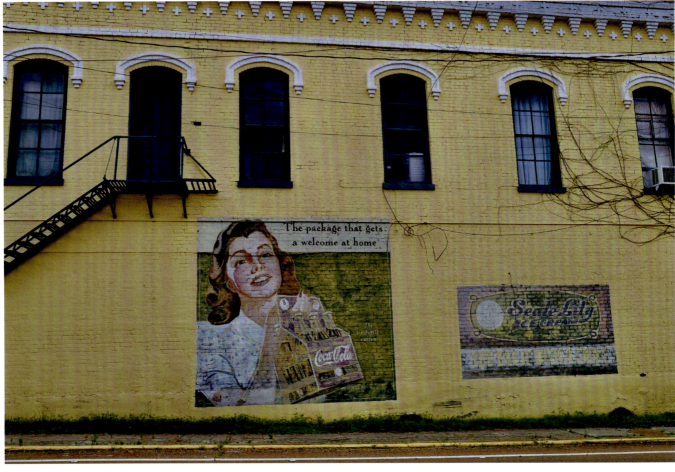

"I marvel at the sense of sharing that binds together friends and strangers alike in small towns—sharing time with small favors, sharing leftovers or goods from the garden, sharing labor when chores require more than my own two hands, sharing emotions in good times and bad, and of course sharing tips and opinions on all manner of daily life. For me, so much is bigger in a small town. Big hearts, for friends and strangers alike. Big helping hands, when my own can't get the job done alone. Big hopes for a good tomorrow, no matter how bad the world seems today."

—KELLE BARFIELD

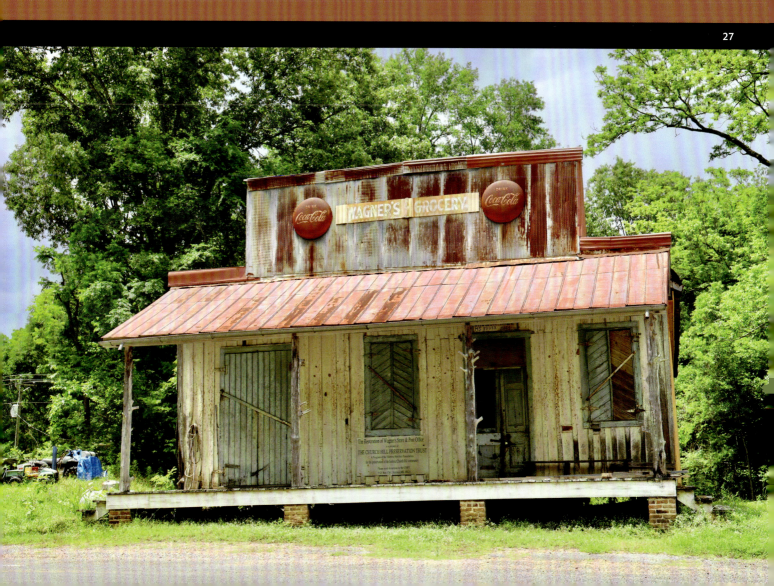

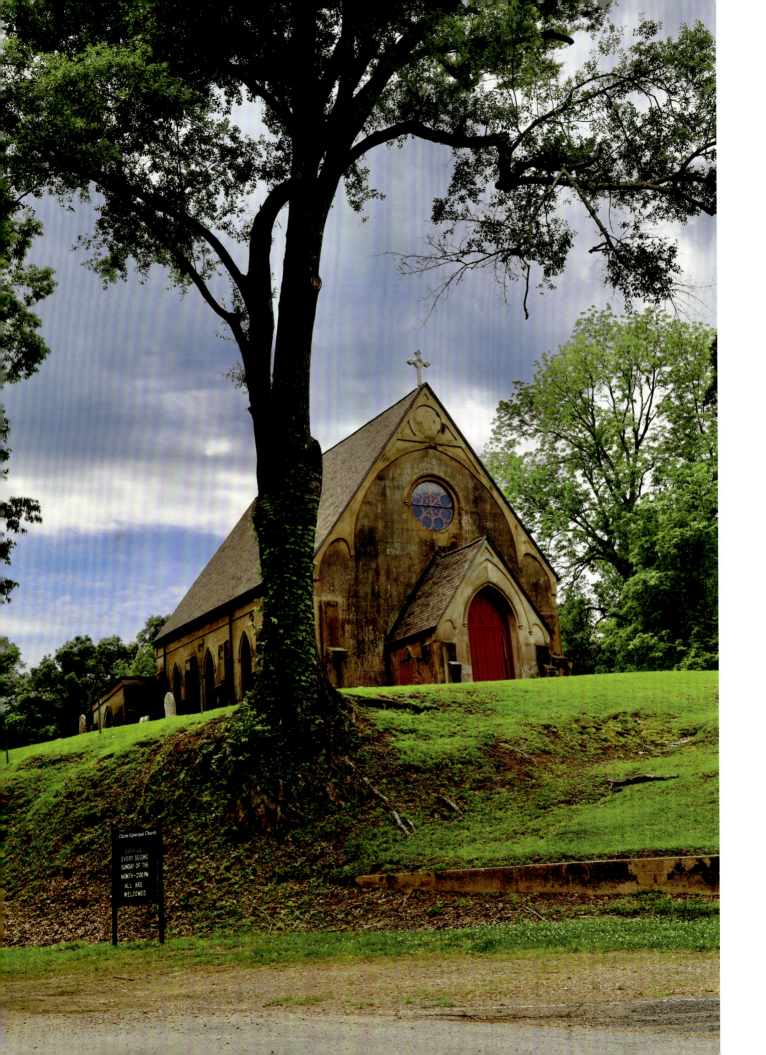

"I grew up in a small crossroads that had more dogs than it had people. We were nine miles outside a town of five hundred-ish (Hernando in DeSoto County) and counted on one another for everything. We didn't know then that our lives were charmed, lit by fireflies and simple lessons in how to love and live. But they were."

—AMY WHITTEN

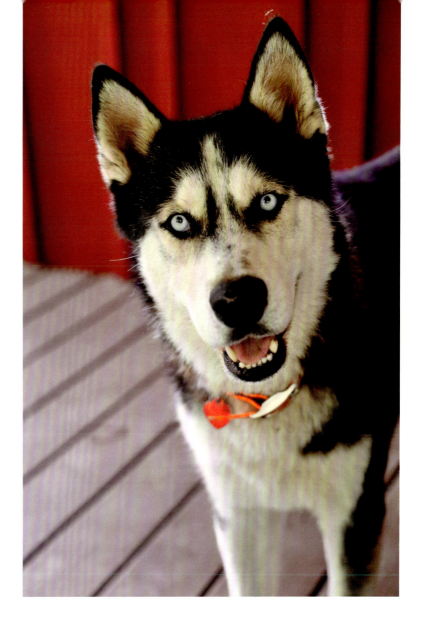

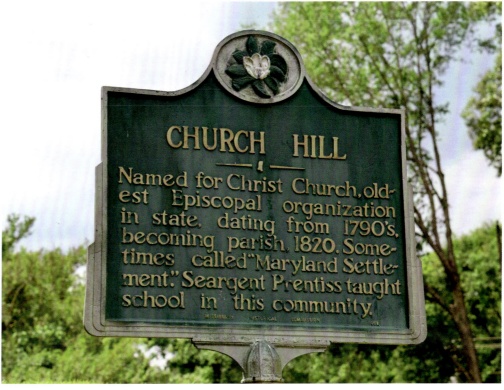

"I've lived in Clarksdale since 1976, and I have no plans to leave. I grew up near Lambert, Mississippi (population 1,081 in 1970). My office is five minutes from my house, and I can go hunting and fishing within twenty minutes of my home. I like to play golf and can be on the course in fewer than five minutes. I've never been in a traffic jam here. But, when things are bad, our community is always present to help and provide overwhelming support."

—RALPH CHAPMAN

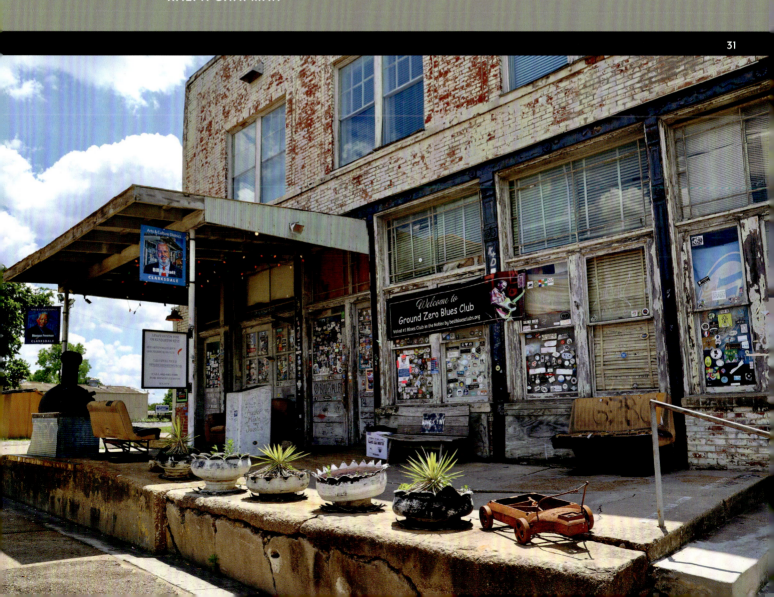

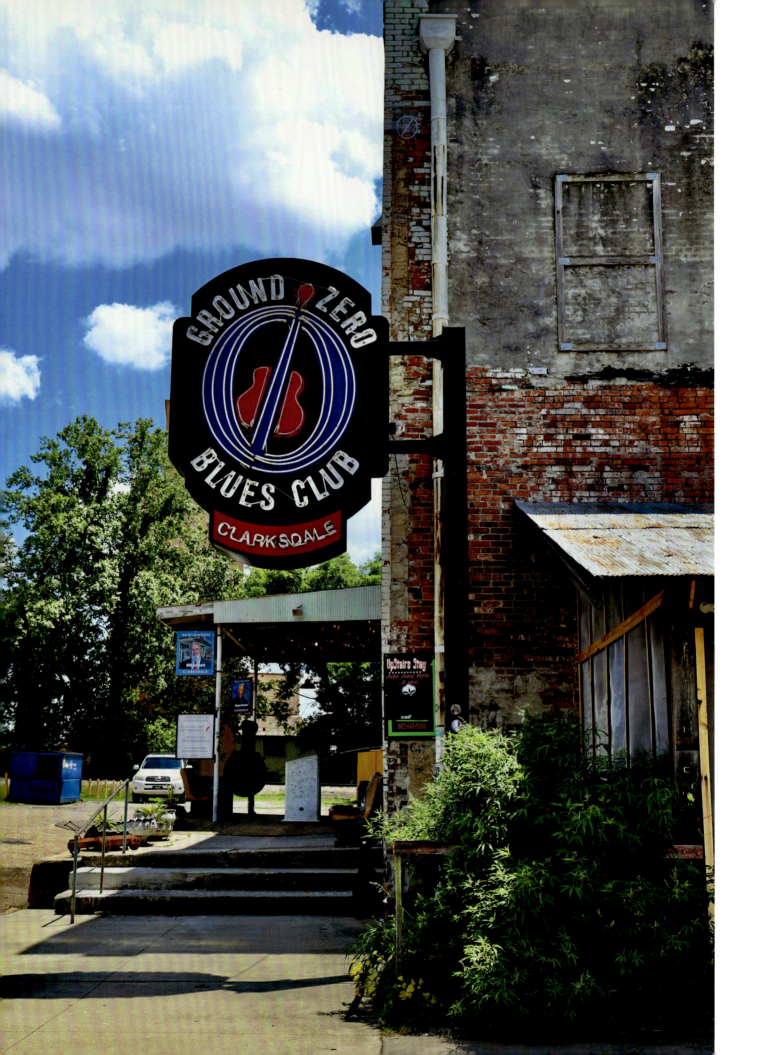

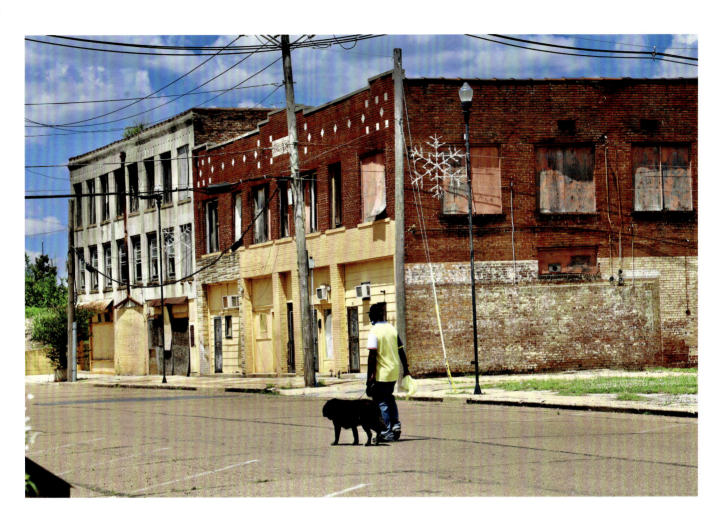

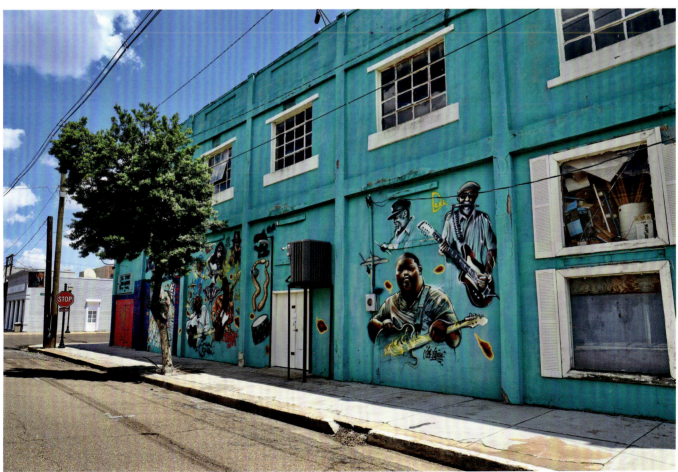

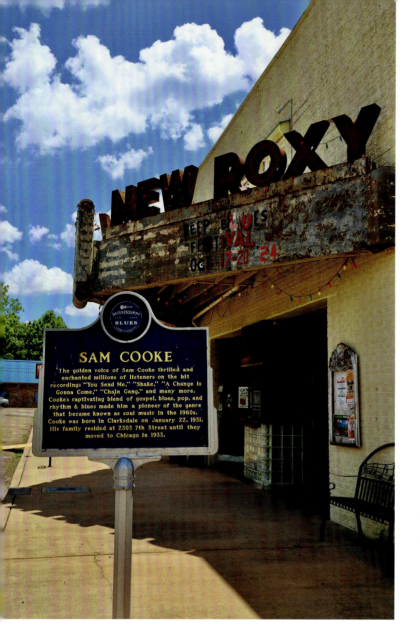

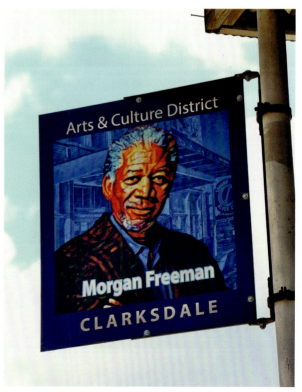

"I was raised in a small town in Mississippi. I went to school there. I graduated from there. My values, my morals, my ethics all come from there. It's who I am."

—MORGAN FREEMAN

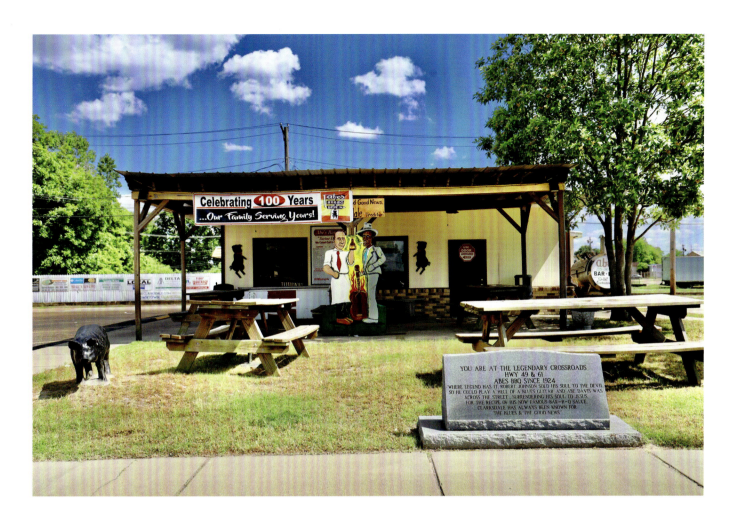

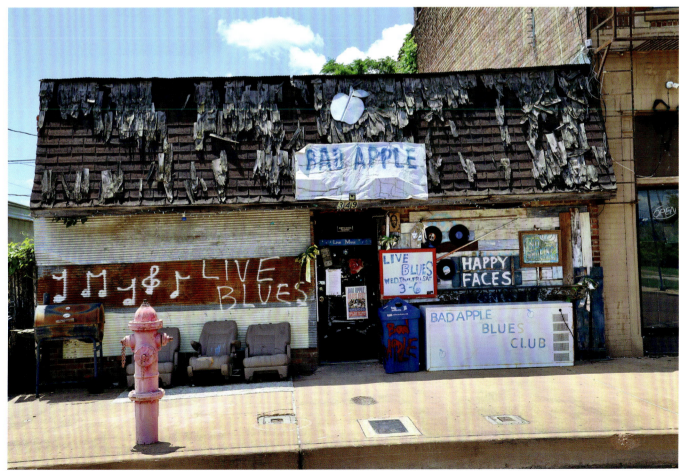

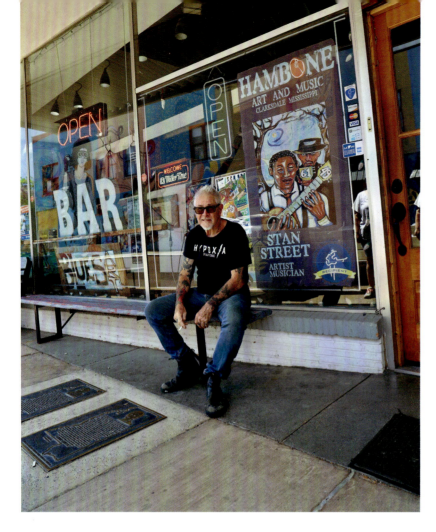

"In small towns one saying is always true: 'Same story different people.'"

—JOHN REID GOLDING

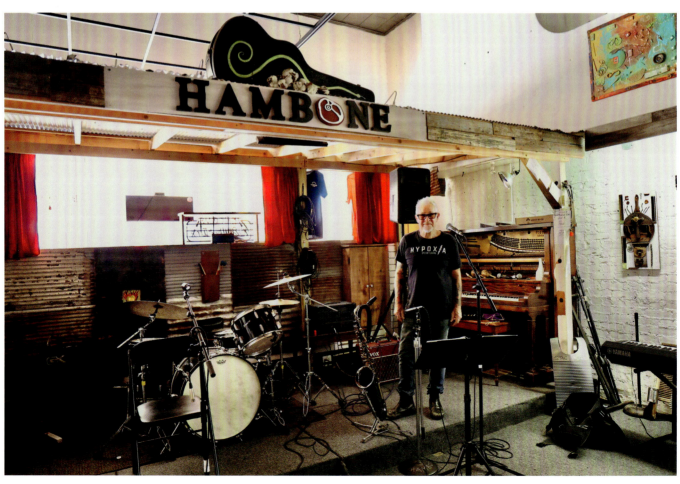

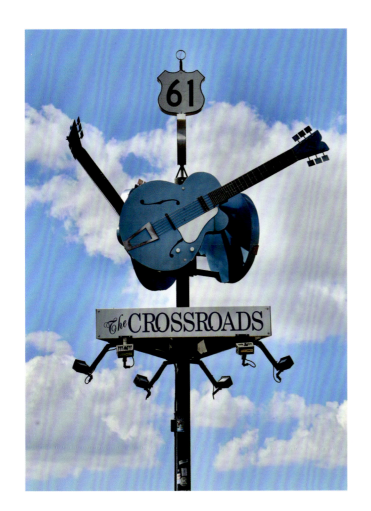

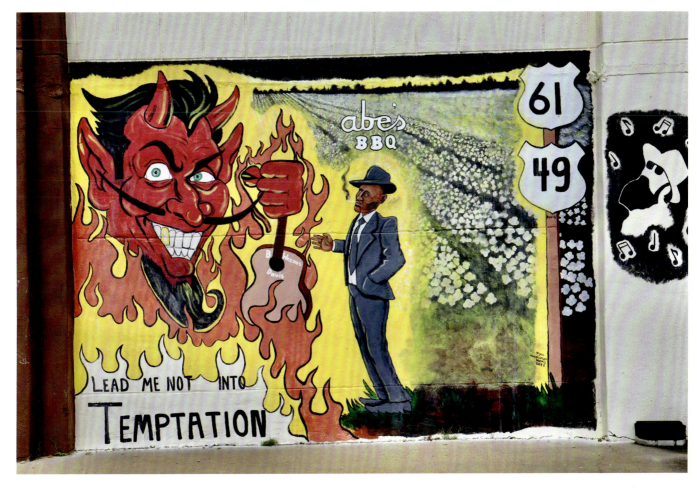

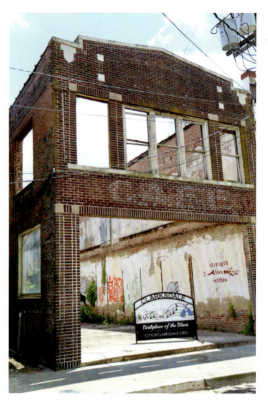
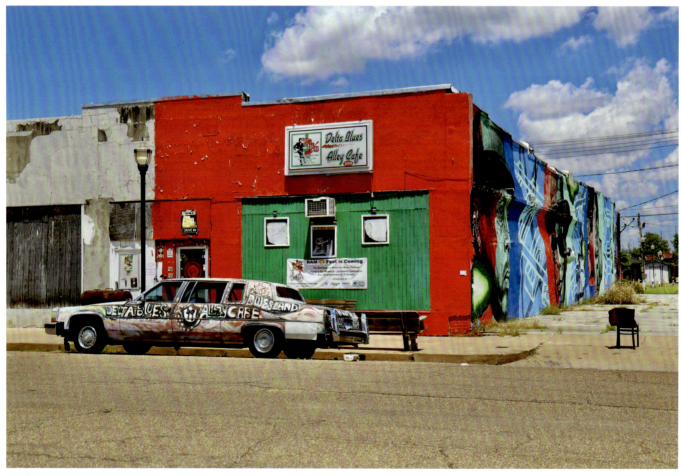

"By growing up in a small Delta town, you establish friendships from adjoining small towns that last for generations to come."

—**PAUL JANOUSH,** Mayor of Cleveland

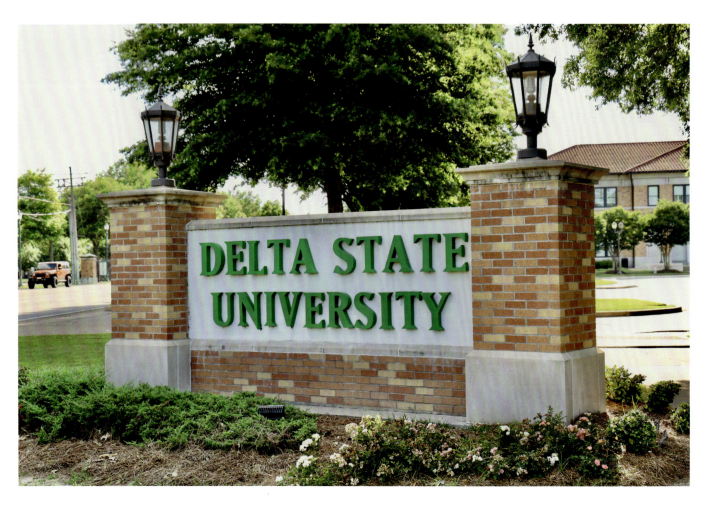

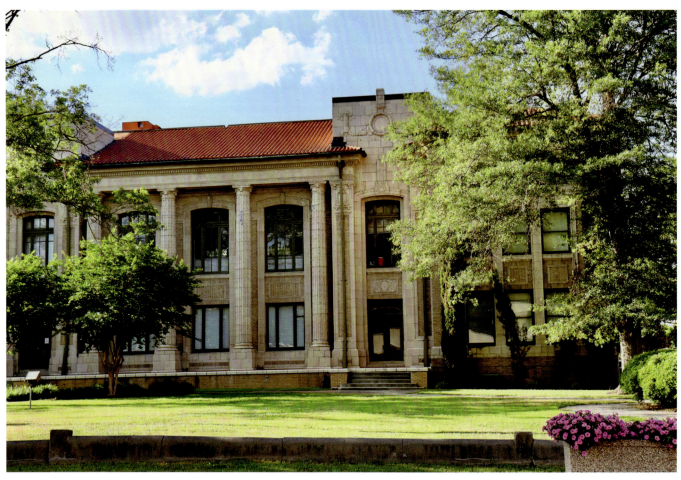

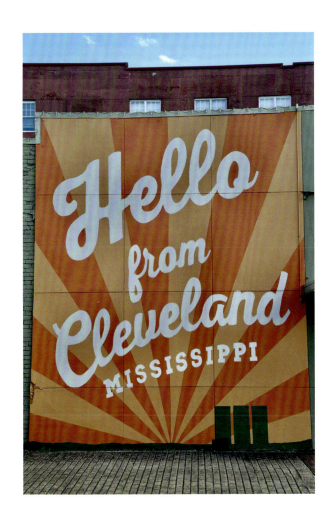

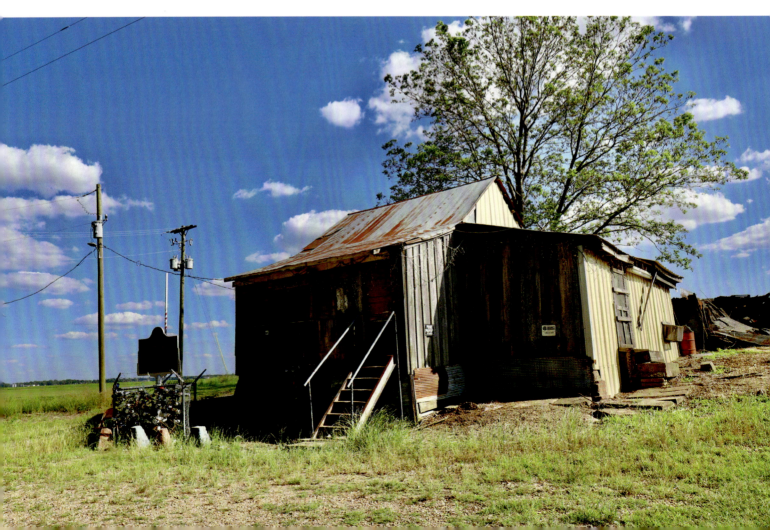

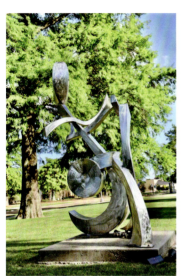

"When things are really good, it is never really good in the Delta, but when things are really bad, it is never really bad in the Delta. I will take the Delta!"

—JOEL J. HENDERSON

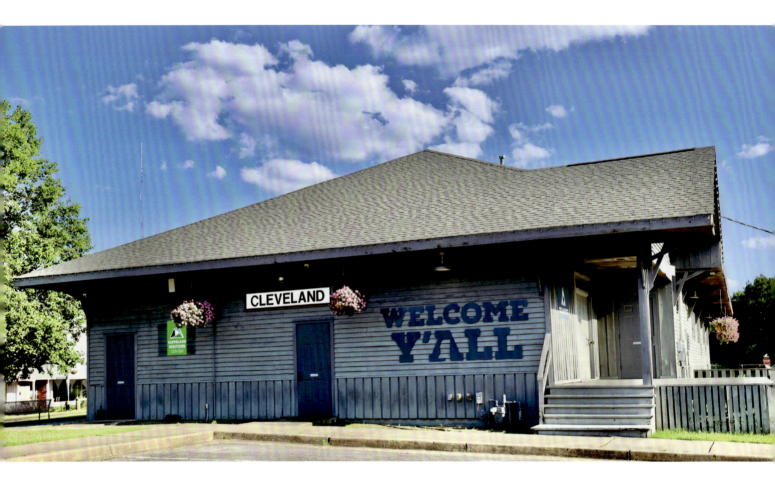

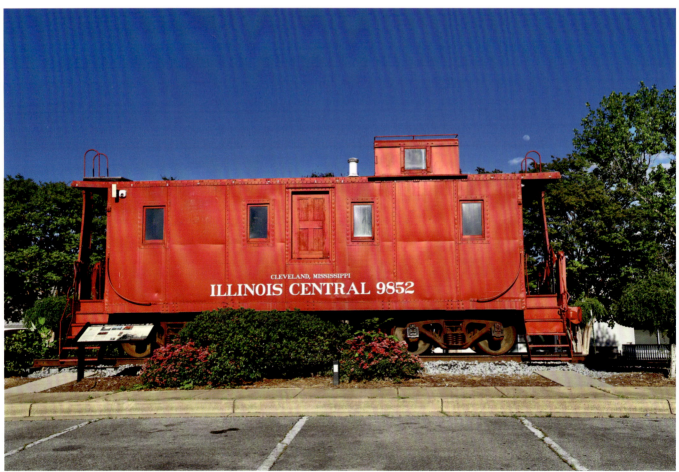

"I enjoy living in Columbus, Mississippi, 'The Friendly City,' because it lives up to that nickname. The kindness of the people, the rich history, and the sense of community make this place very special. We are home to the first public university for women in this country, Mississippi University for Women."

—NORA ROBERTS MILLER,
President of Mississippi University for Women

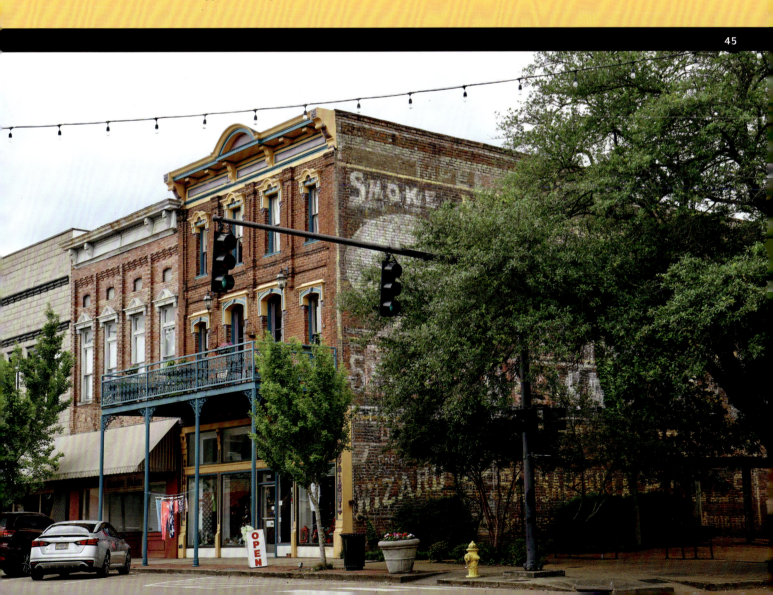

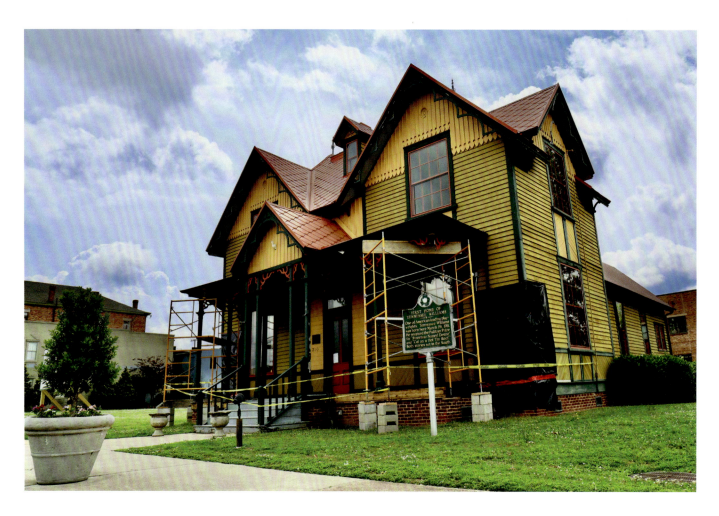

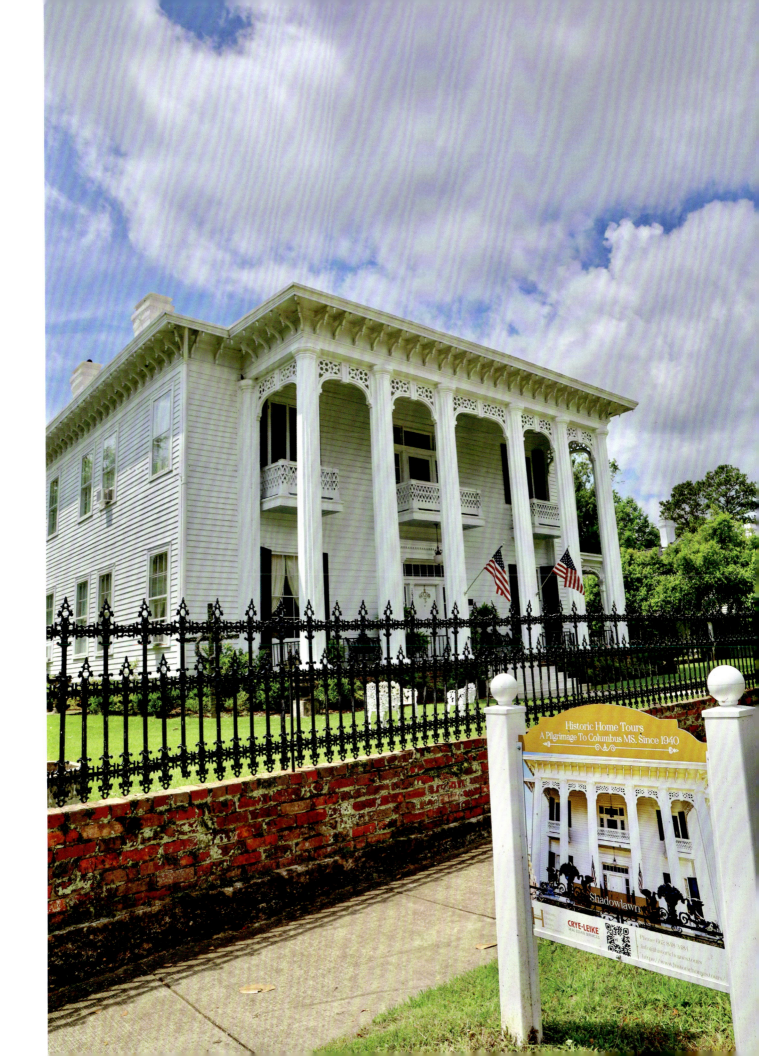

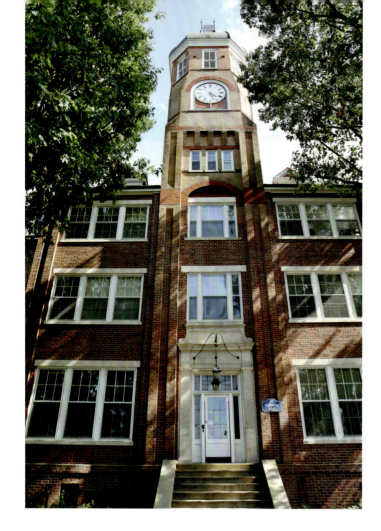

"I feel very fortunate to have raised my children in such a loving, family-oriented place where we are surrounded by great friends and extended family."

—**KATHLEEN GEARY**

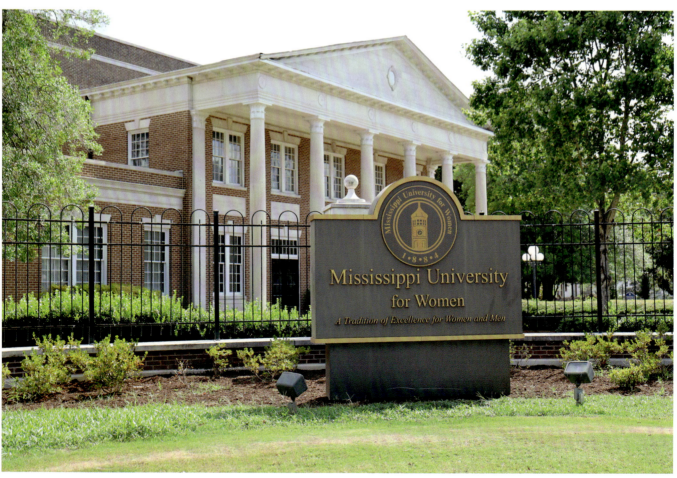

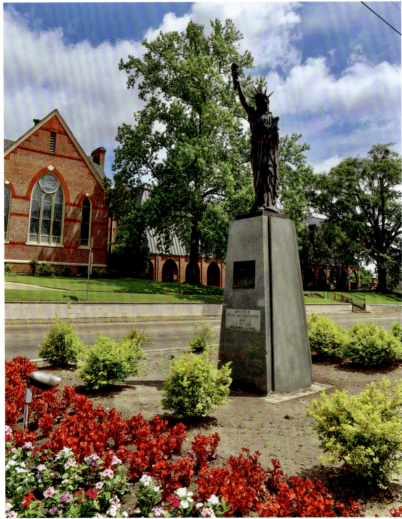

"I lived in Jackson most all my life. I moved to the Flora area six years ago. Dropping by Mayor Childress's office unannounced and talking about what is going on in town, family, and of course hunting is so refreshing!"

—BILL LAMPTON

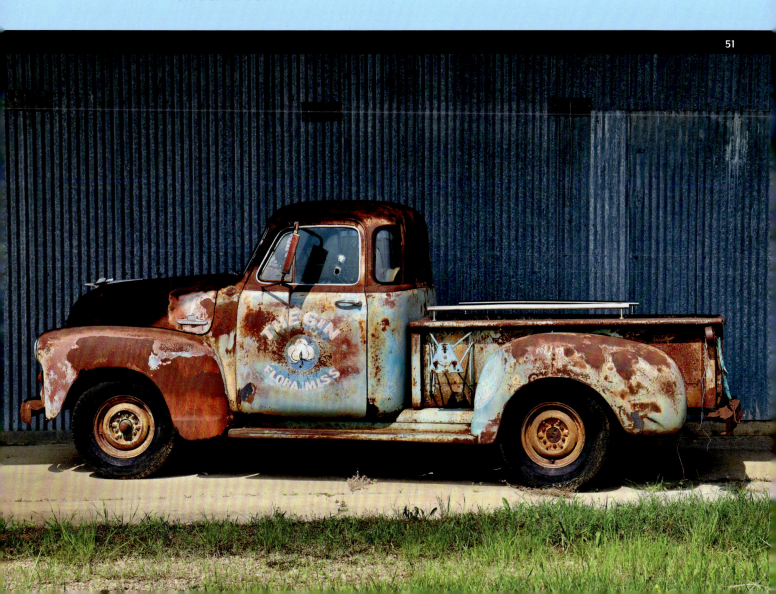

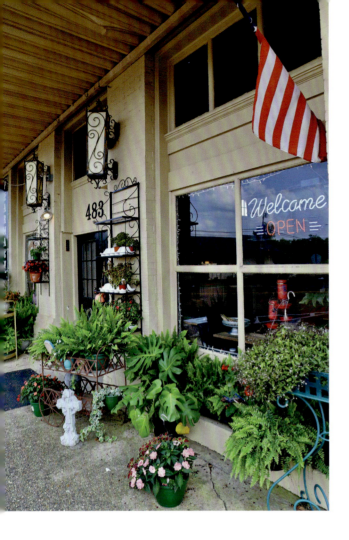
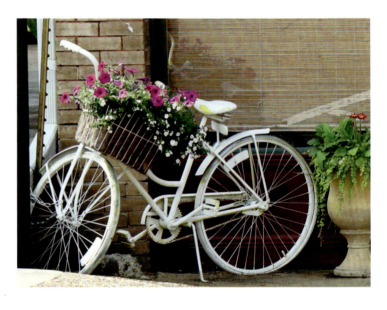
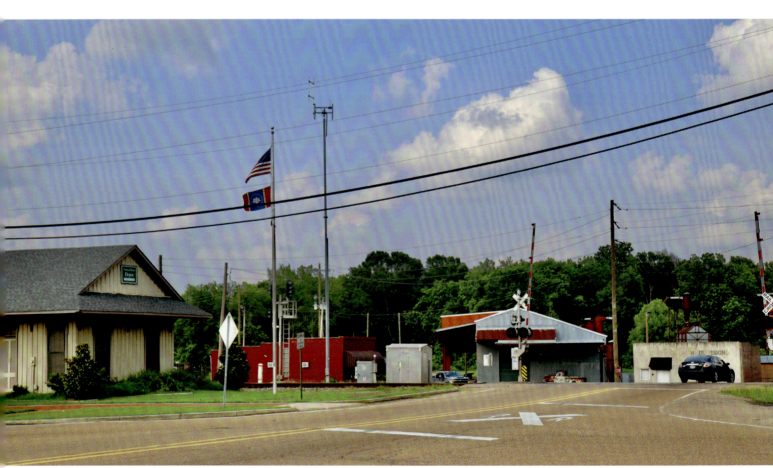

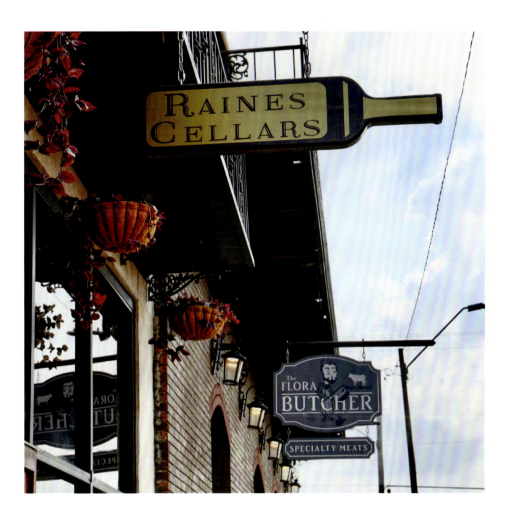

"I would like to share this from my dad who immigrated to Greenwood, Mississippi, in 1968 from India to teach as a professor at Mississippi Valley State University. He always says, 'When I came to Greenwood, Mississippi, I came to Heaven on earth.'"

—MONICA SETHI HARRIGILL

"The one quote that I have used on many occasions, some to juries, is, 'If the truth kills Gramma, let her die.' This quote was given to me by an old lawyer in Greenville about forty-five years ago by the name of Raymond Kimble. He was a tough old bird."
—FRANK DANTONE

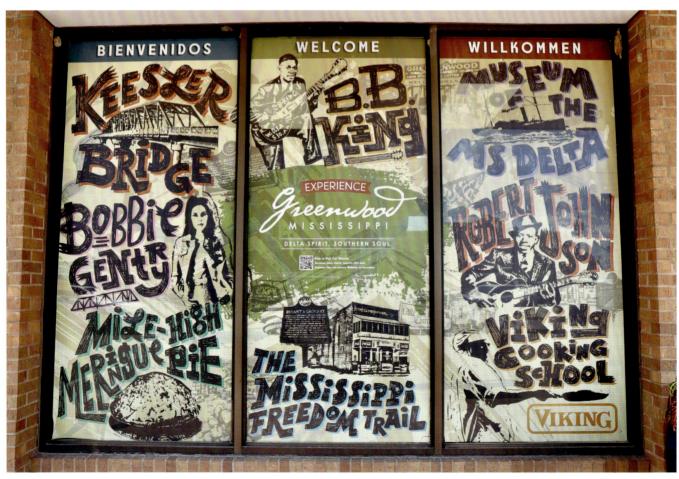

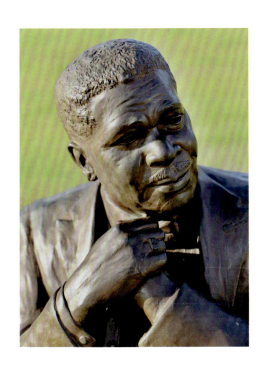

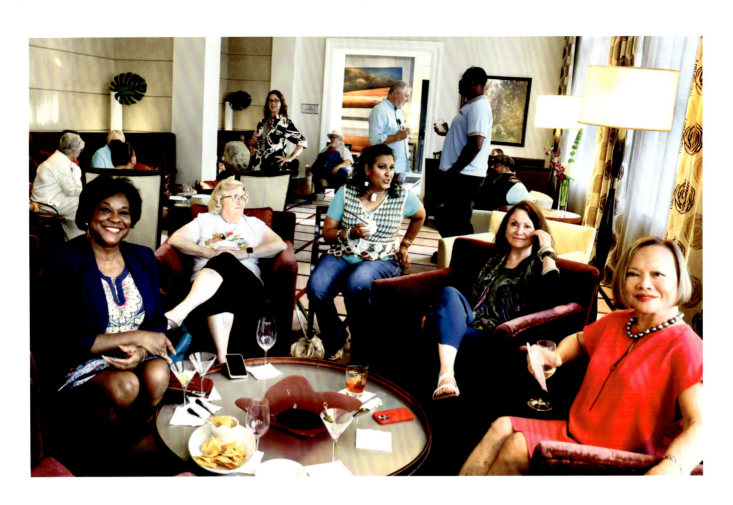

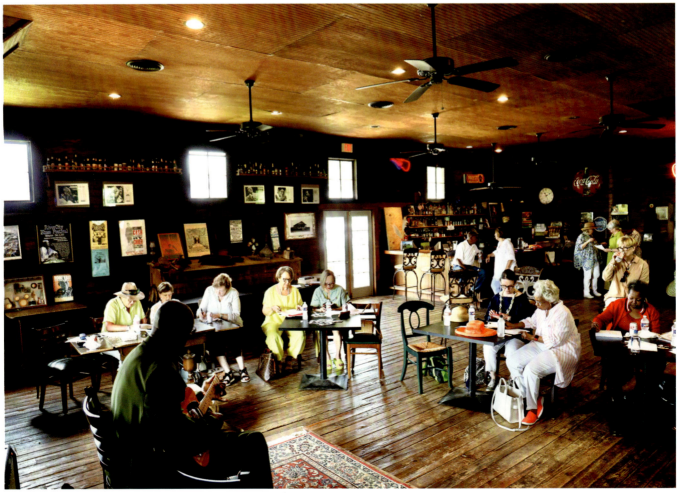

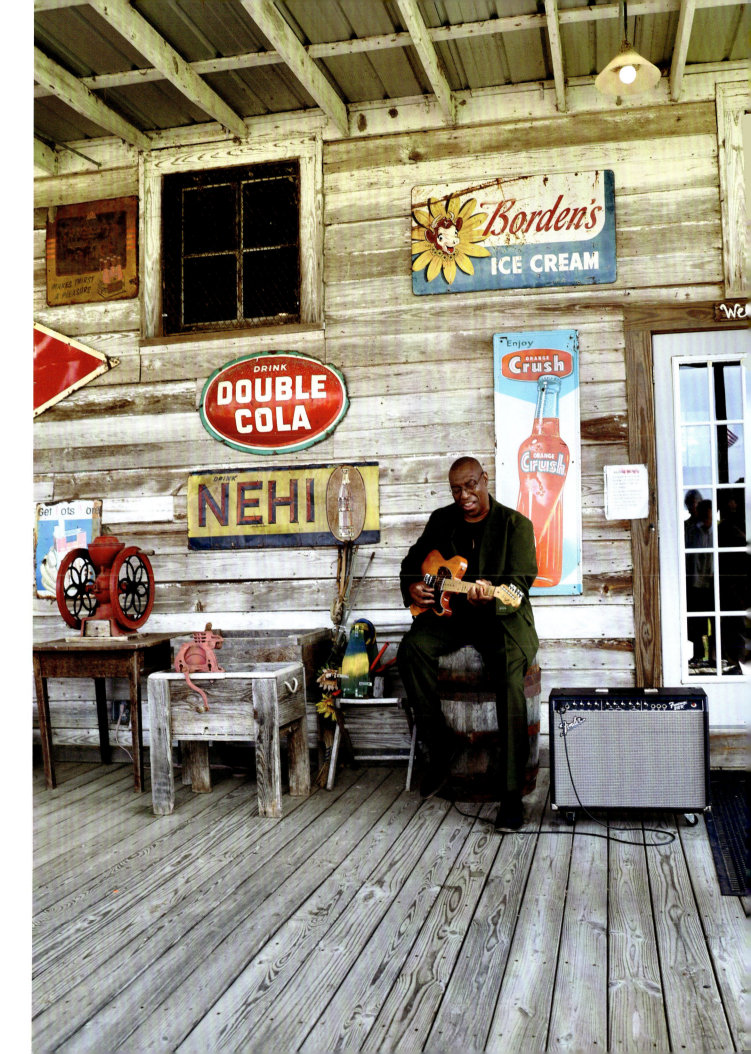

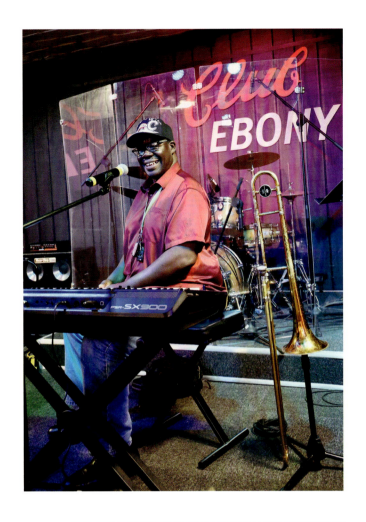

"There is no question that we have scars and bruises from a rough, cruel, and many times inexcusable and unexplainable past, but those are the burdens of the entire country, too. All nations have scars. What defines us as a culture is how we move past those tragedies. I believe Mississippi has risen above our past. I believe I am a son of the new Mississippi."

—ROBERT ST. JOHN, Restauranteur and Author

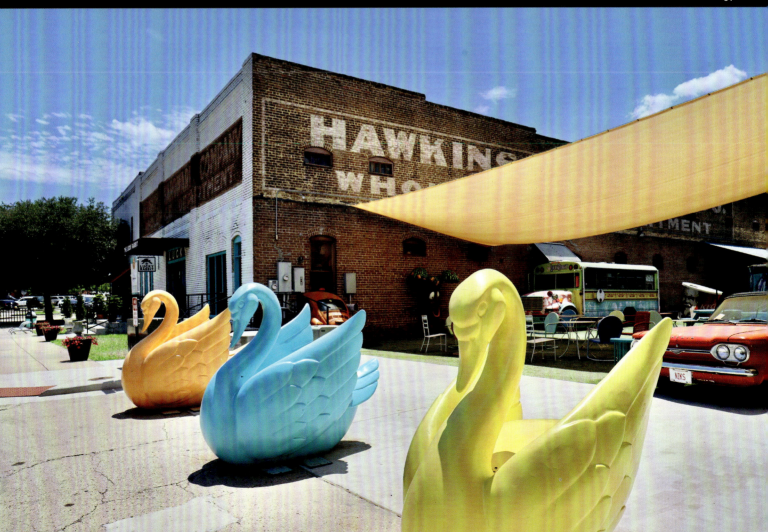

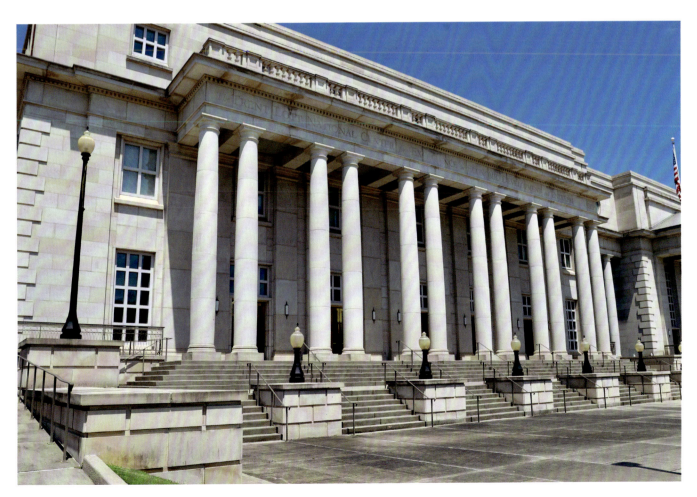

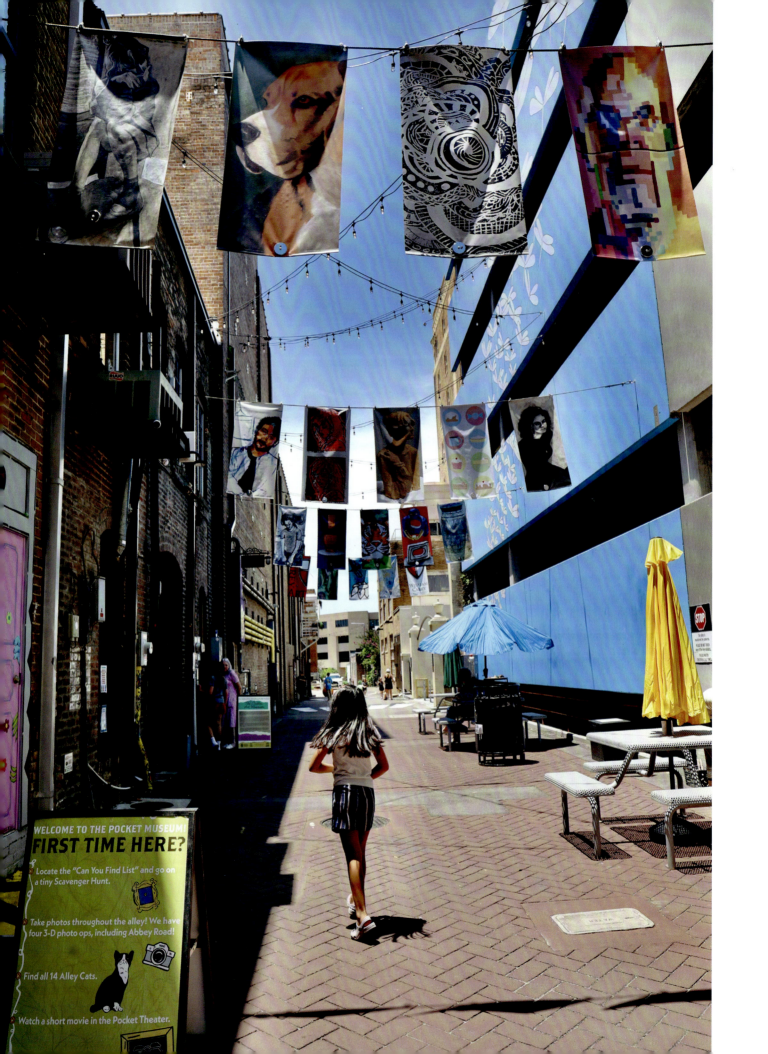

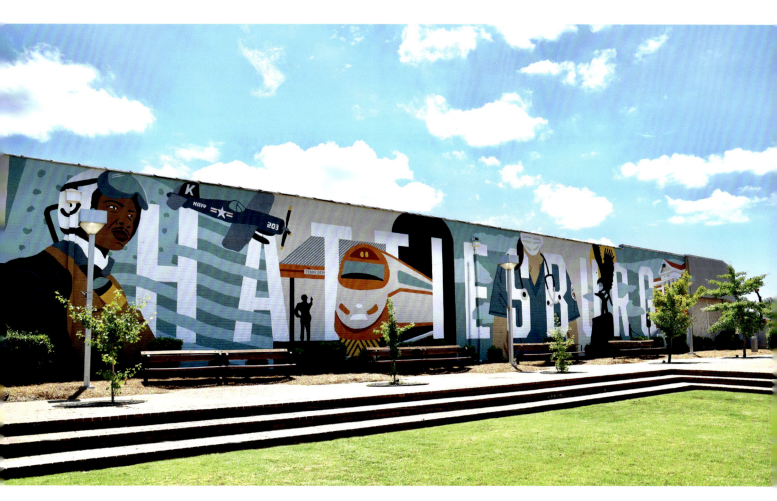
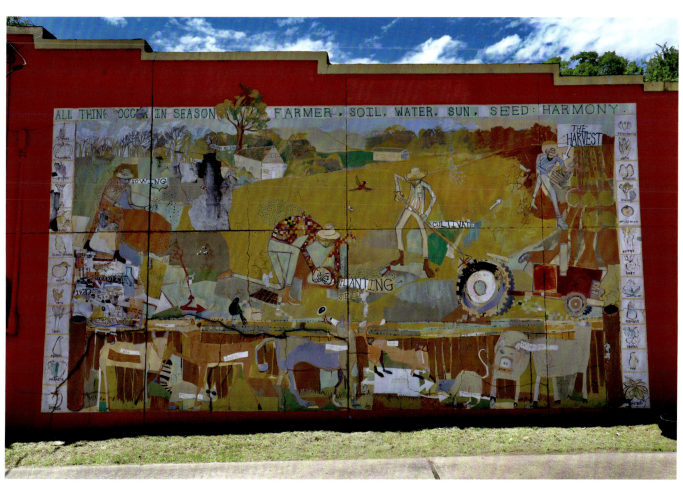

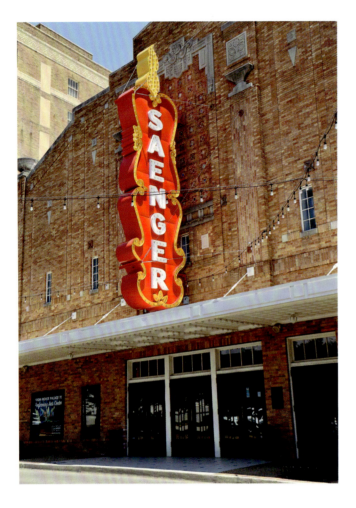

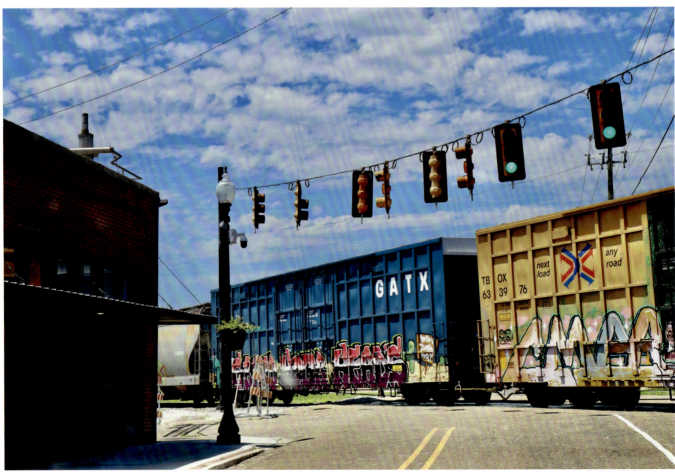

"Growing up in a small town is a blessing that people who didn't grow up in one will never understand. Growing up in small-town Mississippi was a blessing that only a few of us got to experience."

—RANDALL P. SWANEY

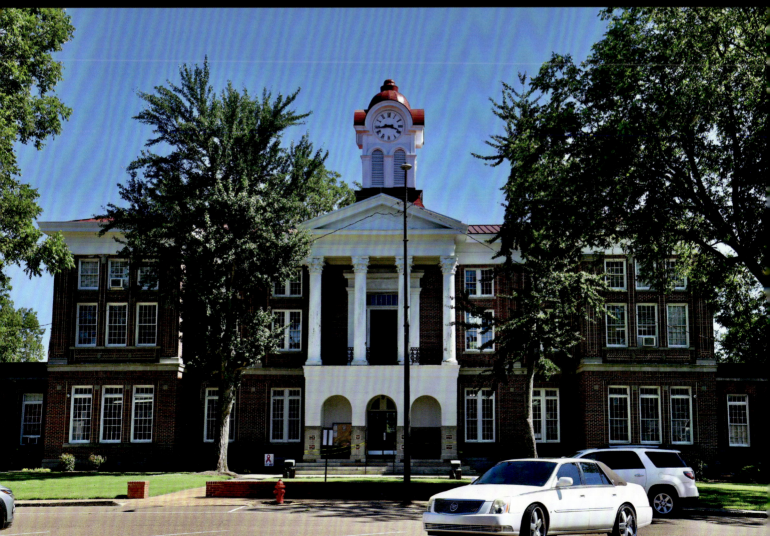

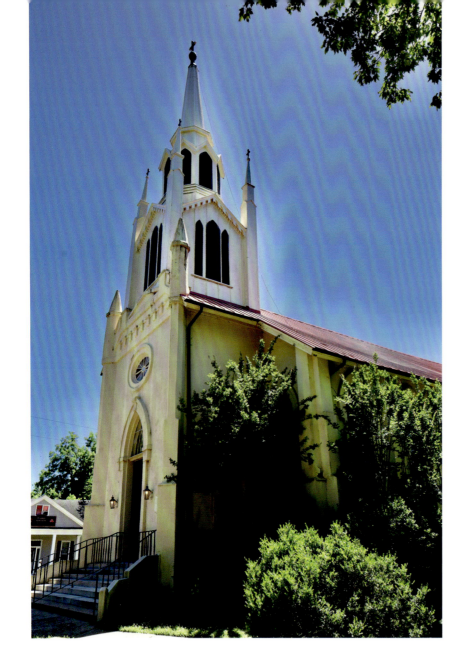

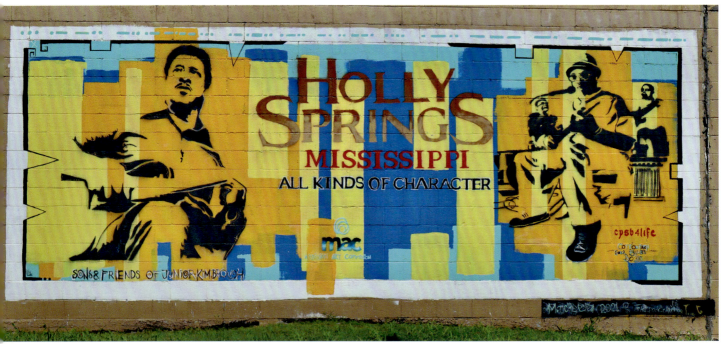

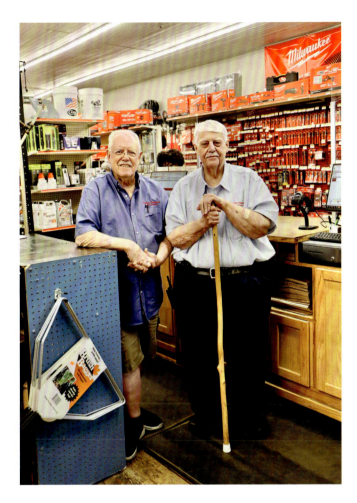

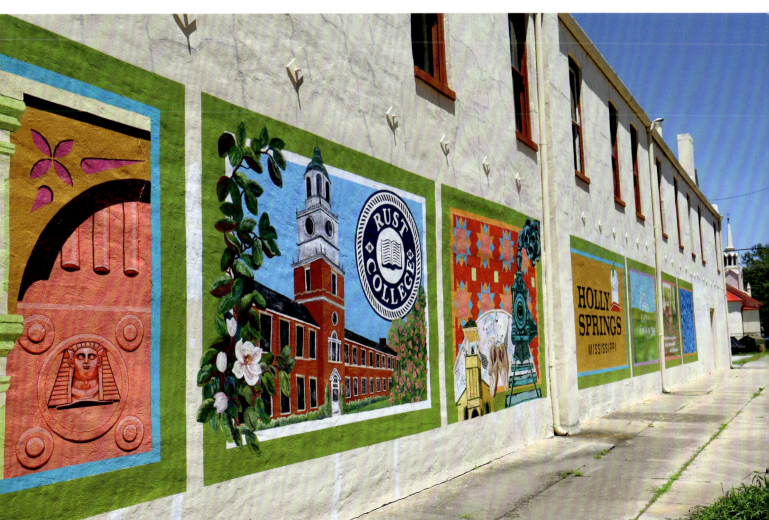

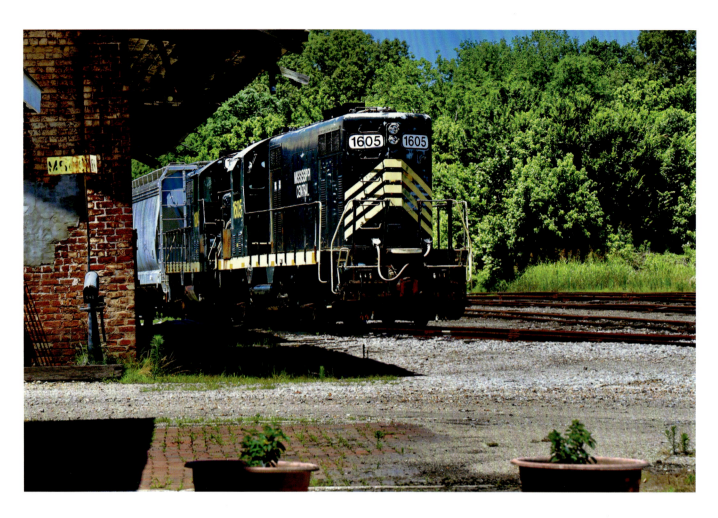
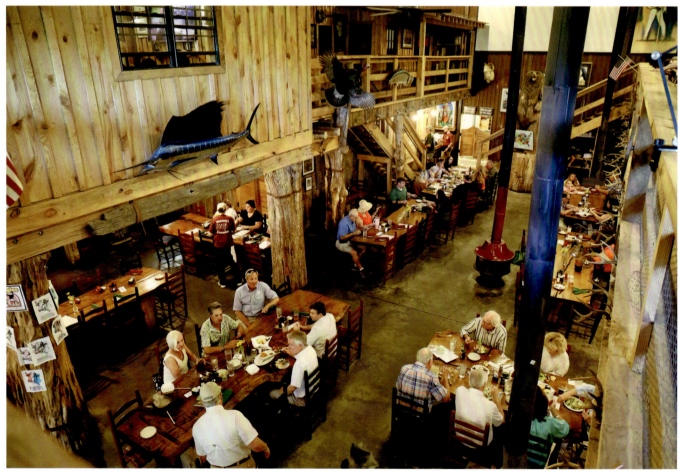

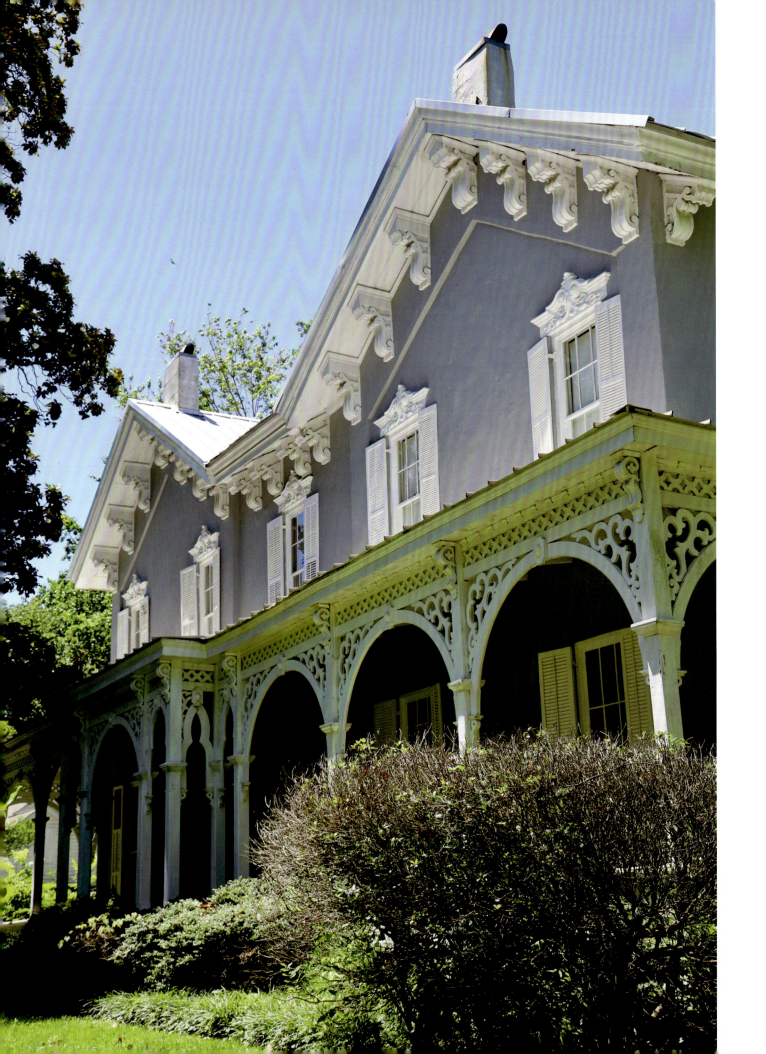

"I am a native Mississippian. I grew up in a small community located between Terry and Crystal Springs. Following college and marriage, my late husband and I made a conscious decision to remain in Mississippi. We made Jackson our home. It has been a great place to raise our children and participate in the life of our community in meaningful ways through work and other civic and social activities. I enjoy the rich cultural attractions and the opportunity to live among neighborly people with a strong sense of community."

—**BEVERLY WADE HOGAN**,
President Emerita of Tougaloo College

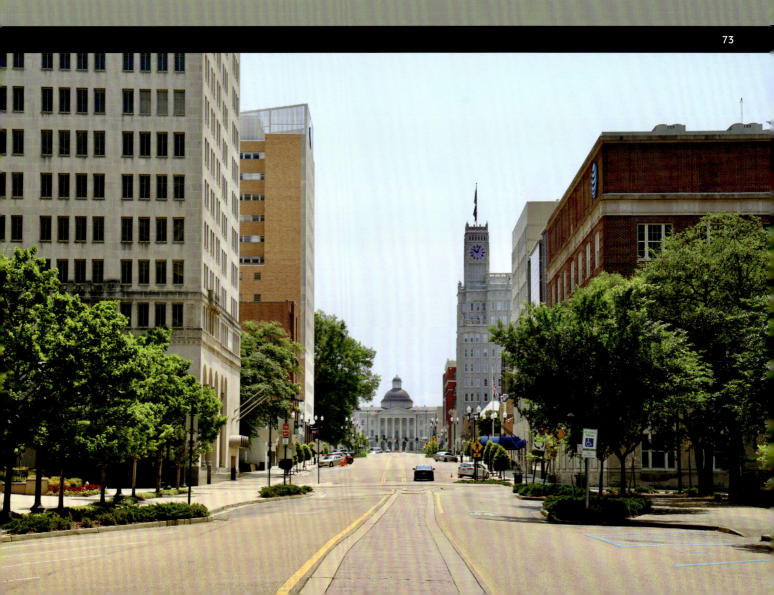

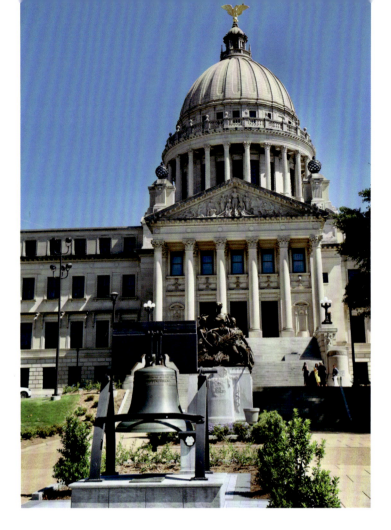

"I am proud to live in a state where people care deeply about history. By telling our stories and preserving our historic communities, we honor the places where significant events took place and our forebears' extraordinary accomplishments. I love how Mississippi's rich heritage is woven into the fabric of our towns."

—KATIE BLOUNT,
Director of Mississippi Department of Archives and History

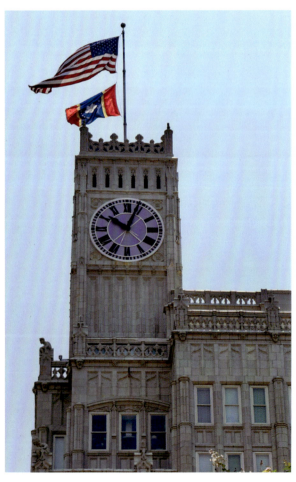

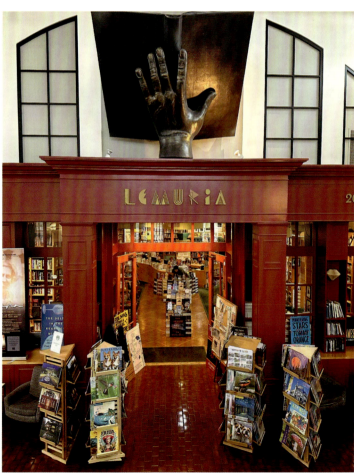

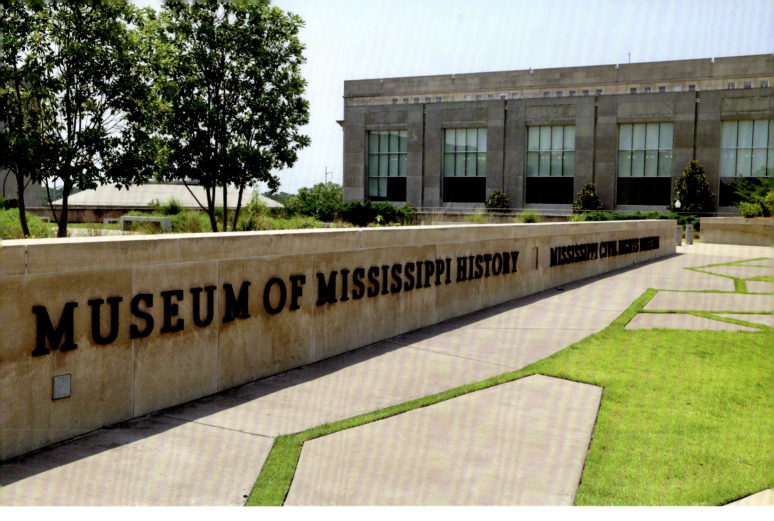

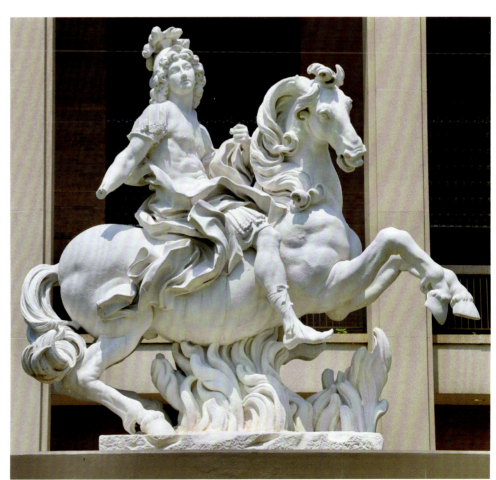

"I grew up in the Fondren neighborhood of North Jackson. For fifty years I've been my neighbors' bookseller. Through Lemuria, I've shared books and authors with my hometown friends. Being the heartbeat of Jackson's literary presence is my creative commitment."

—JOHN EVANS

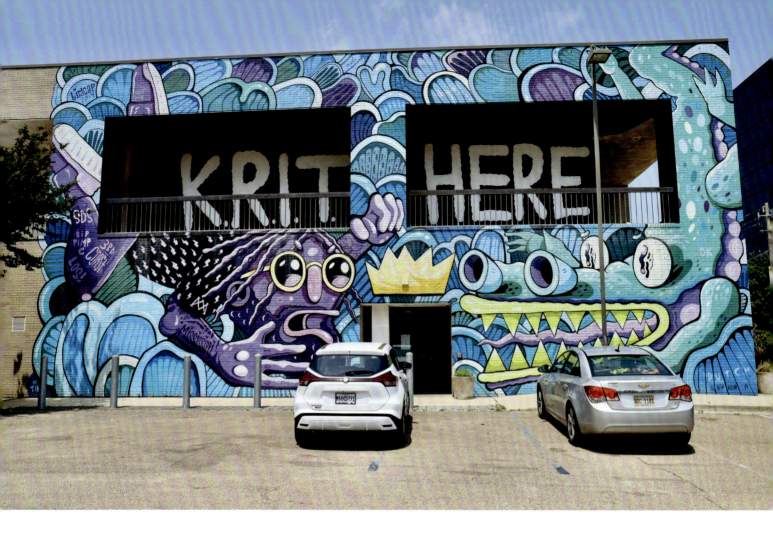
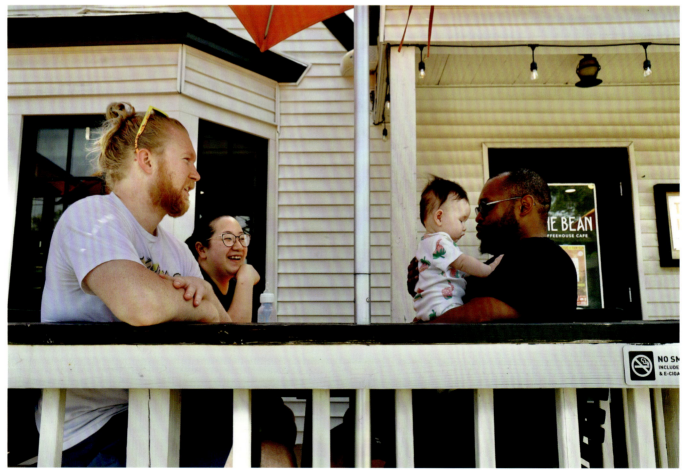

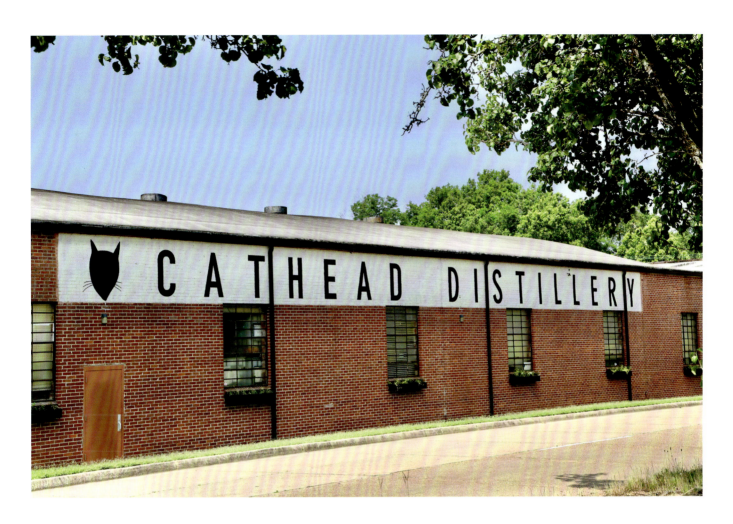
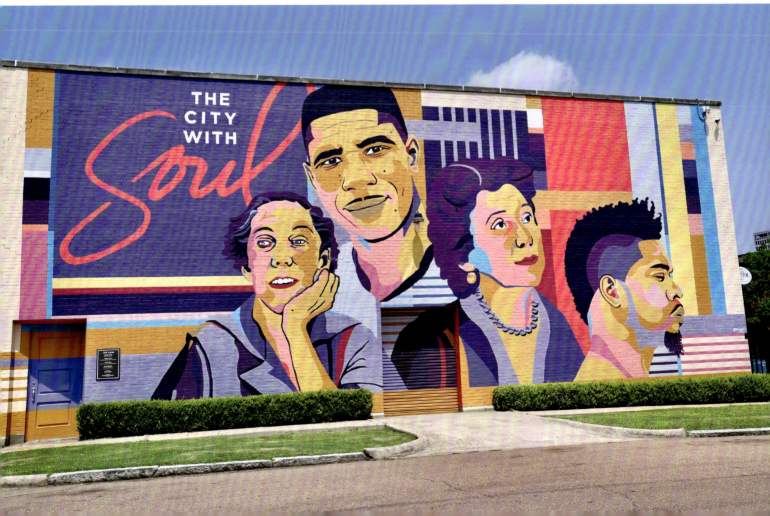

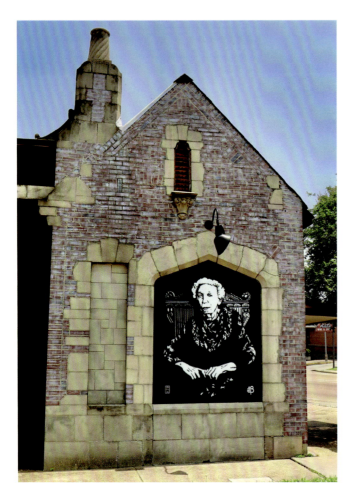

"I moved back to Jackson in my late twenties and have been so happy to have made that decision. People here build long-term friendships and strong families and enjoy life. The city has been a great fit for us and our kids, and we love living here."

—BILL GEARY

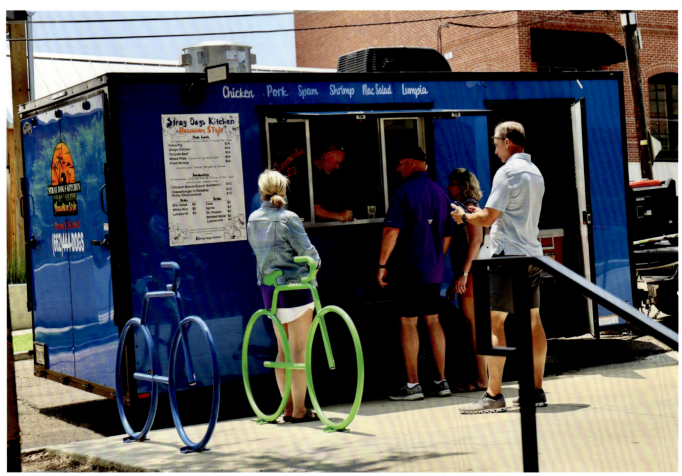

"In a small town we have a very close connection with our family. We take it very personal when someone loses a grandparent, a parent, a spouse, or even a child. We are on a first-name basis and are there to help them through a process with love and compassion you might not receive from a large funeral home in a big city. We put our own family second to take care of a family in need."

—JOHN KAMMON, Funeral Director

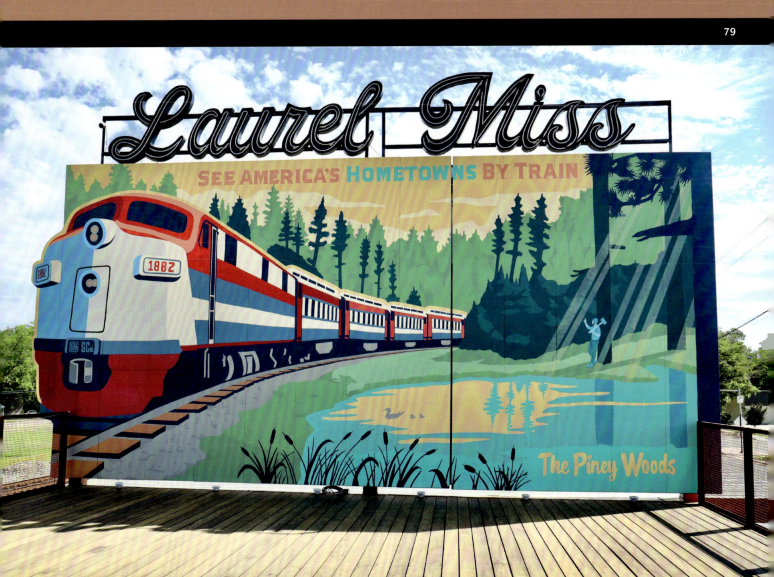

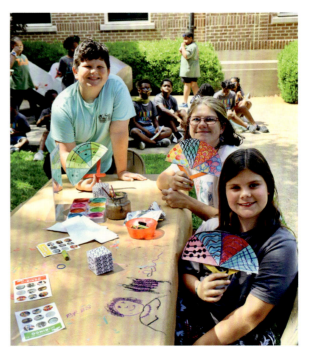

"A saying from an old wise man: Things are more like they are now . . . than they ever have been!"

—DOUGLAS MAULDIN, Singer/Songwriter

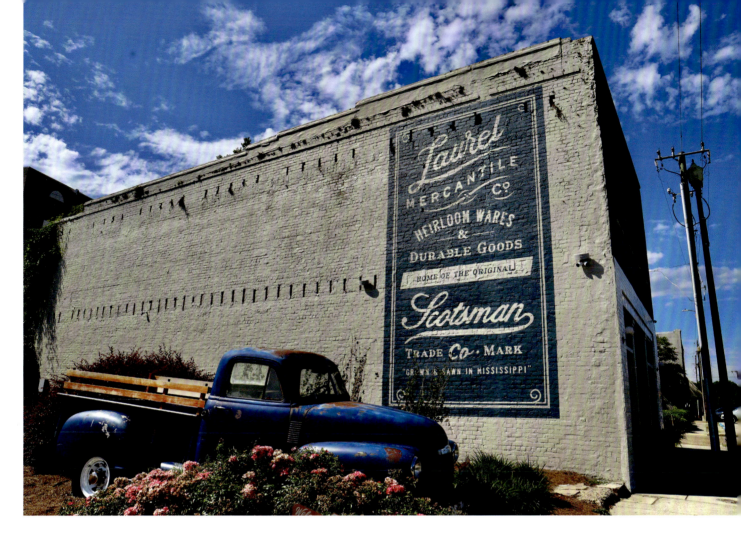
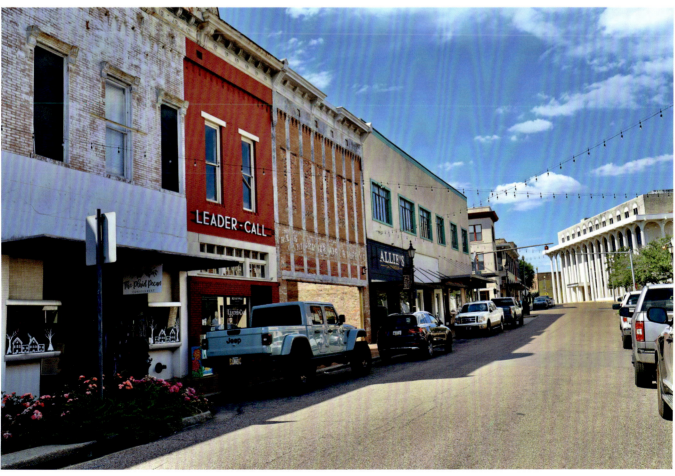

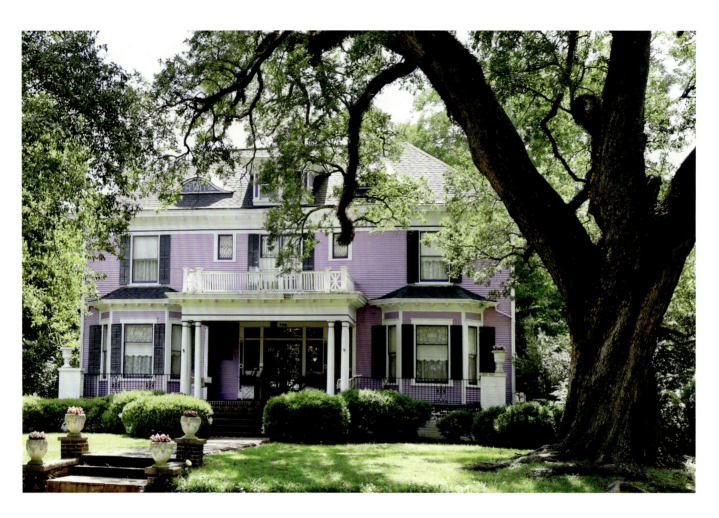

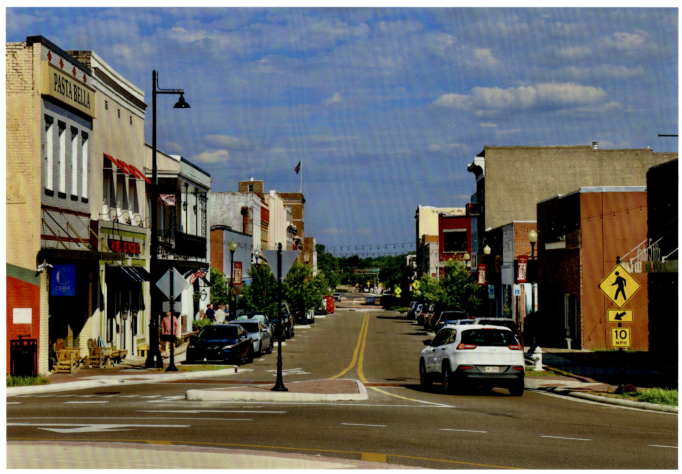

LELAND MISSISSIPPI

"For many years Abie 'Boogaloo' Ames taught me how to really play the piano, and because of him I became immersed in a vibrant blues community, performing among many well-known artists. I now perform all over the world, but I always come back home to Mississippi where I belong."

—EDEN BRENT

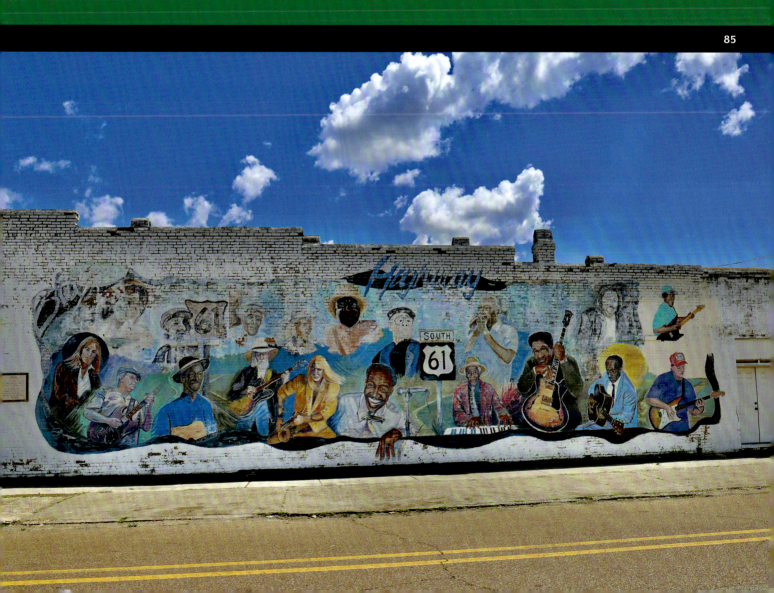

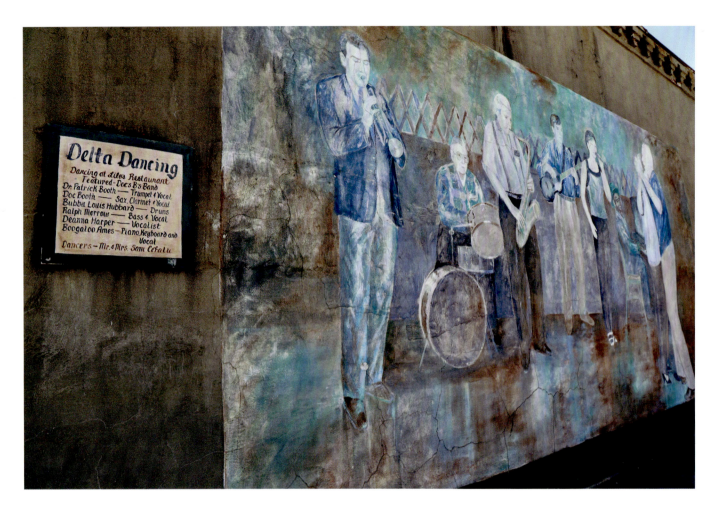

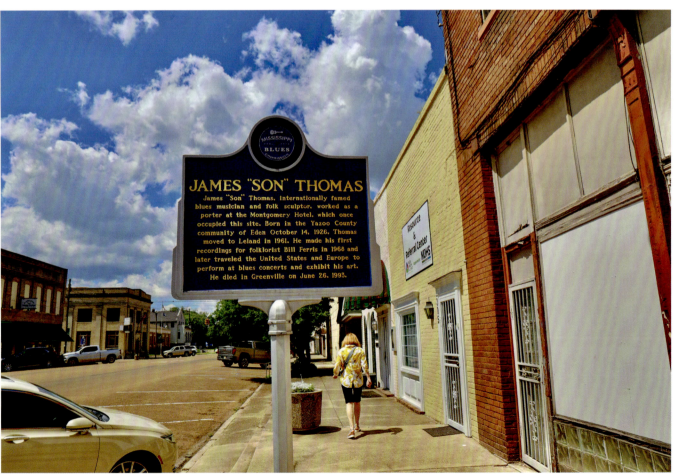

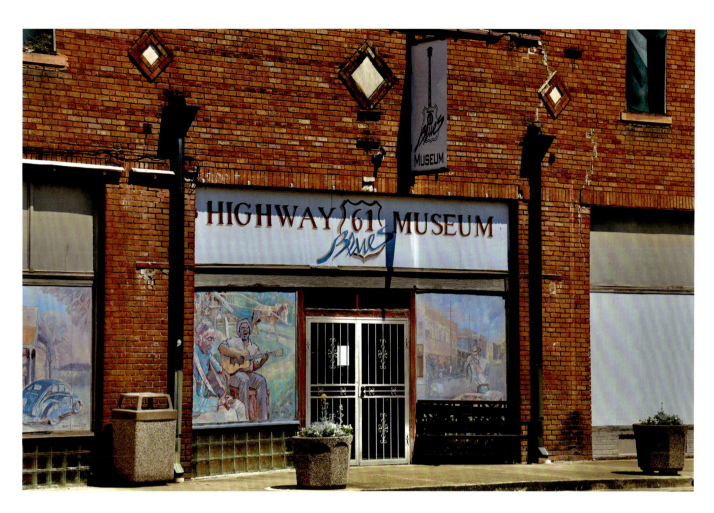

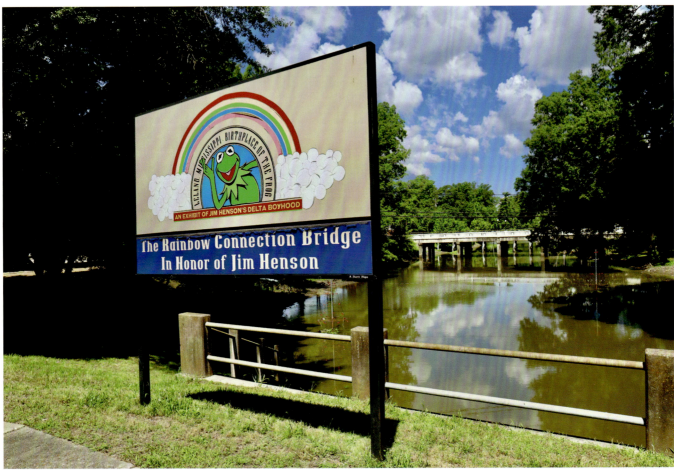

"I'm proud to live in small-town Mississippi where people know and support each other. Brandon is a wonderful place to live, worship, and raise a family, and I'm grateful to my friends and neighbors who call it home."
—CONGRESSMAN MICHAEL GUEST

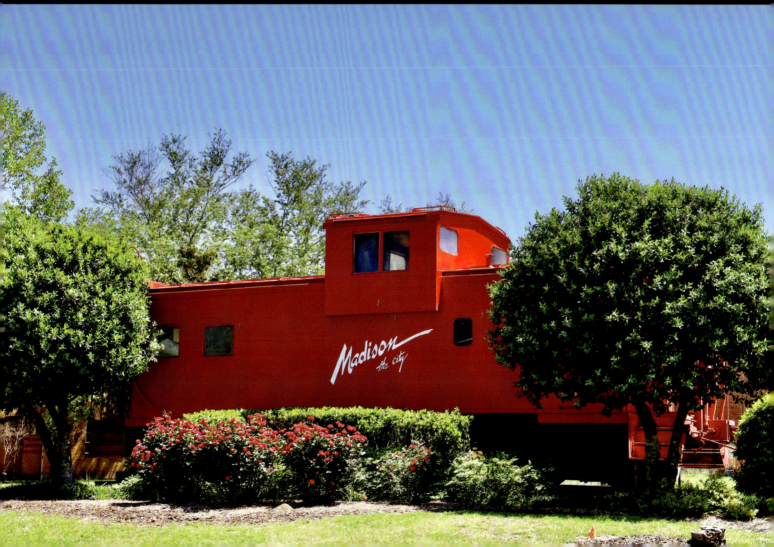

"After living in Washington, DC, for over thirty years, having the opportunity to come home is a blessing. The hometown closeness is incredible. We accept everyone and it ain't fake, even if we don't like each other! Growing up in a small town gives one a sense of place more than anywhere else. Nothing feeds the soul more than being at your church where you have been baptized, watched baptisms, and seen loved ones in their caskets. Praise God!"

—KEITH HEARD

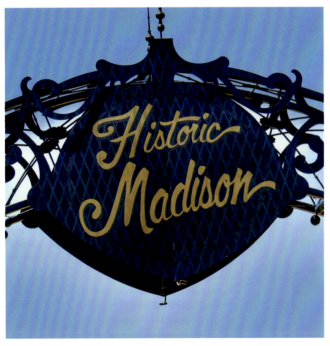

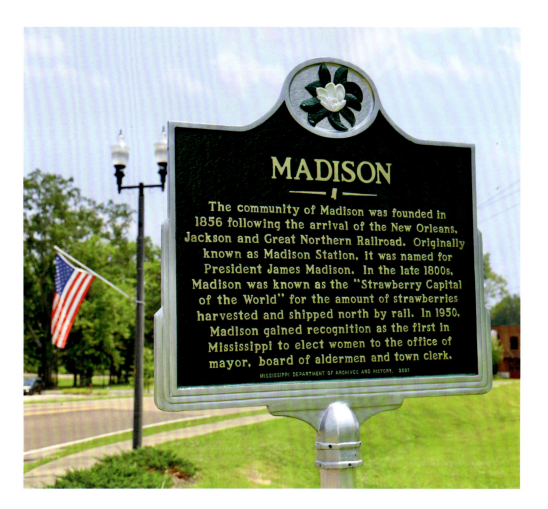

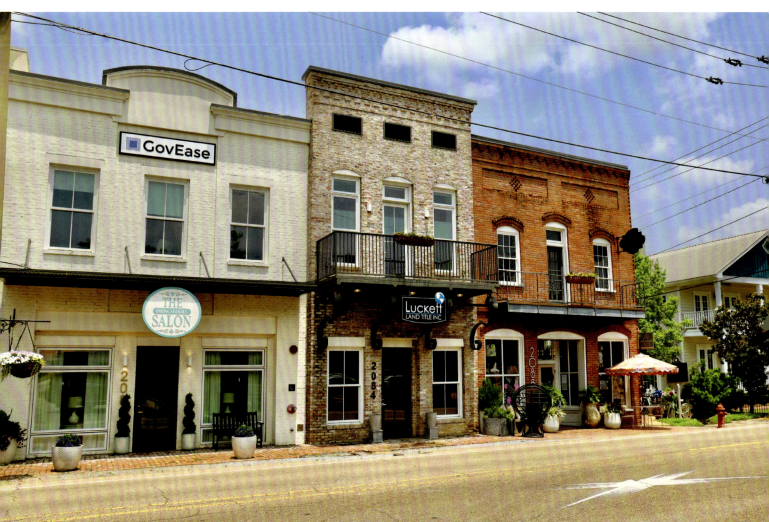

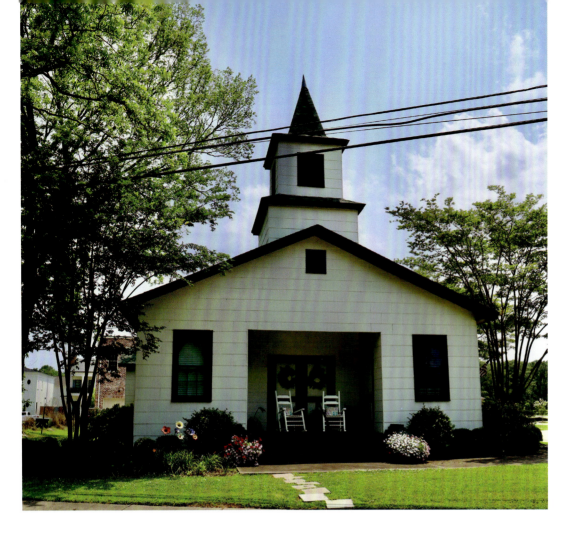

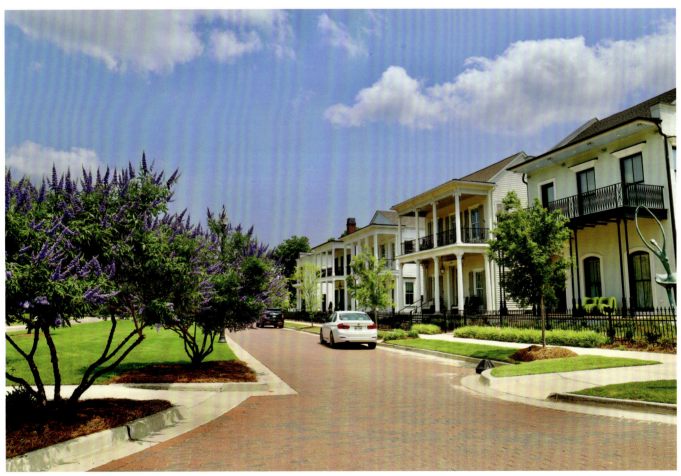

"Meridian is the 'Coolest Downtown in Mississippi,' and it really is."

—BRUCE MARTIN

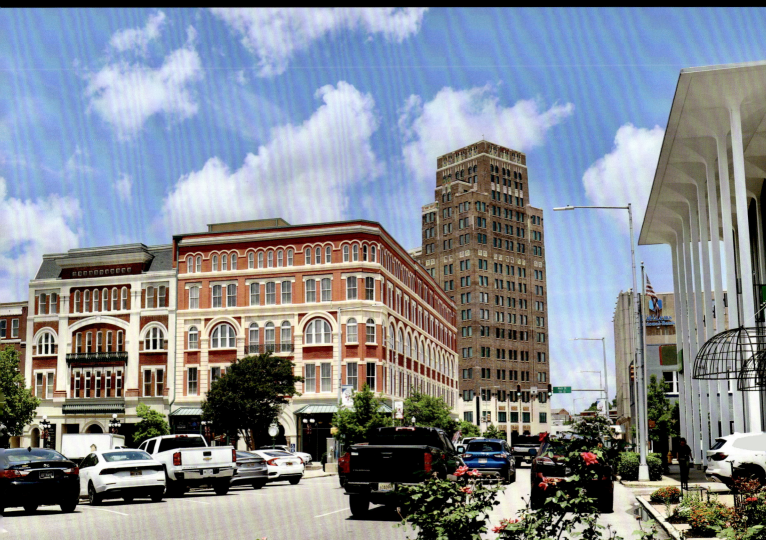

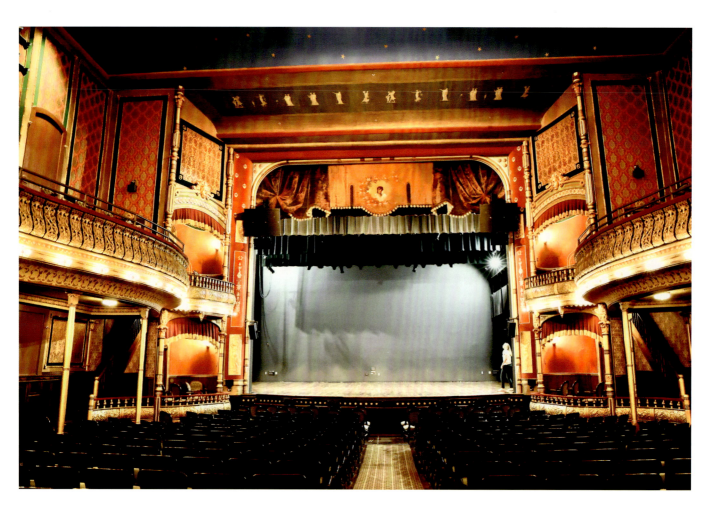

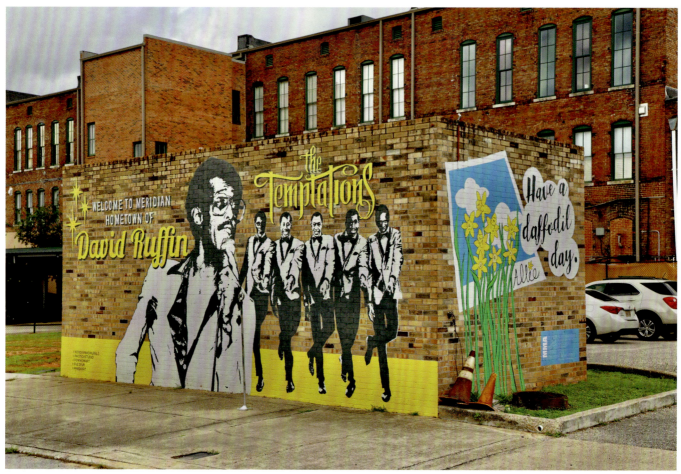

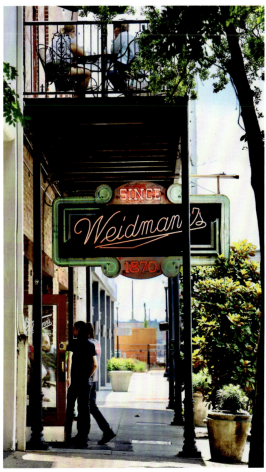

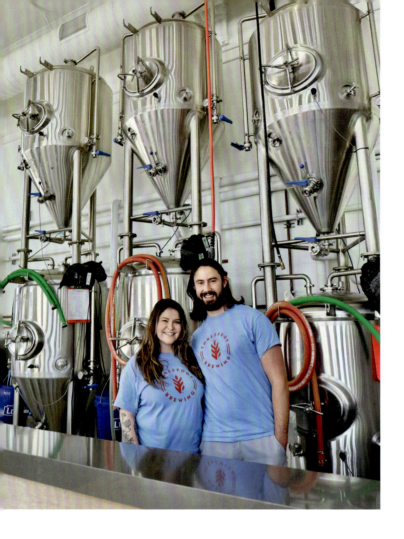
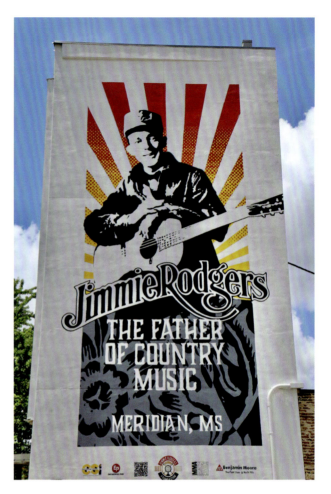

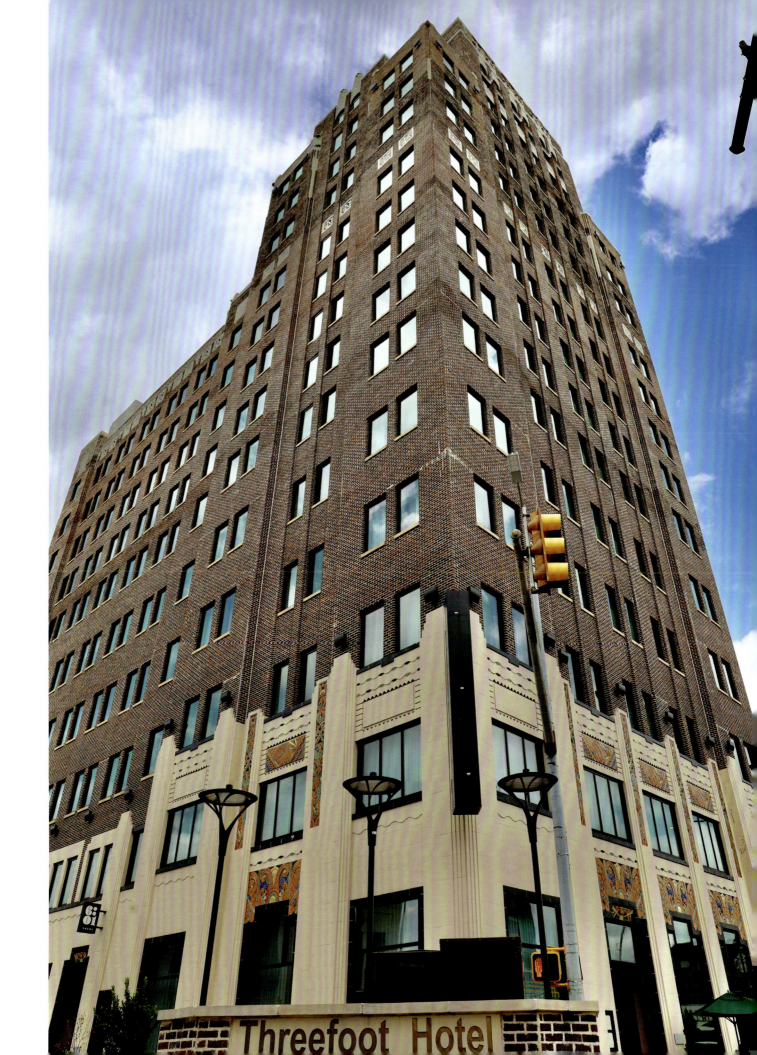

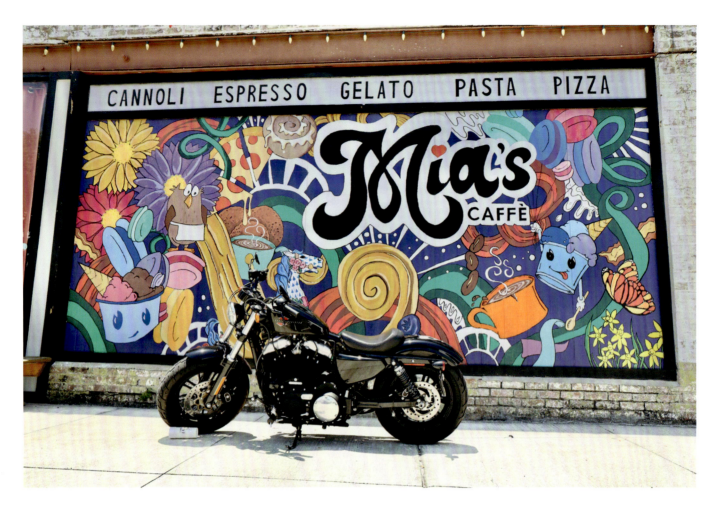

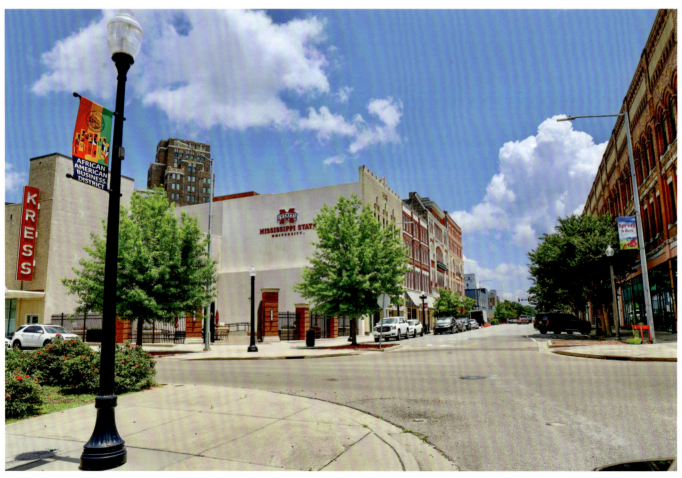

"I'm a songwriter, and living in a small town affords me close-up views of eccentric characters, random acts of kindness, and the sacred and the profane in ways that seem harder to find in a large city. To be sure, these things often show up in future works."
—TRICIA WALKER, Singer/Songwriter

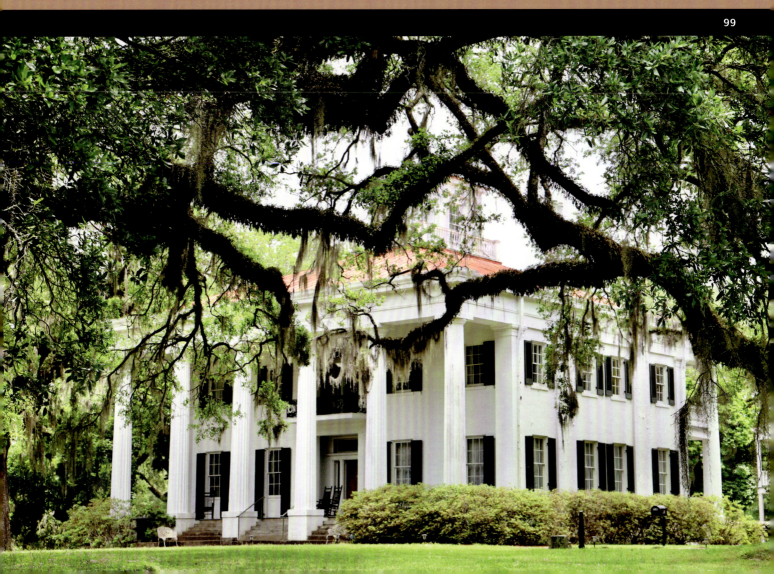

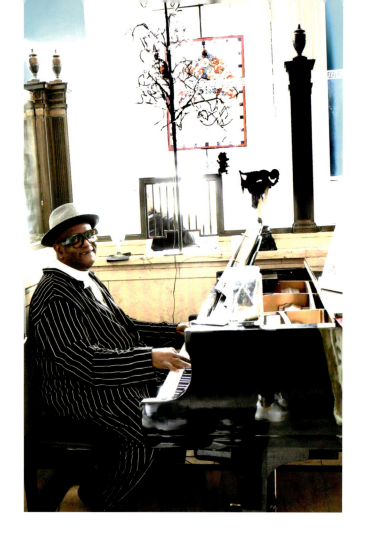
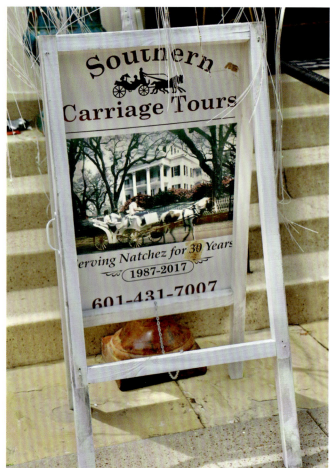
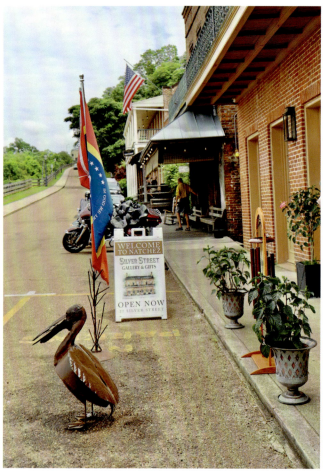
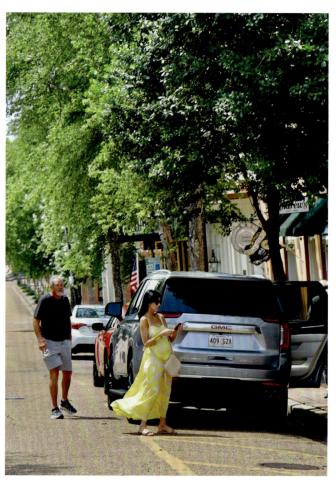

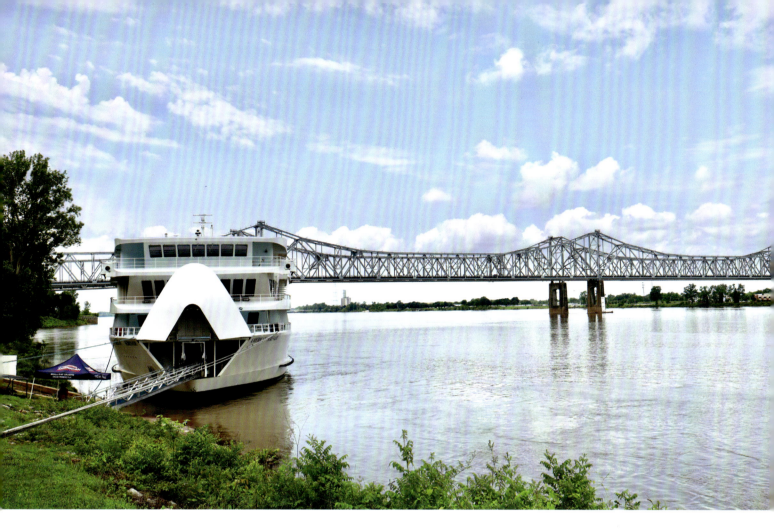

"Having grown up and worked in rural Australia for forty years and Mississippi for the past thirty-four years, it never ceases to amaze me how similar the values of rural life are. Love of country, community, friends, and a willingness to help those in need are the glue that keeps these communities thriving."

—GILBERT ROSE

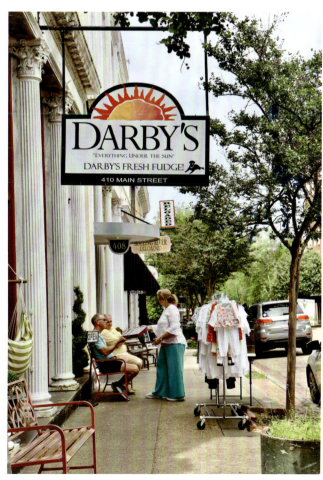

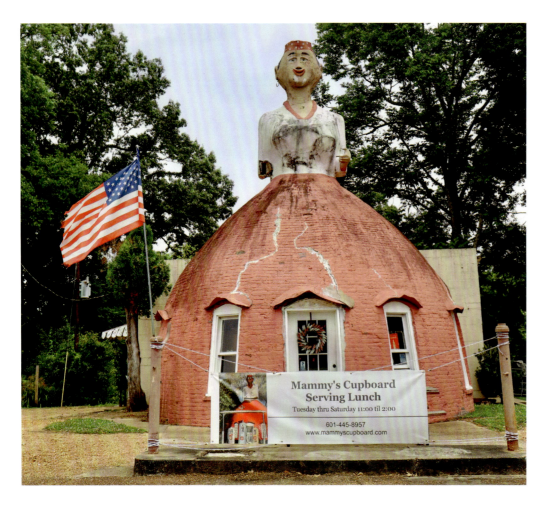

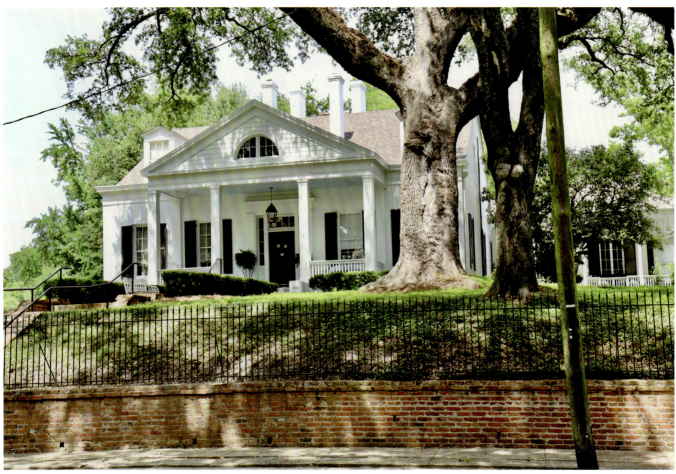

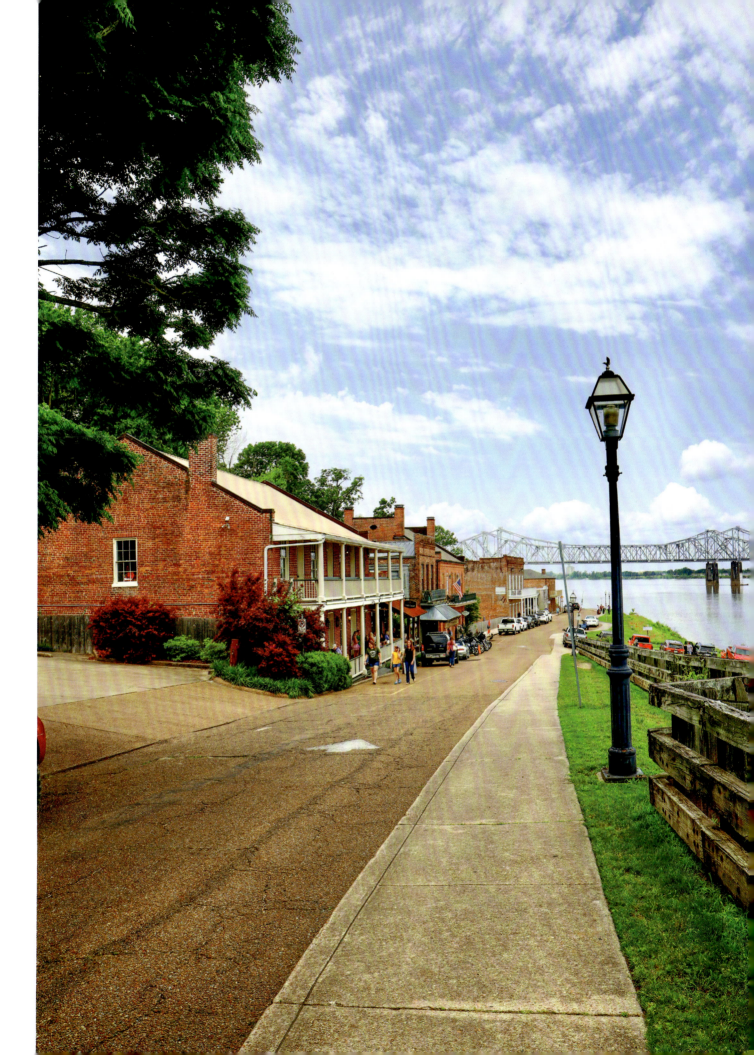

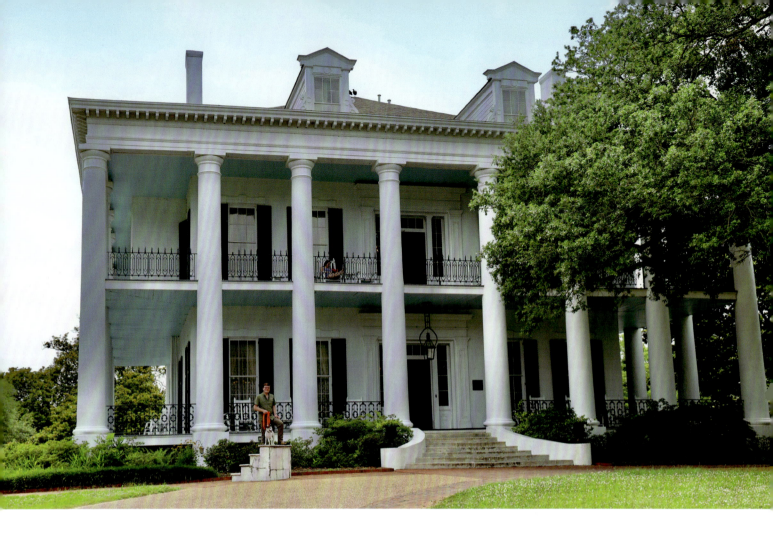
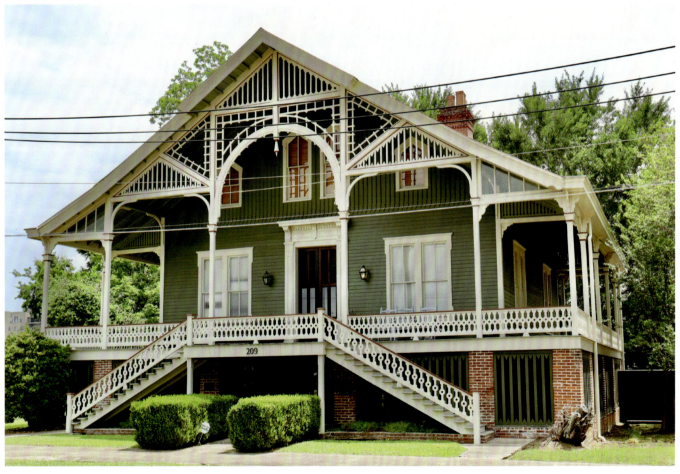

"I loved growing up in the small town of Pascagoula because of the tight-knit community. Every family knew each other, every kid played alongside their neighbors, and our parents never worried about us because our friends' parents always watched out for us. I'm thankful to still share many of these friendships to this day, and to have raised my family in the same community."

—CONGRESSMAN MIKE EZELL

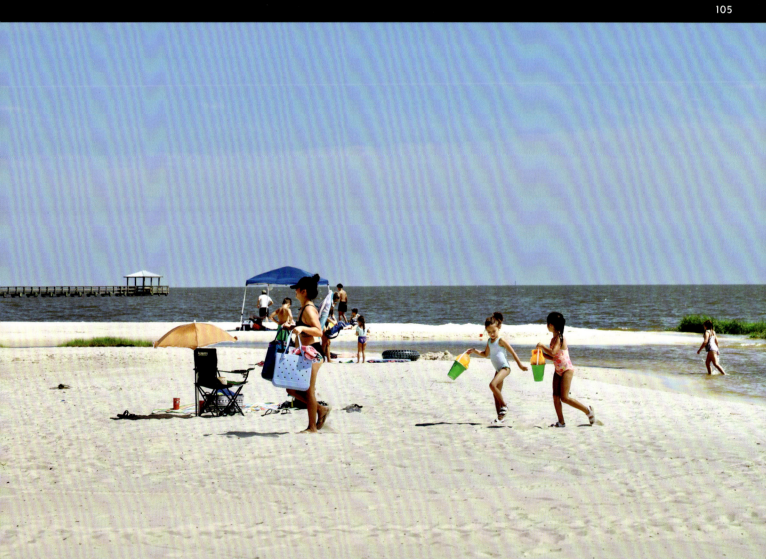

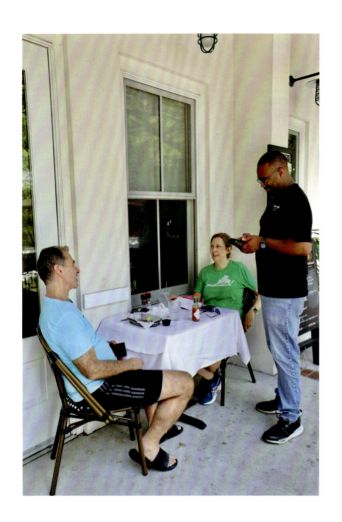
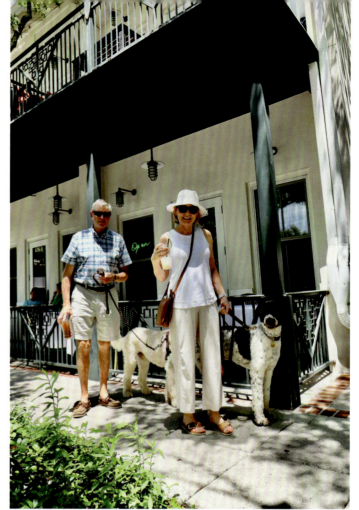
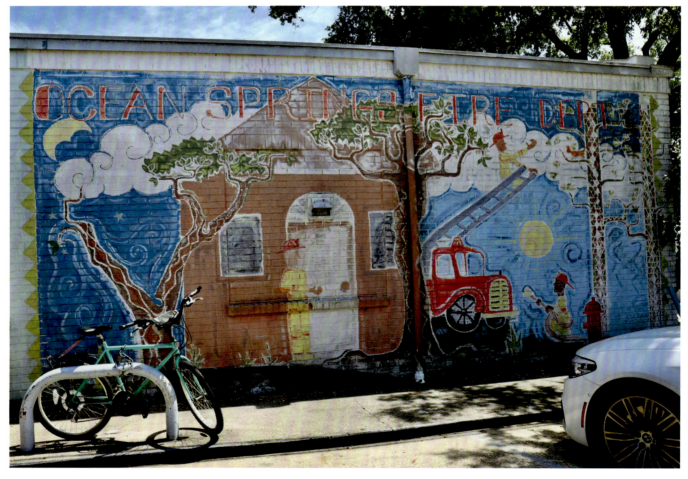

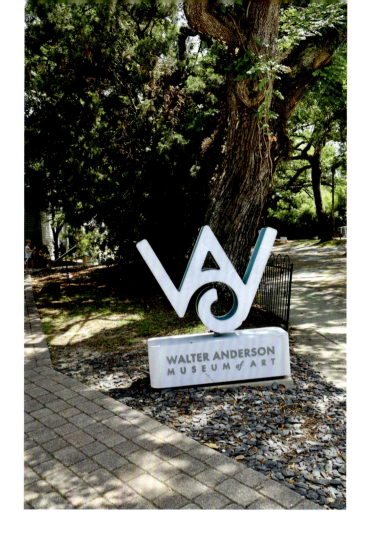

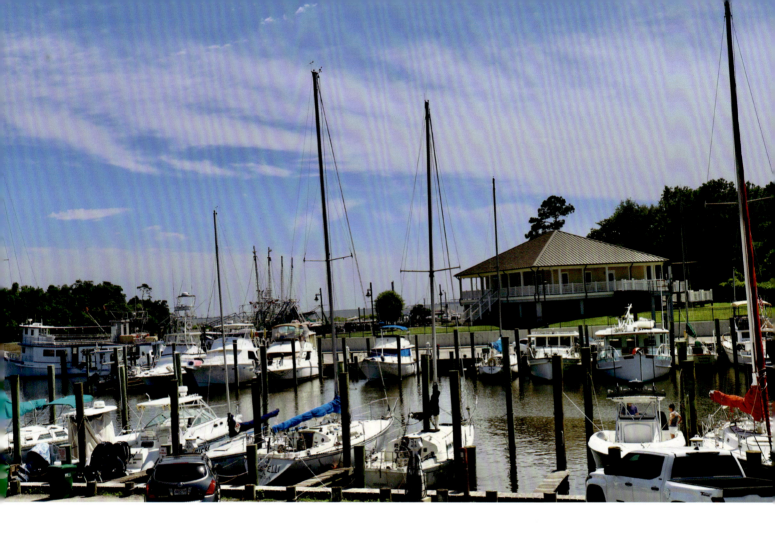

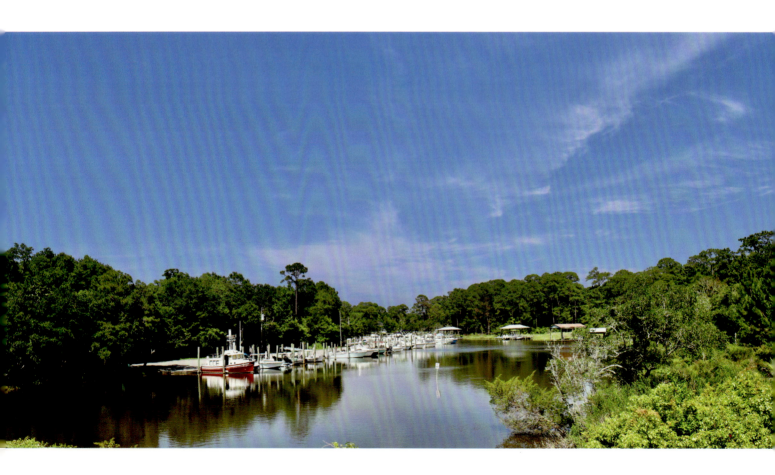

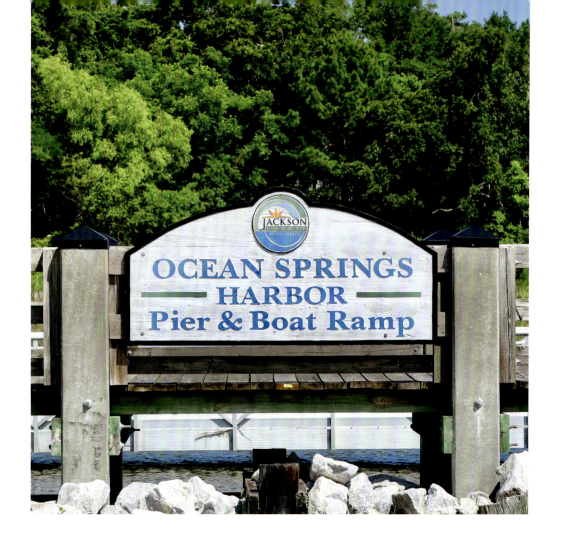

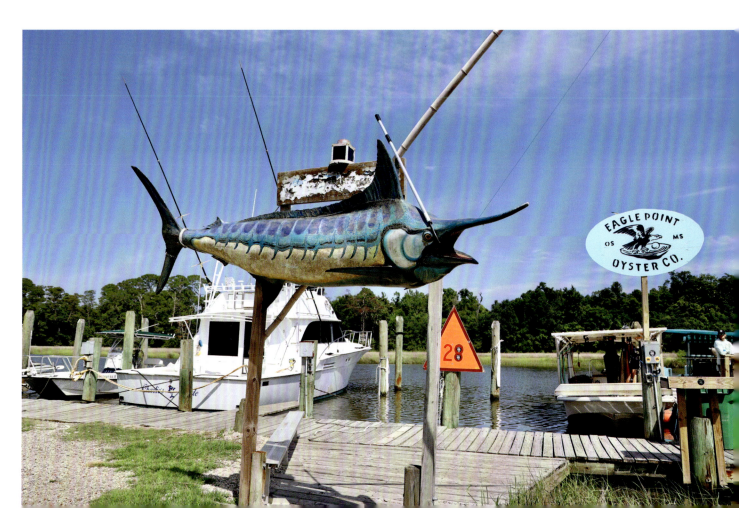

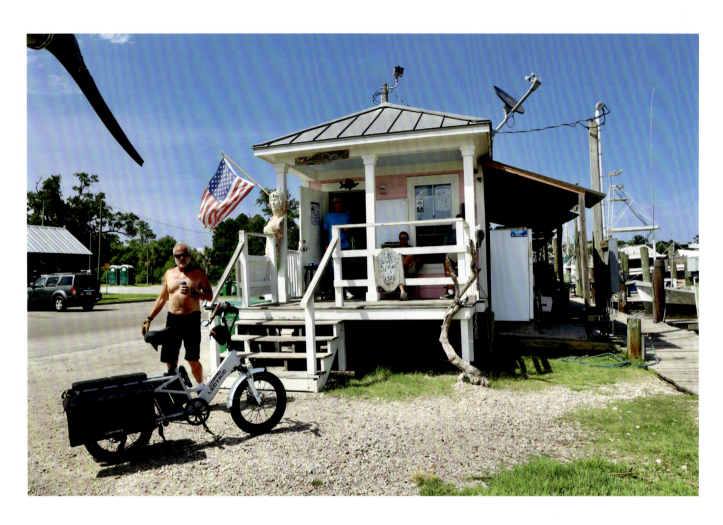

"Living in Mississippi is challenging and wonderful and worth every minute of it."

—DAVID ELLIOTT

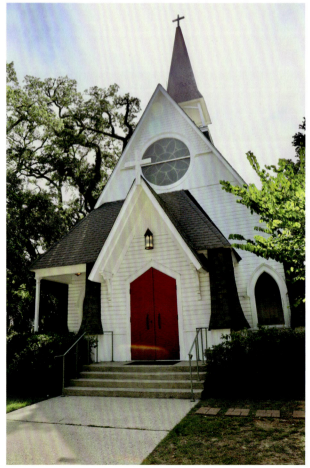

"I have always loved my little town. From early years, when my siblings and I rode to school with our mom and dad—who both happened to work next door to the elementary school—we would walk home in the afternoons, enjoying our fabulous little town and all the people who loved us, encouraged us, and knew us by name. Everyone knew everyone. I tell my children all the time, Oxford is especially charming, and we are so lucky to live here and enjoy all the great things Oxford and the university have to offer. Please don't tell too many people. Let's keep it our secret!"

—MOLISSIA LOVELADY SWANEY

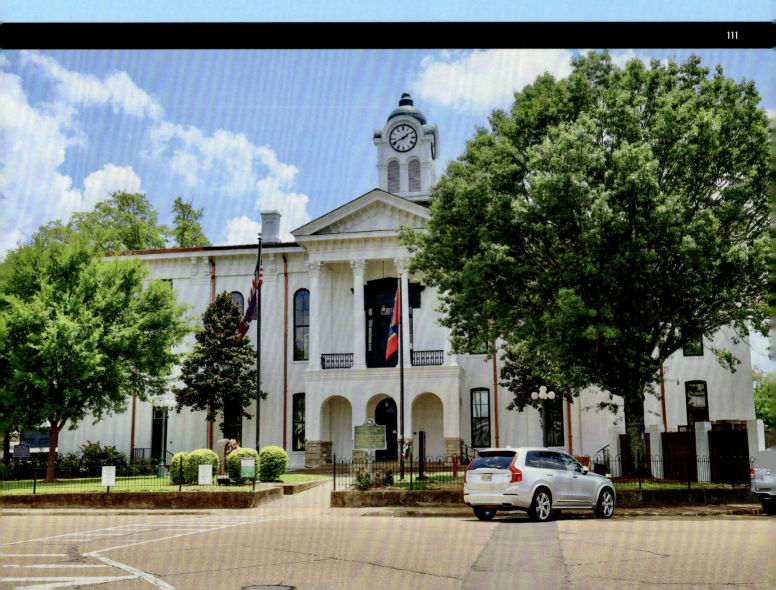

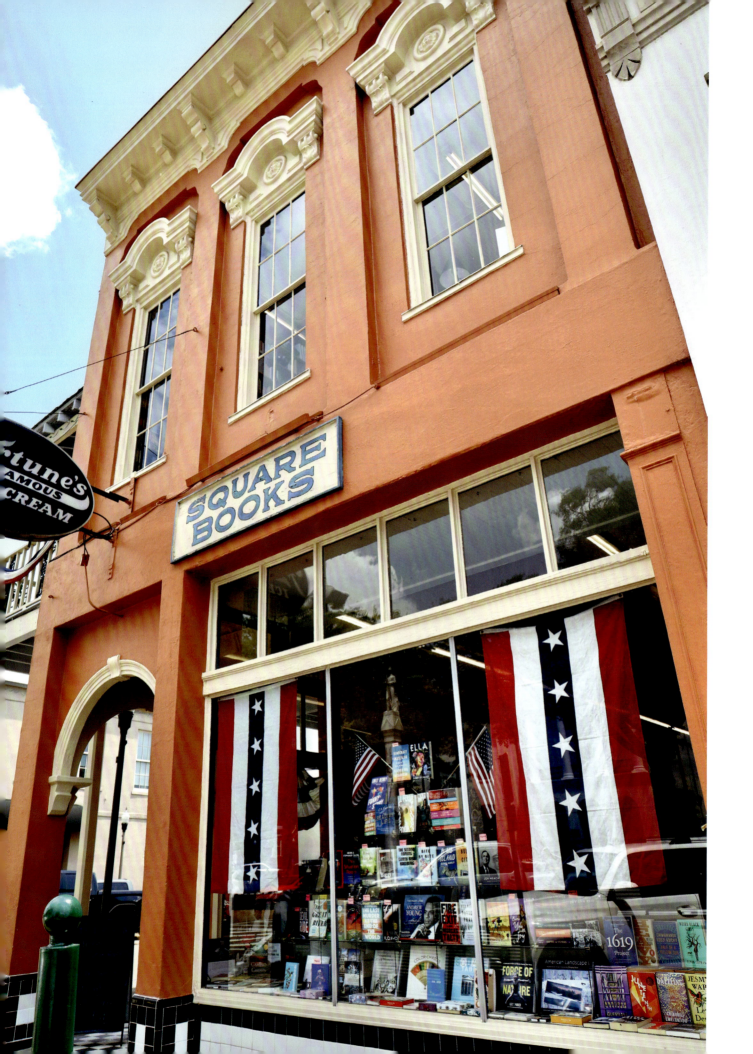

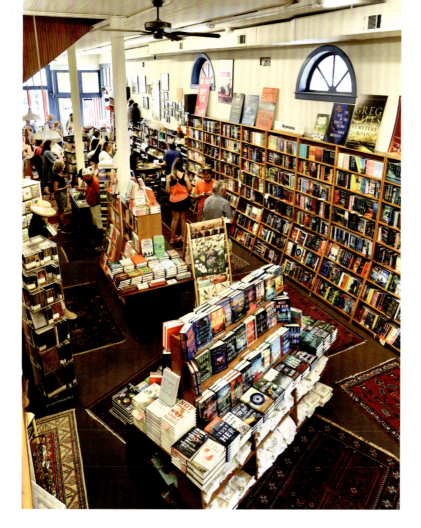

"For generations my family has been connected to both Oxford and the University of Mississippi, and my parents—who met and married here—moved back here when I was twelve. There was always idle chatter in the family that Oxford could use a bookstore—so, Lisa and I began Square Books in 1979 and haven't stopped. We're devoted to this place."

—RICHARD HOWORTH

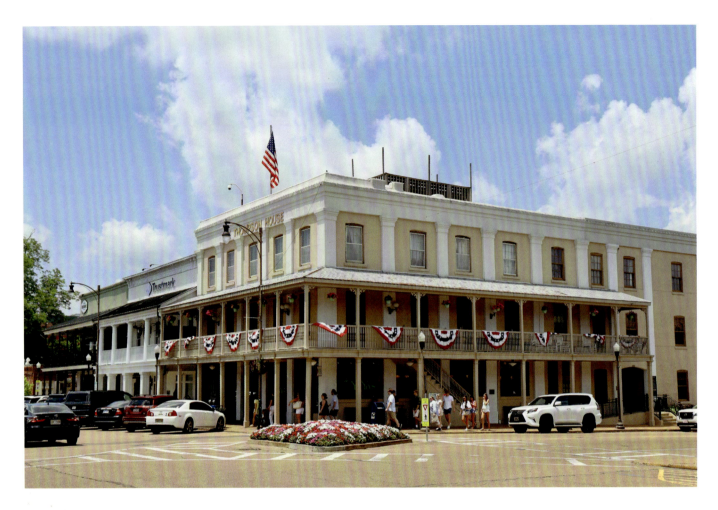

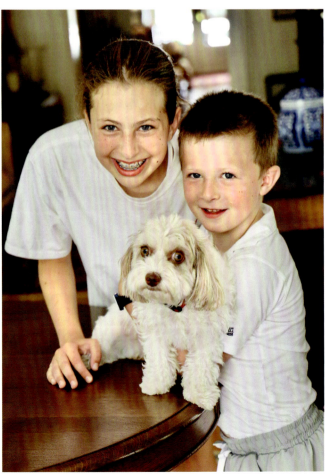

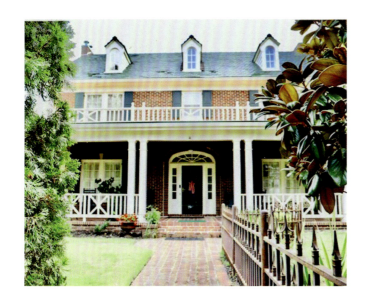

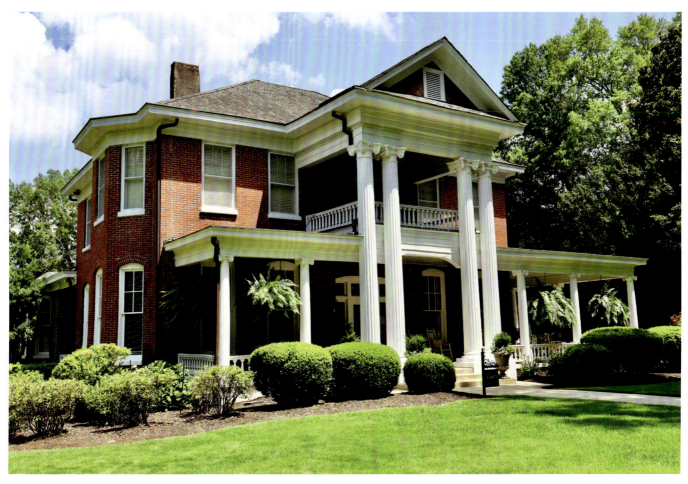

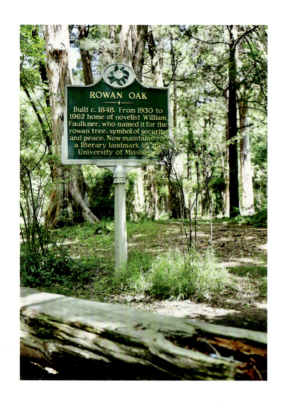
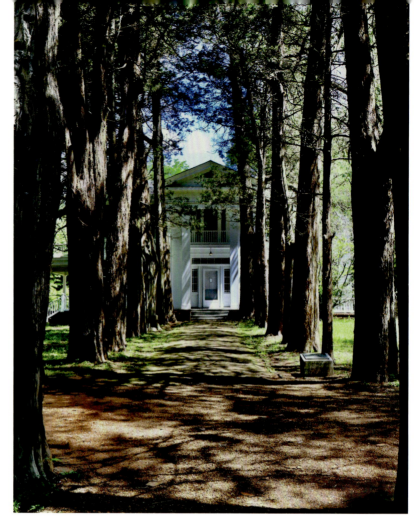

"Pass Christian was completely devastated—we lost 100 percent of our businesses and 80 percent of our homes. Our physical world was shattered, but somehow to a person, our community's spirit remained unbroken. Over time the sharpness of our pain softened, yet the memory of our collective determination remains strong. In the end, what Katrina revealed most clearly is that people, at their core, are genuinely good. And it's that goodness that continues to guide us twenty-plus years later."

—MARTHA MURPHY

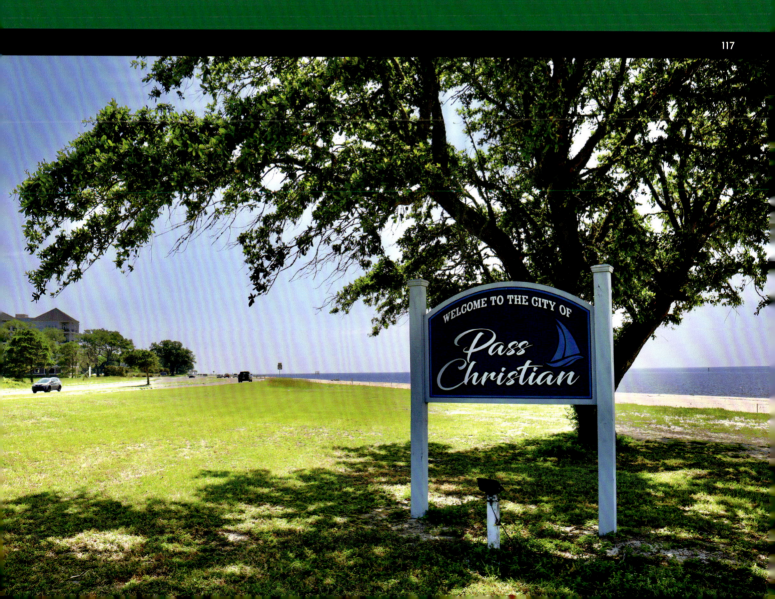

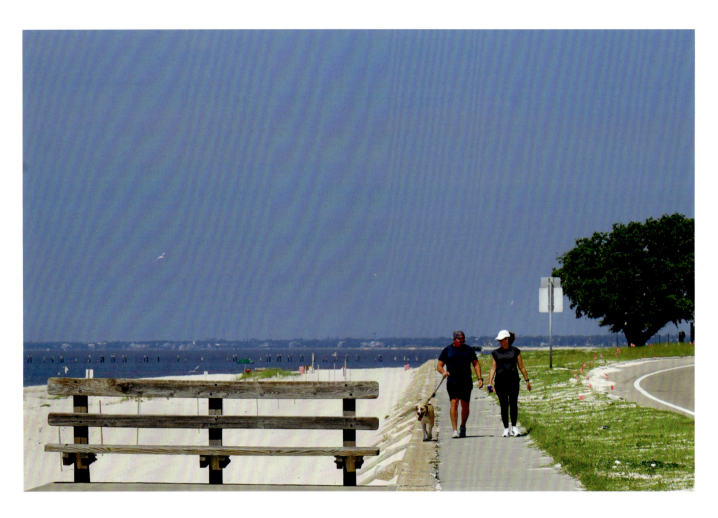

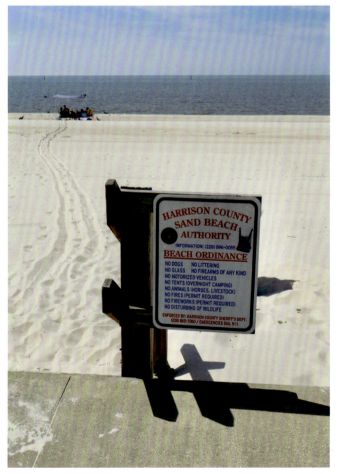

"Enjoy life like there is never going to be tomorrow."
—WICK EATHERLY

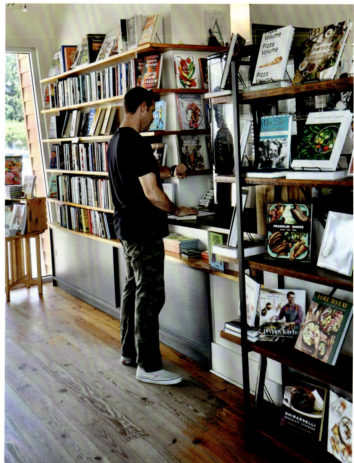

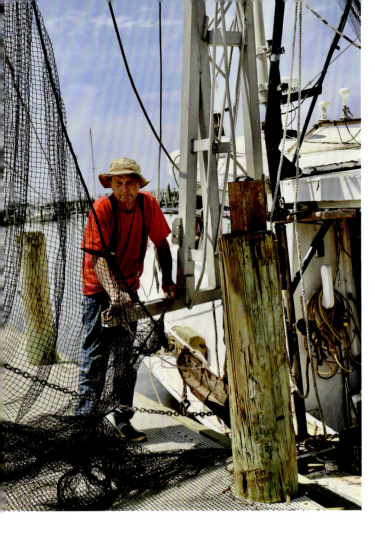
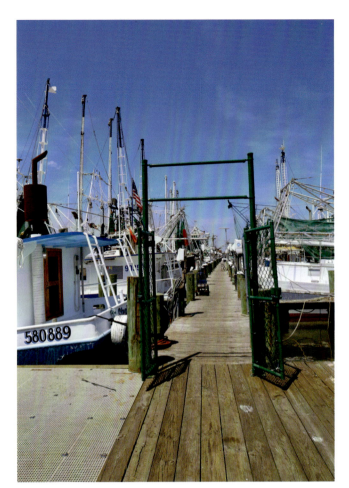
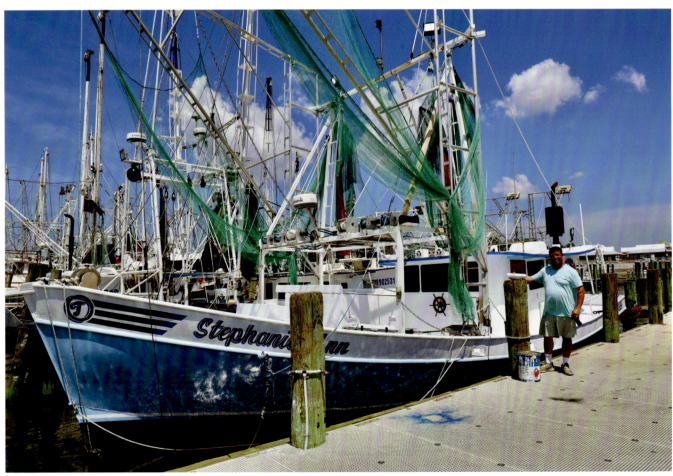

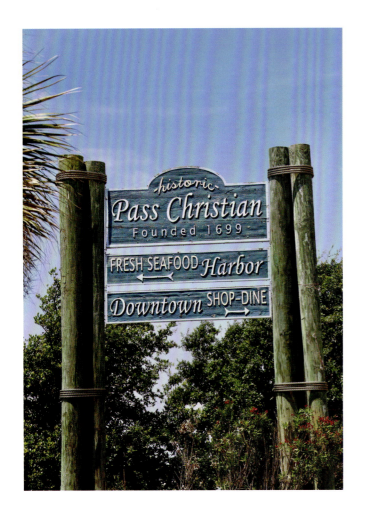
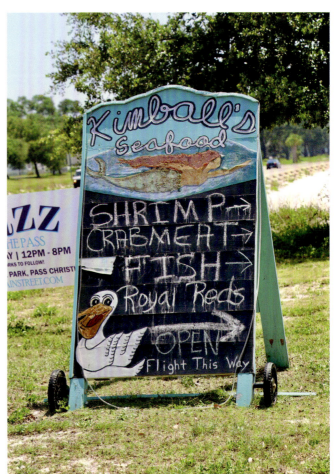
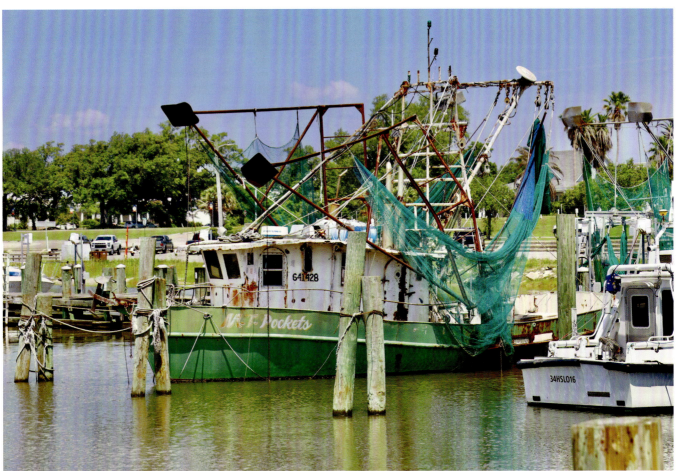

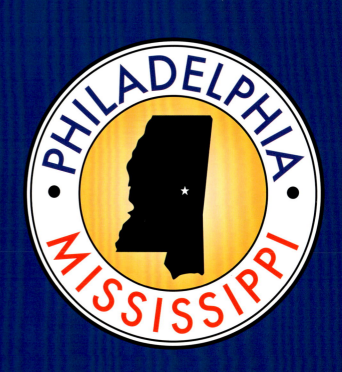

"Having lived in a large city, I have found that life in a small town is more relaxed and moves at a slower pace than in large cities."

—W. JAMES THREADGILL

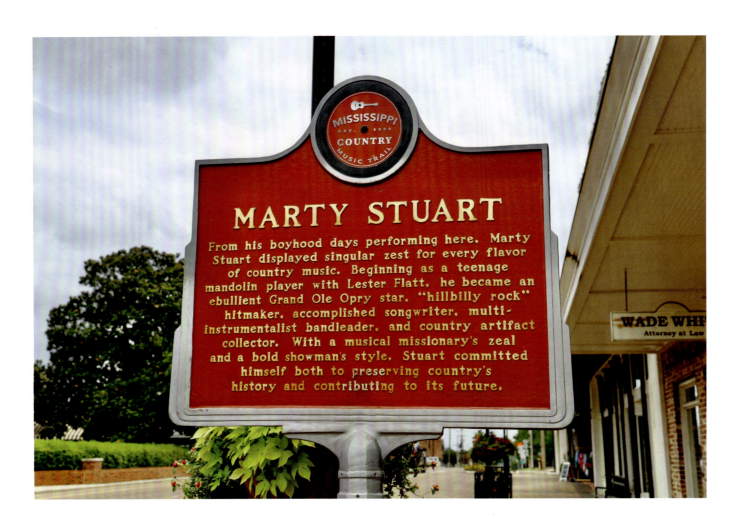

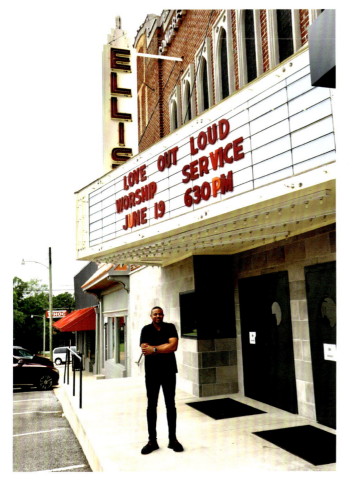

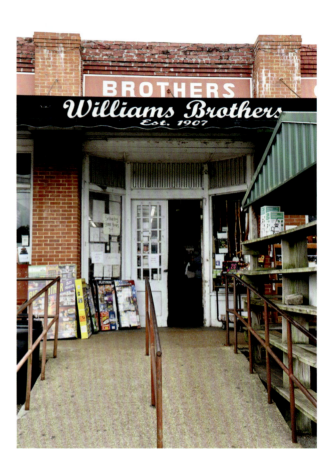
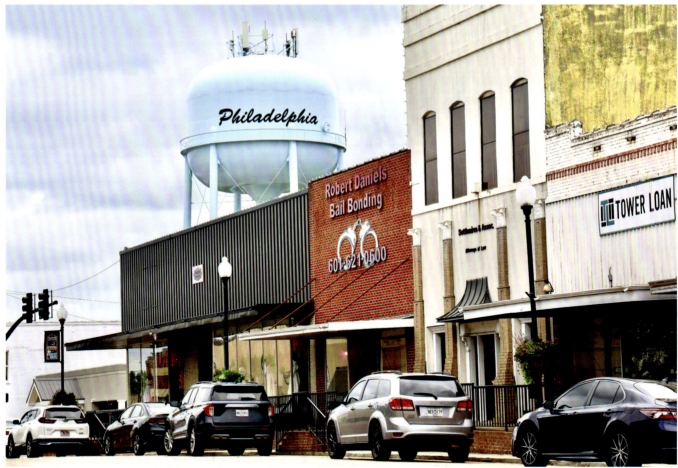

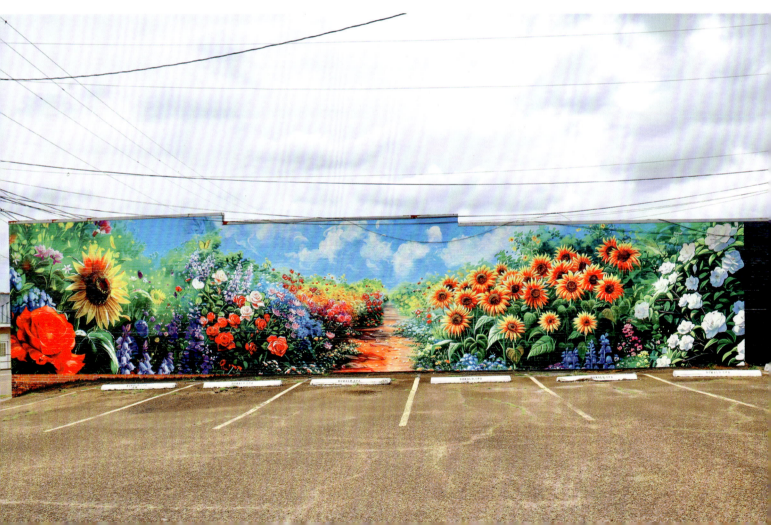

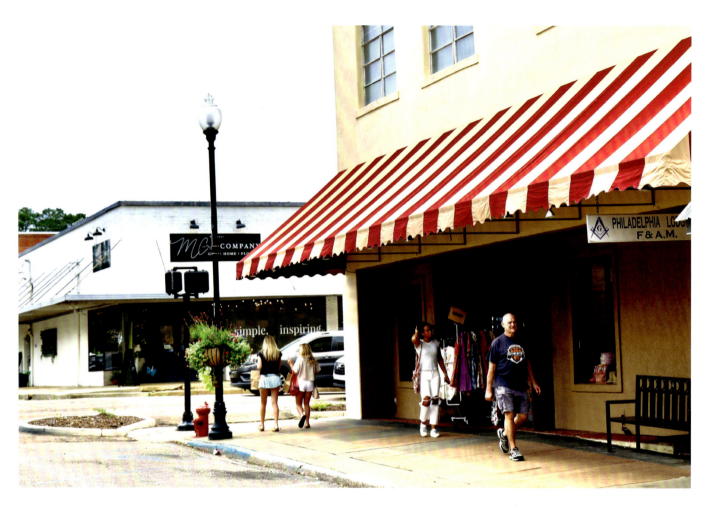

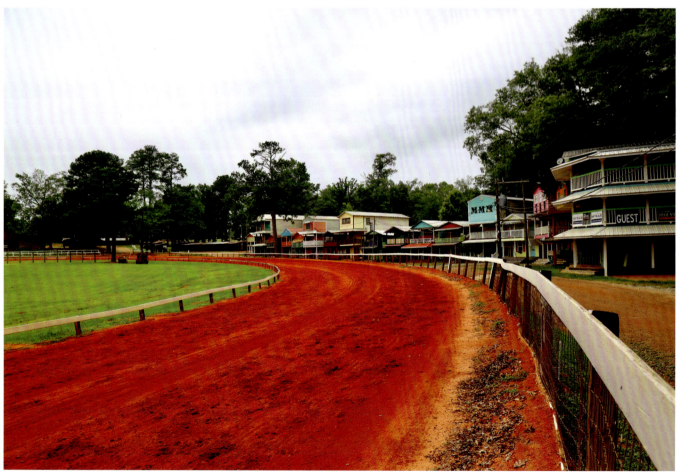

"The Neshoba County Fair is a unique event featuring family fun at cabins and campers, outstanding entertainment, horse racing, cattle and other exhibits, and political speaking. You won't find anything like it anywhere!"

—REUBEN MOORE,
Retired MSU Administrator, Neshoba County Fair Board Member

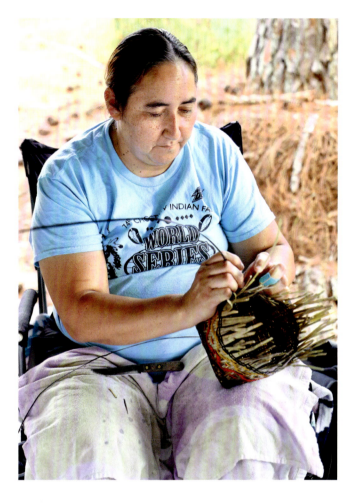

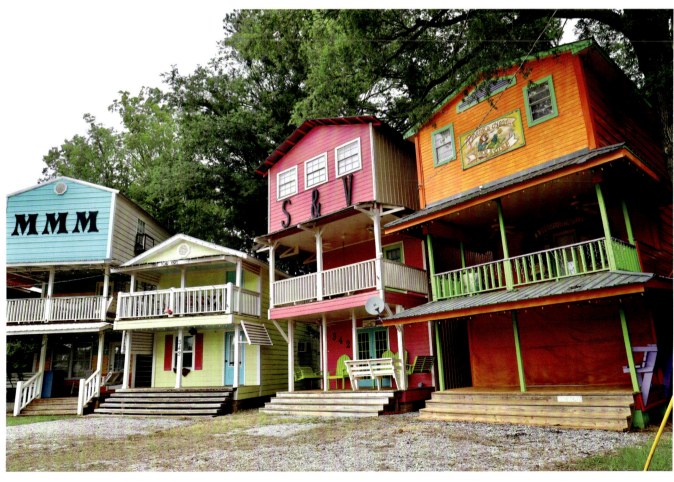

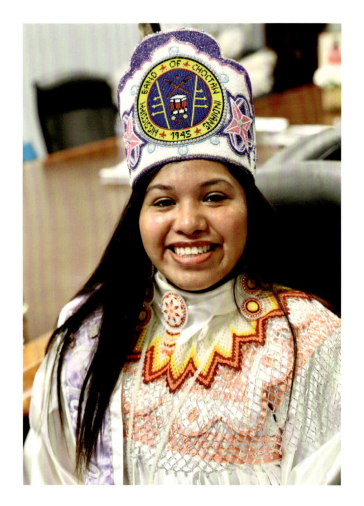
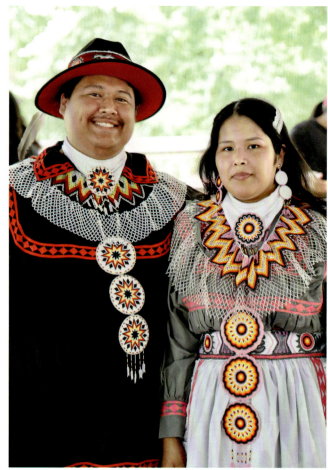
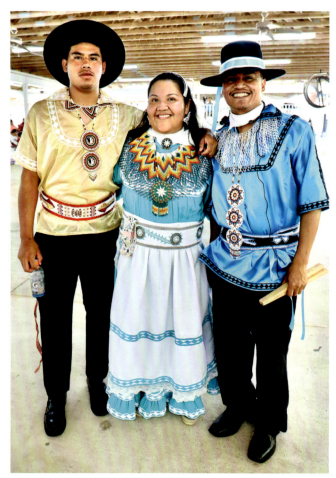

"This is my home because this is the original homelands of the Choctaw people. Before there was statehood and even before acts of the US government attempting to remove my ancestors, this was our people's land. Fast-forward to the present, as a member of the Mississippi Band of Choctaw Indians, I was born and raised here on our tribal lands in the red clay hills of Neshoba County where I am now proudly raising my family. Today I am grateful to be entrusted by my people to serve as the Tribal Chief of MBCI. I believe that Mississippi has many great traits, one of those being the deep, rich cultural traditions of the Choctaw people which are still alive today."

—CYRUS BEN,
Tribal Chief of the Mississippi Band of Choctaw Indians

"I grew up in a small crossroads that had more dogs than it had people. We were nine miles outside a town of five hundred-ish (Hernando in DeSoto County) and counted on one another for everything. We didn't know then that our lives were charmed, lit by fireflies and simple lessons in how to love and live. But they were."
—AMY WHITTEN

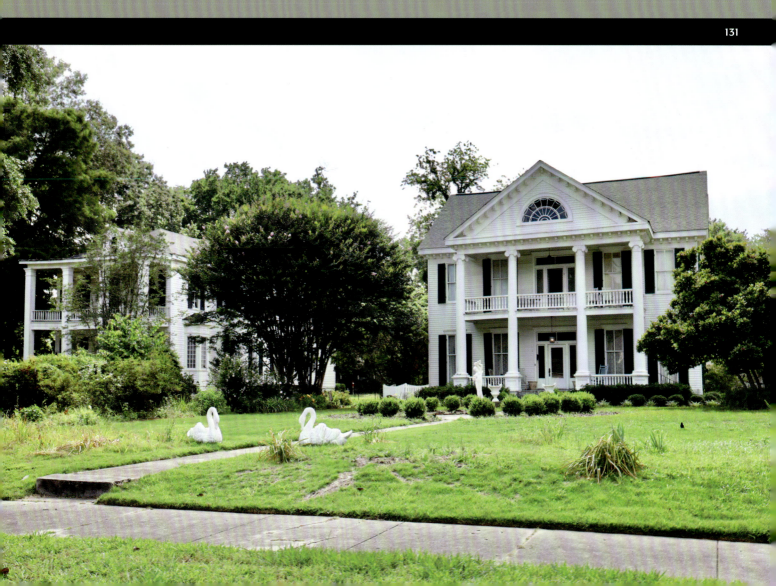

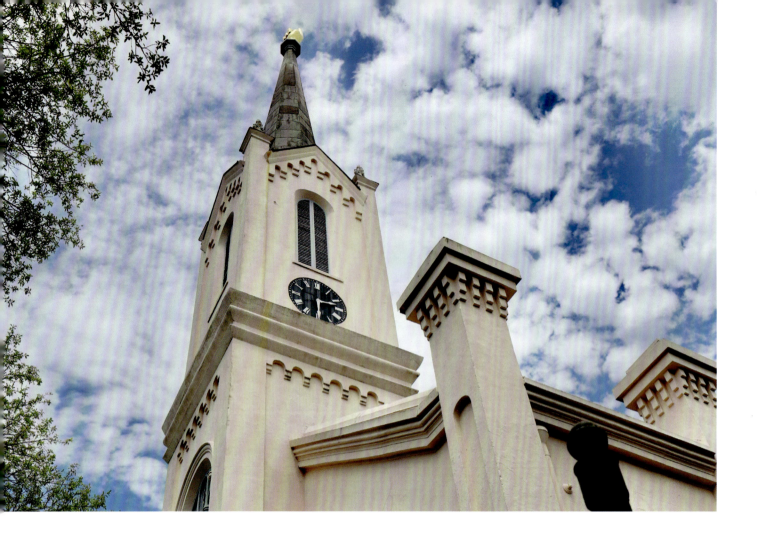

"When a Mississippi treasure like Melody Golding aims her lens toward our hallowed state, there's no surprise that she would capture the romance and authenticity of what small-town Mississippi is all about."

—STEVE AZAR,
Music and Culture Ambassador of Mississippi

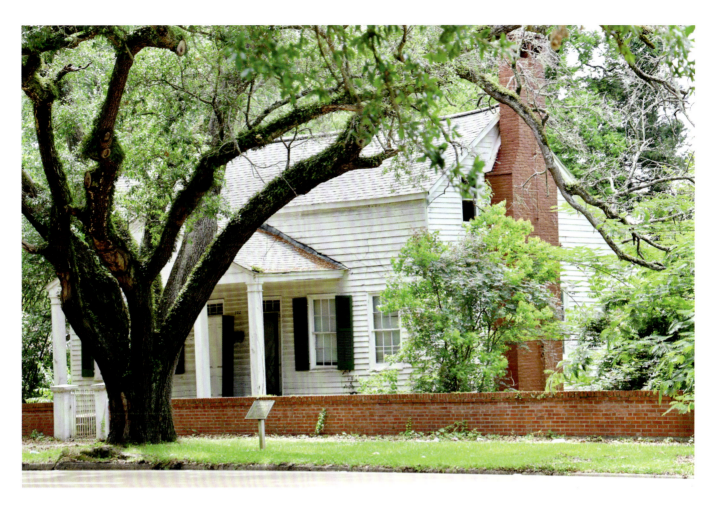

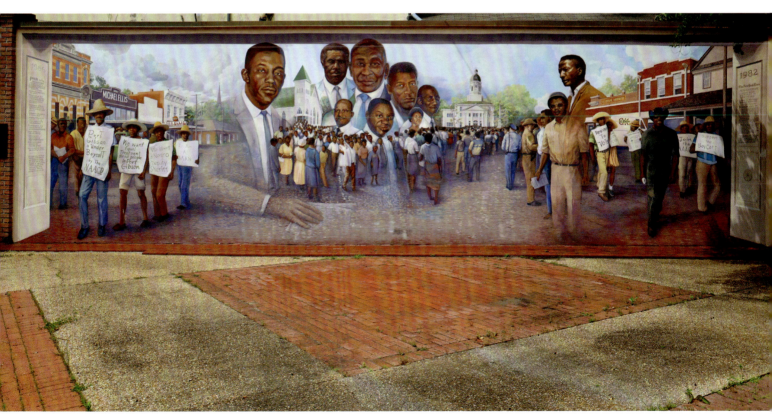

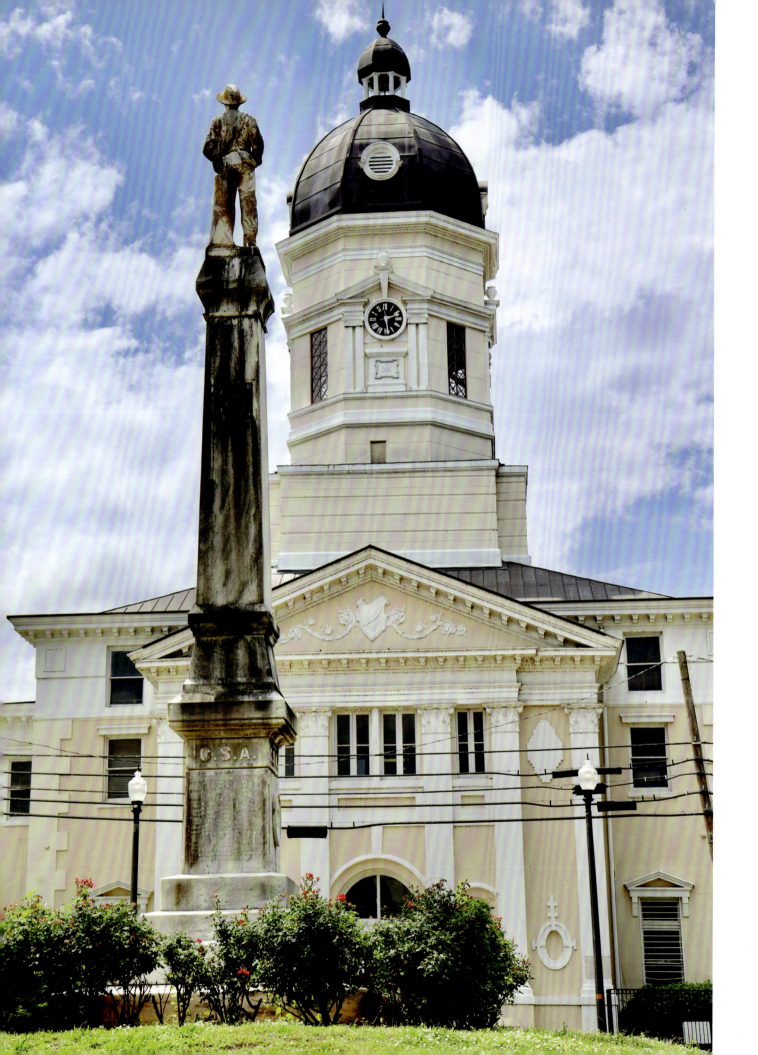

"Small towns are the lifeblood of Mississippi—each with a unique story to share. Growing up in Union was filled with lifelong friends, a helping hand when needed, and a lifetime of great memories."
—CONGRESSMAN TRENT KELLY

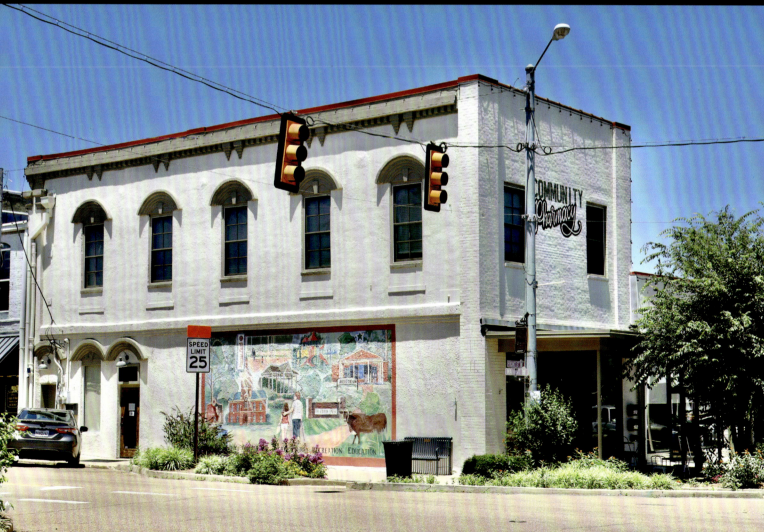

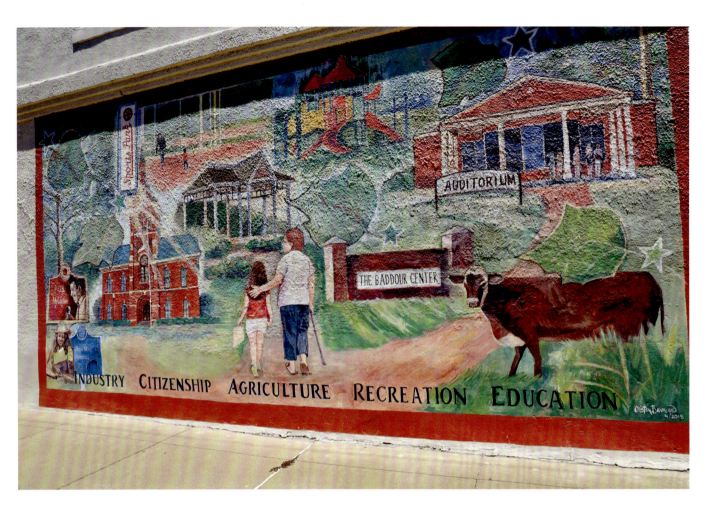

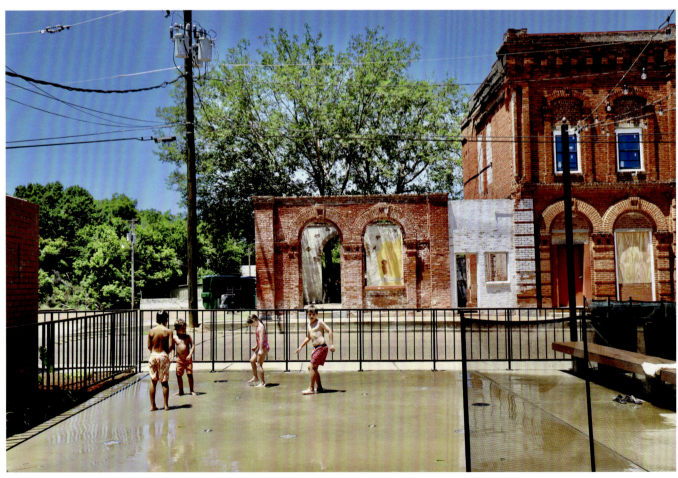

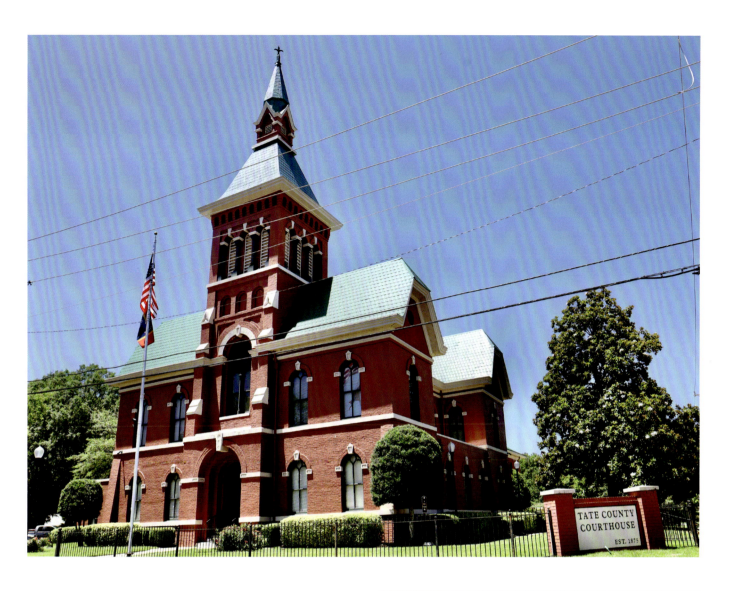

"Cascilla is our hometown. Twenty-five minutes from the closest Walmart. Nice people and quiet nights. Peacefully we've lived out of the city lights."

—DOUG AND SASSY MAULDIN

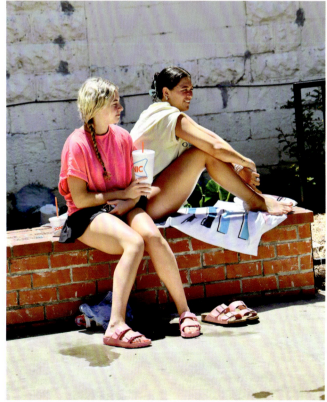

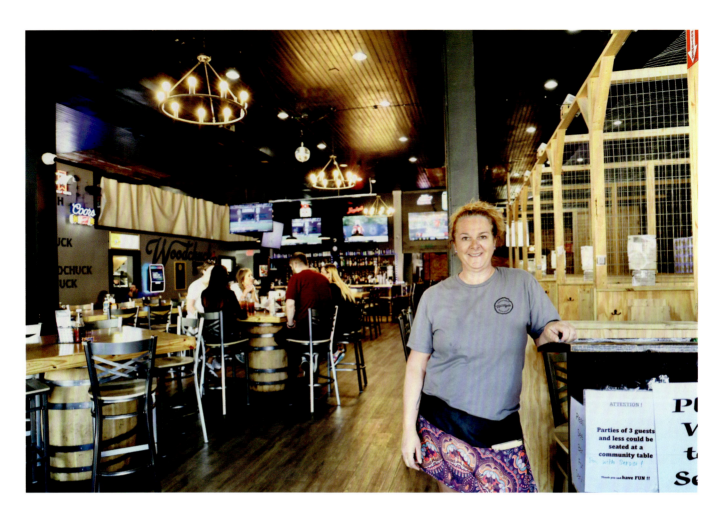

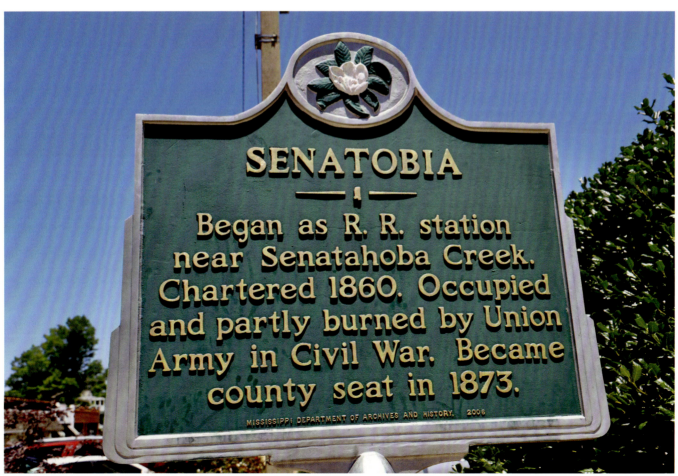

SENATOBIA

Began as R. R. station near Senatahoba Creek. Chartered 1860. Occupied and partly burned by Union Army in Civil War. Became county seat in 1873.

MISSISSIPPI DEPARTMENT OF ARCHIVES AND HISTORY. 2006

STARKVILLE MISSISSIPPI

"Growing up in Starkville and being around Mississippi State and our people was an absolute dream. After college, I couldn't wait to experience another place. After a very short time, I couldn't wait to get back. The feeling I get when I'm here is indescribable—it's just where I want to be."

—JAMES V. "BO" HEMPHILL

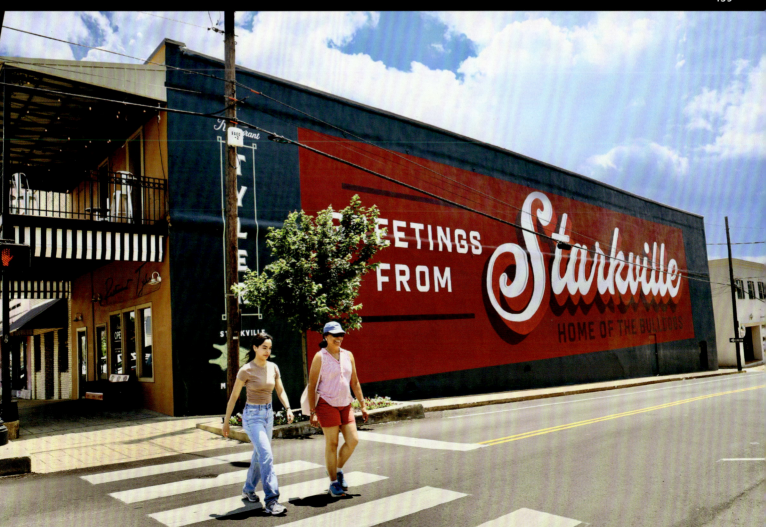

"People make the place, and the people of Starkville offer warmth and charm. Starkville exemplifies we're together as One State."

—ZAC SELMON

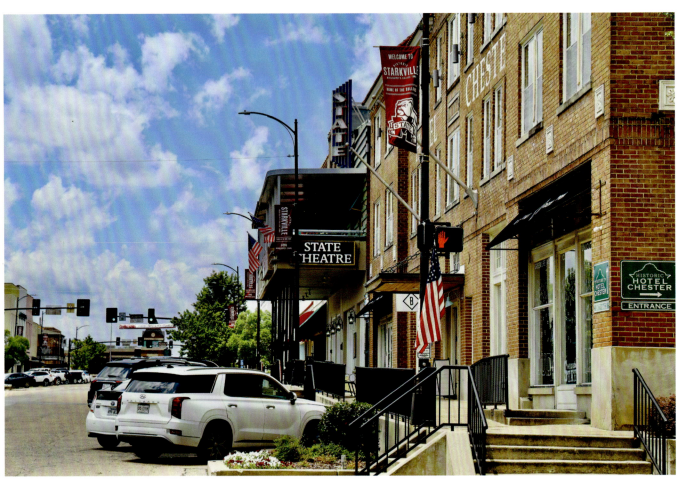

"Our state is blessed with many wonderful small towns and that certainly includes Starkville—the home of Mississippi State University. We are fortunate to have so many good friends and neighbors working hard to make Starkville the best it can be for all who call it home as well as the many visitors we host throughout the year."

– MARK E. KEENUM,
President of Mississippi State University

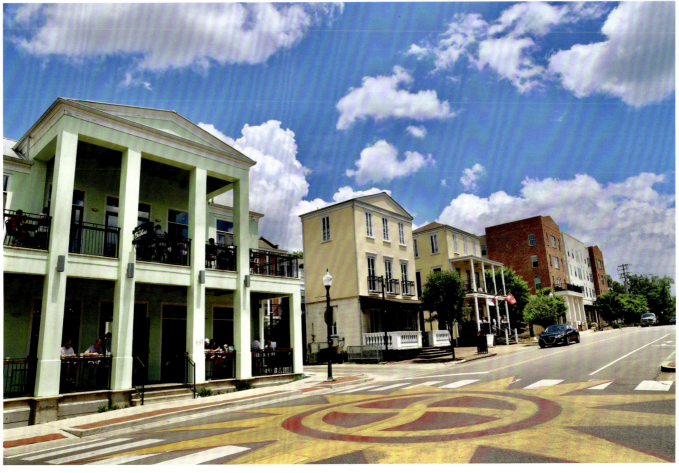

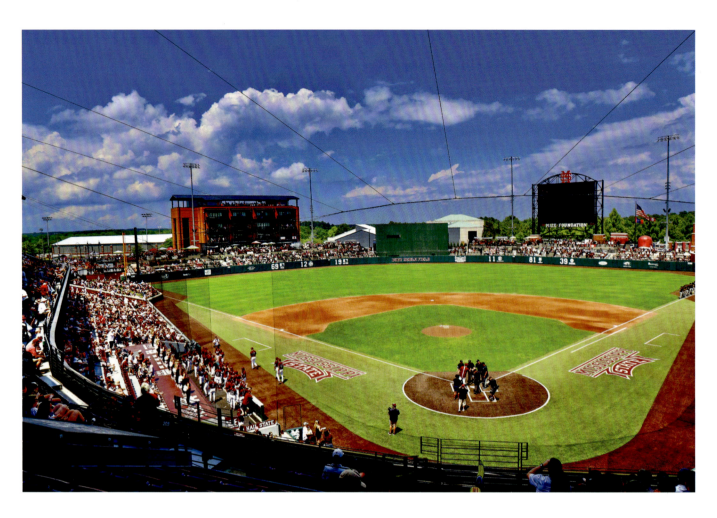
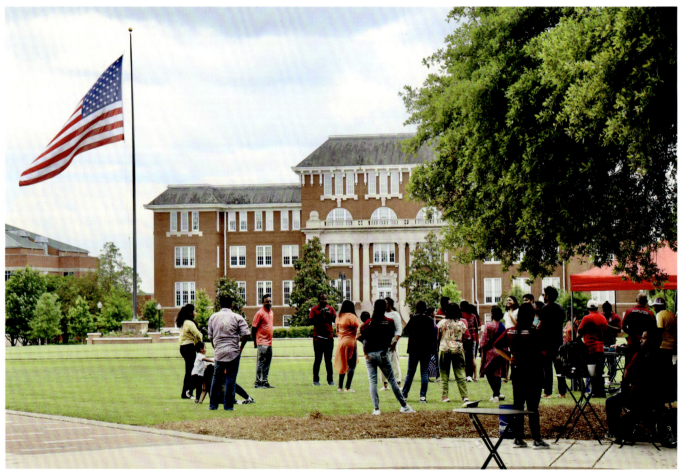

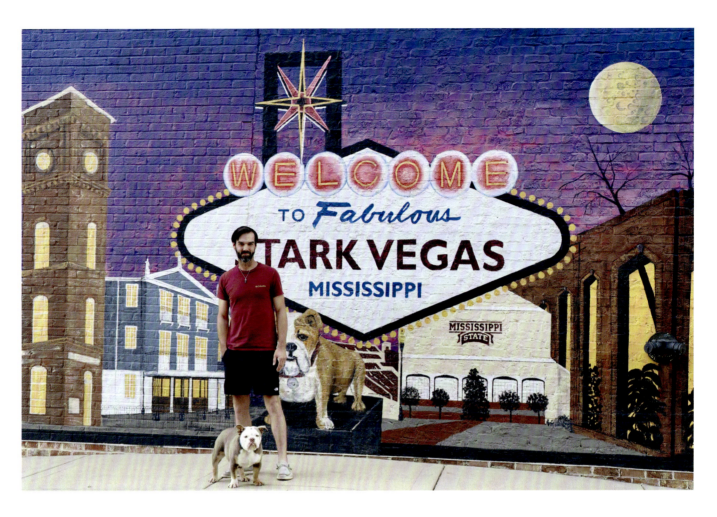

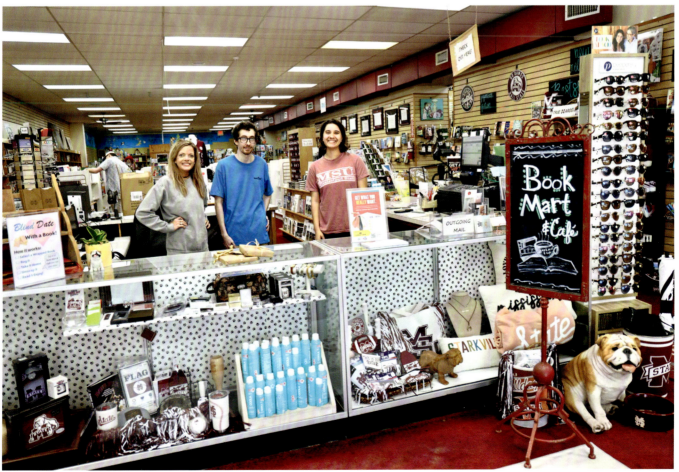

TUPELO MISSISSIPPI

"Mississippi small towns call to us: turn off the four-lane, slow to thirty-five. Look for hidden gems, little treasures, like murals in the post office, swinging bridges, vegetable stands, synchronized-firefly groves, guided Halloween cemetery tours, festivals for watermelons, kudzu, tamales, slug burgers. Oh, and heartland values—Americana!"

—US SENATOR ROGER F. WICKER

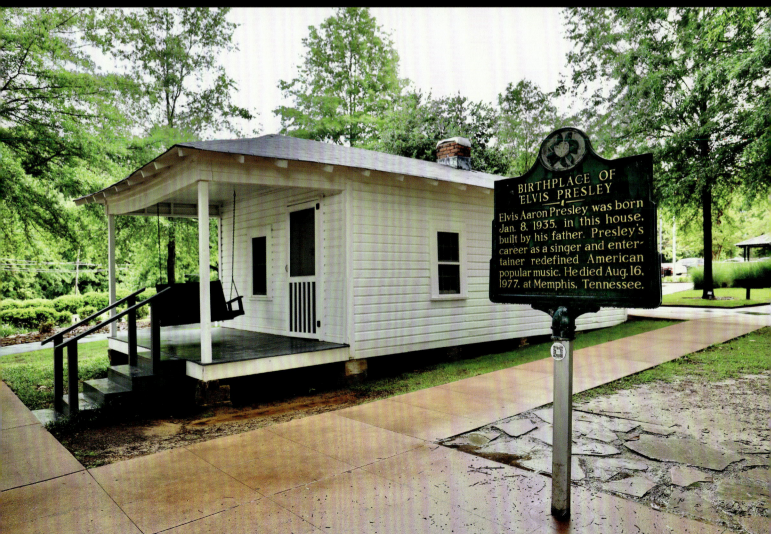

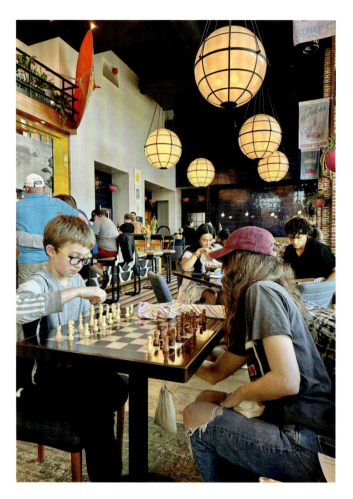

"I was raised in Shuqualak and have lived most of my life in Tupelo, two towns that provided me with a firm foundation, a sense of place, and a deep desire to work hard and to give back. The people that built these towns established a legacy of humble contribution to the common good. As a result, our citizens enjoy safe and supportive communities in which individuals and families have the resources to thrive."

—MICKEY HOLLIMAN

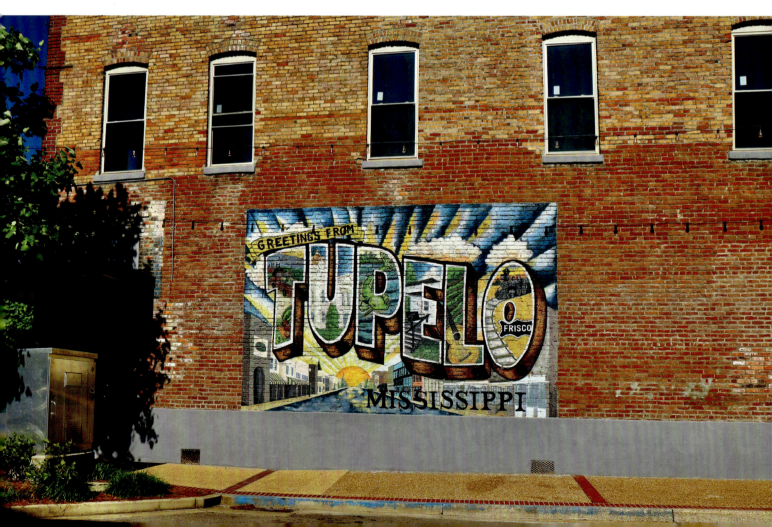

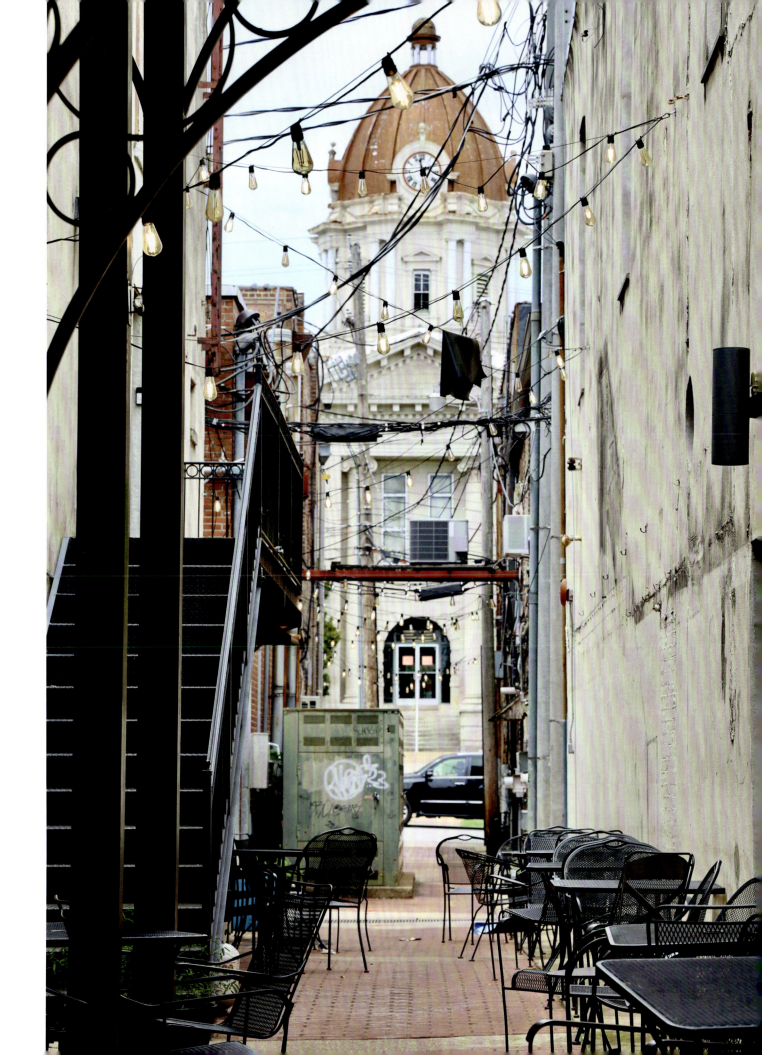

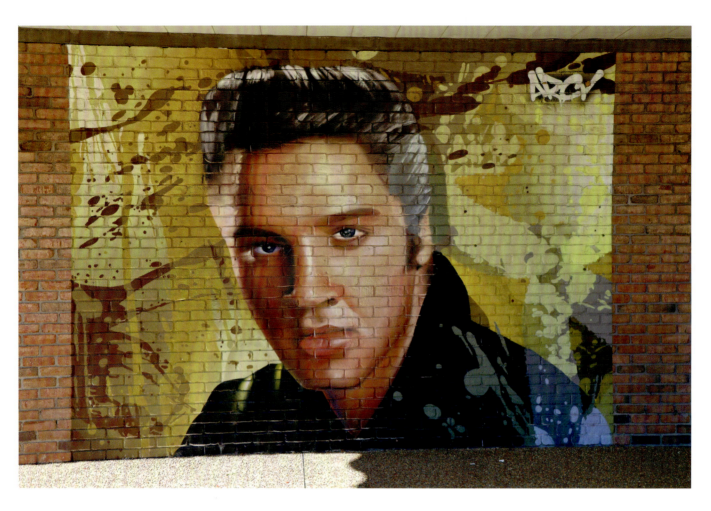

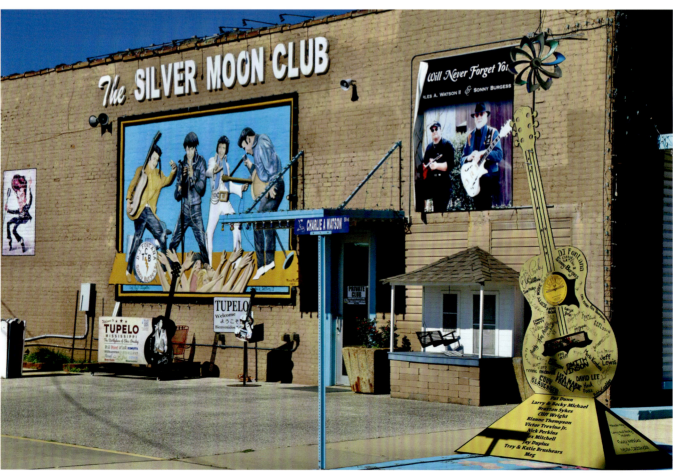

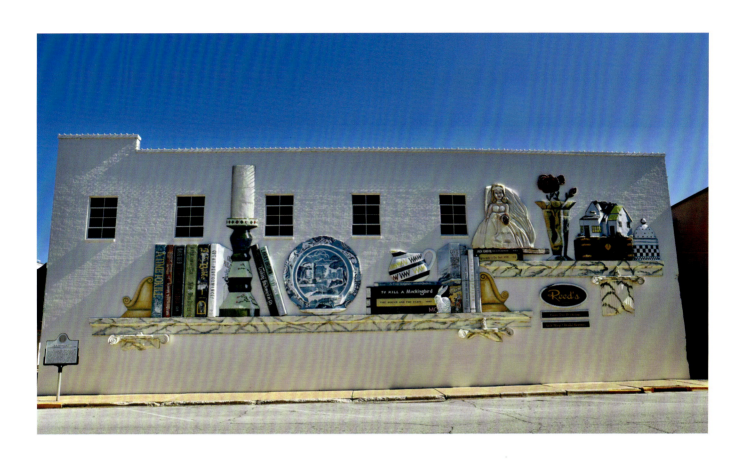

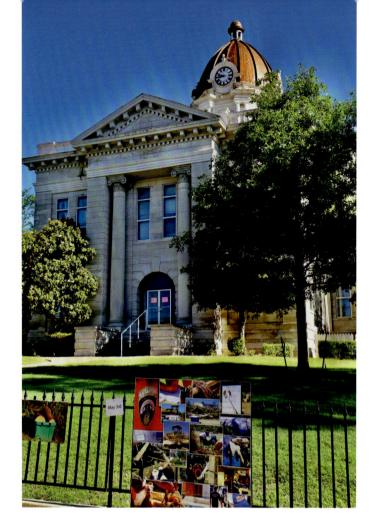

"I could move to a larger town and make some new friends, but I can't make new (fifty-)year friends. No reservations needed for dinner, no tee times needed, and no traffic. This is my comfort zone. 'Faith, Family, and Friends'—to me that's what it is all about!"

—STEVE GOLDING

"My hometown of Vicksburg is celebrated for its rich history, beautiful vistas, economic diversity, and architectural splendor, among other things. But what really sets it, and other small cities and towns, apart is the fellowship and hospitality of its citizens."

—STATE SENATOR BRIGGS HOPSON

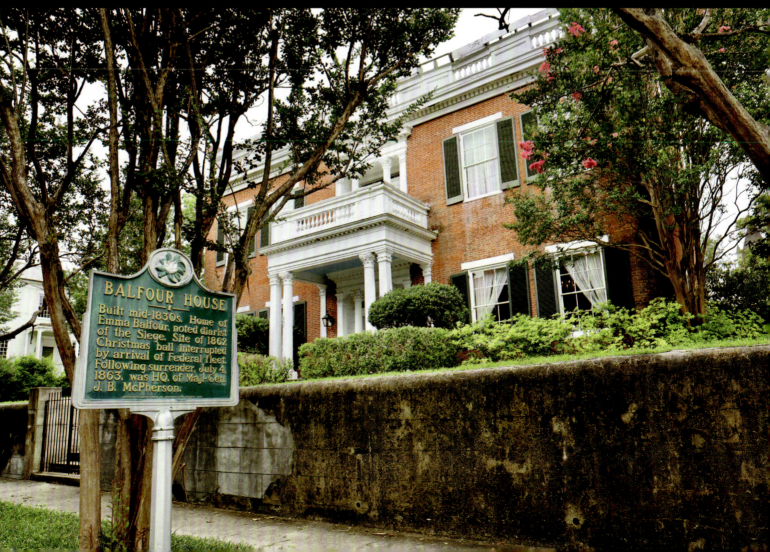

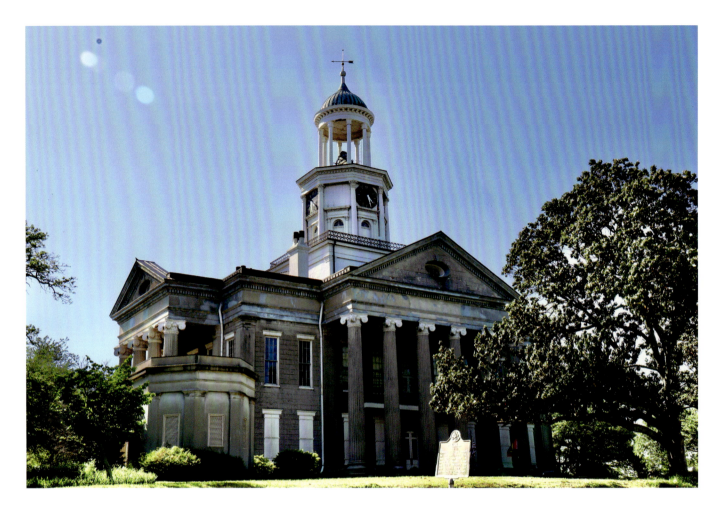

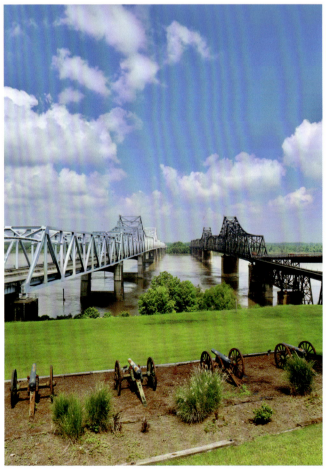

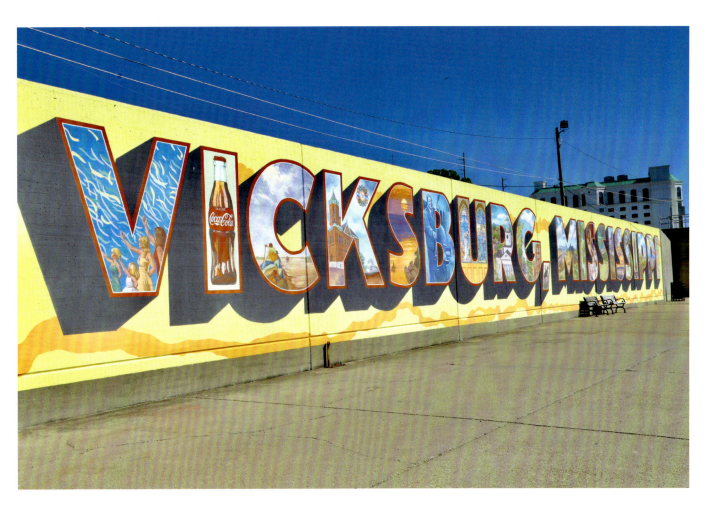

"In Vicksburg, Mississippi, you can live, love, laugh, and forgive in a community where loving God, family, and country are cherished."
—MIKE CHANEY

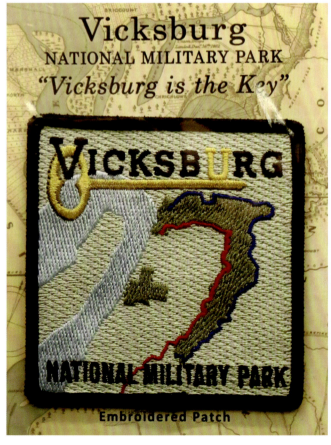

"Growing up in Vicksburg was a privilege, as you knew the community and were influenced by the leaders of the church, the schools, the town, and your neighbors. In my early years, I believed every town was surrounded by a military park. These towns are the cradles of our future and help define our culture."

—DELBERT HOSEMANN,
Lieutenant Governor of Mississippi

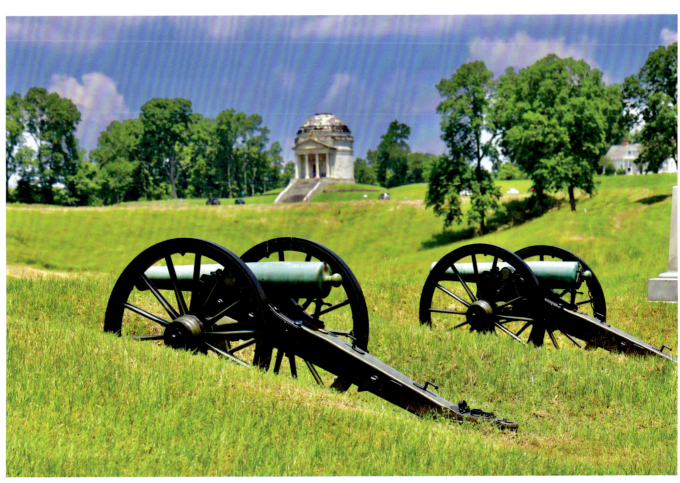

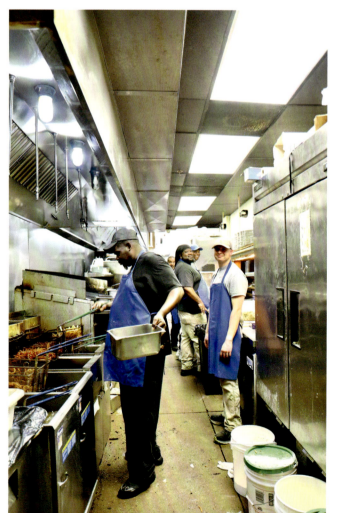

"I guess I have never thought of Vicksburg as a small town because unlike a lot of smaller communities, we have a very diverse and multicultural town as well as a community rich in culture. We also have the Mississippi River, which not only beckons adventurers but we get to experience some of the most beautiful sunsets which is something metropolitan areas miss out on. But most importantly, it's the connection you have with people. More times than not, you will run into a friend or acquaintance just about anywhere you go."

—TERRI FRAZIER

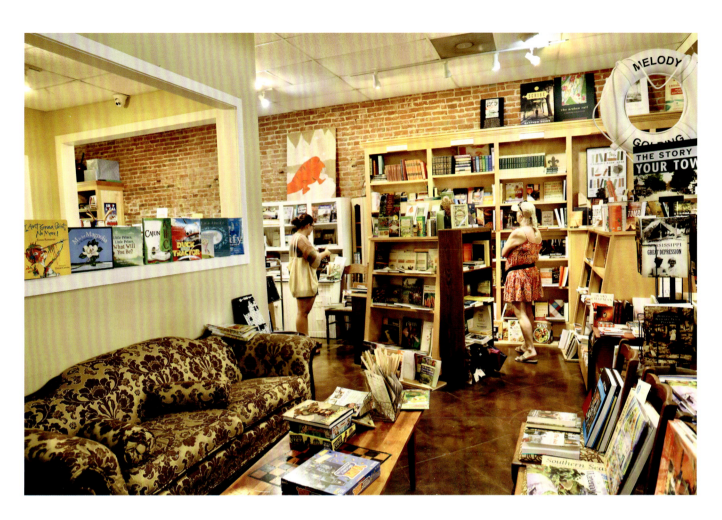

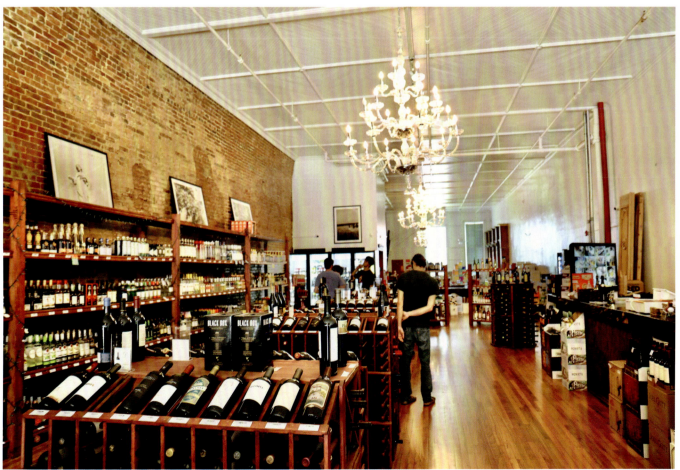

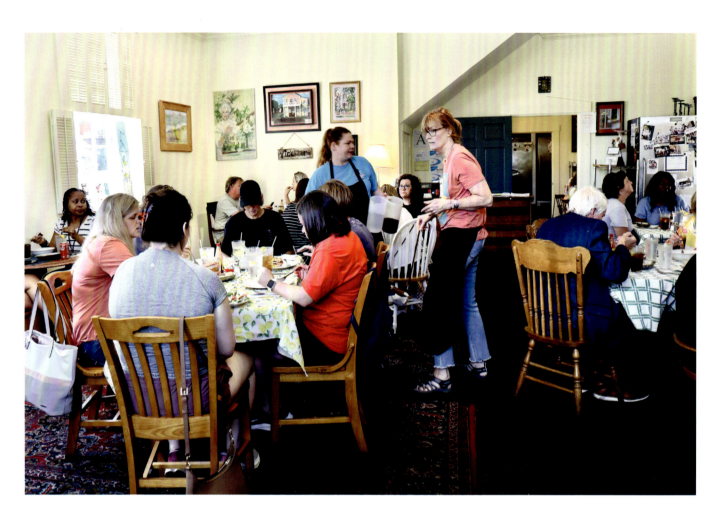

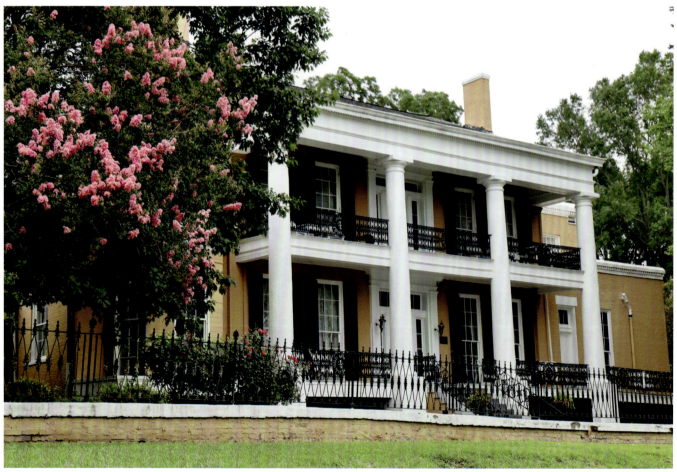

"Living in a small town is the best way to enjoy the American experience. You truly come into contact with the best of what it means to be a community. People care about your well-being; they support you when you are down and count on your support when they need it. It can be as simple as your favorite lunch spots knowing your order by memory or the traffic cop remembering your car each morning."

—AUSTIN GOLDING

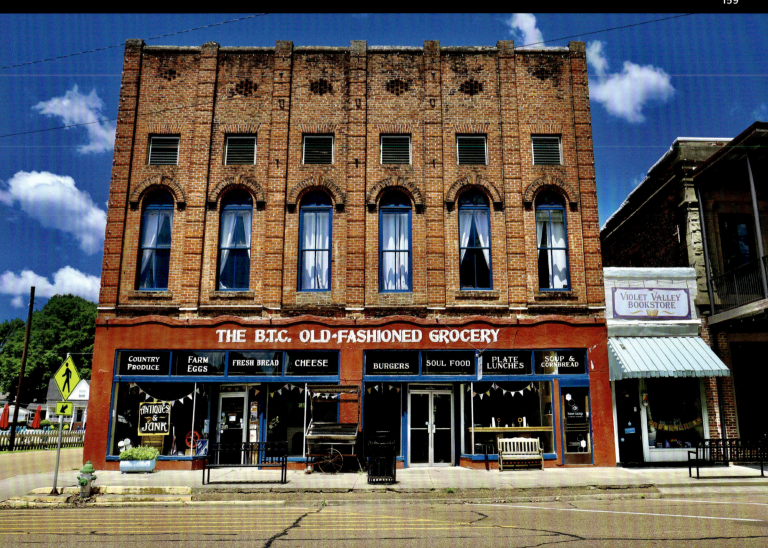

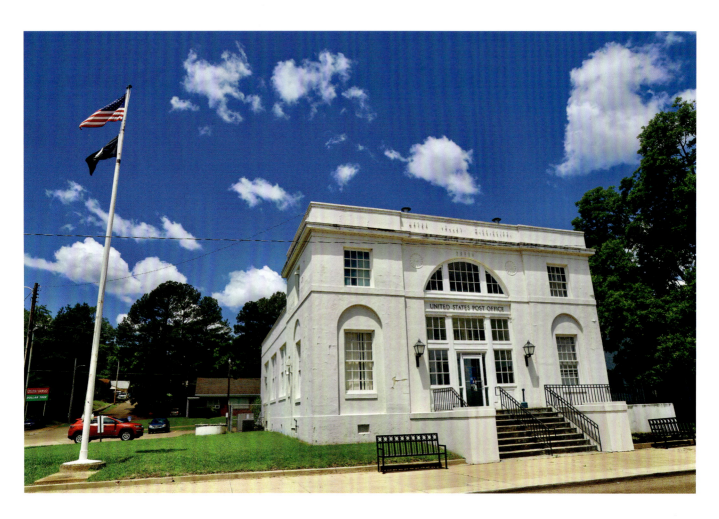
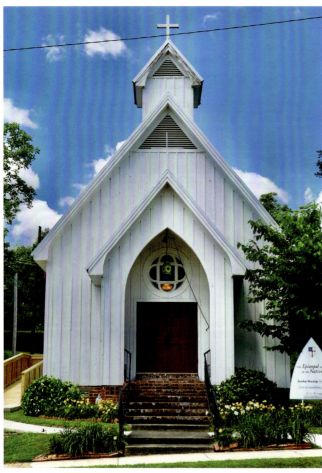

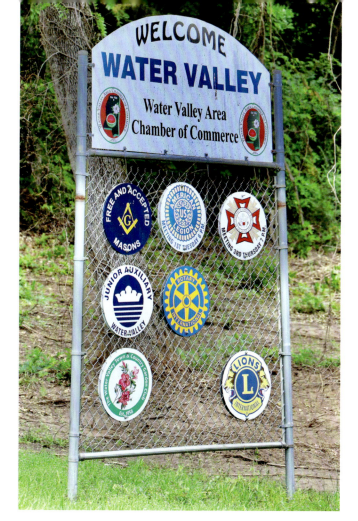
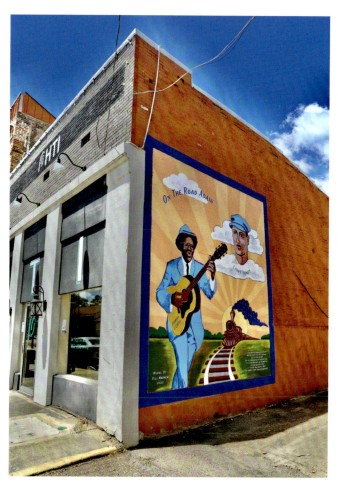
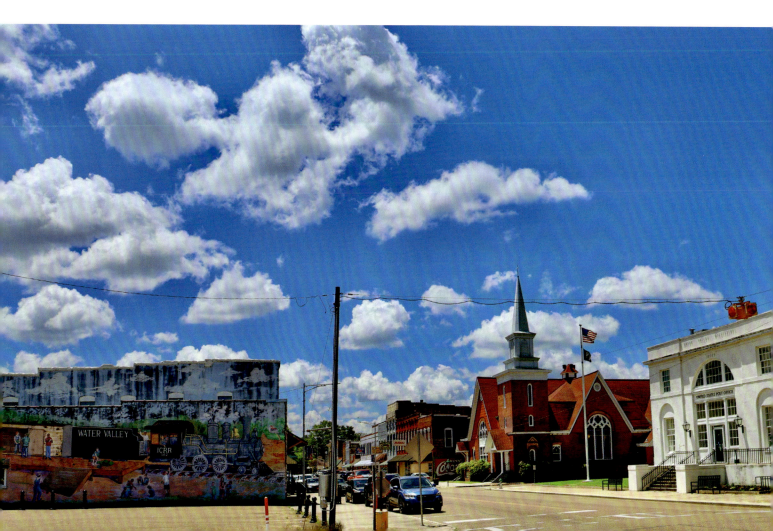

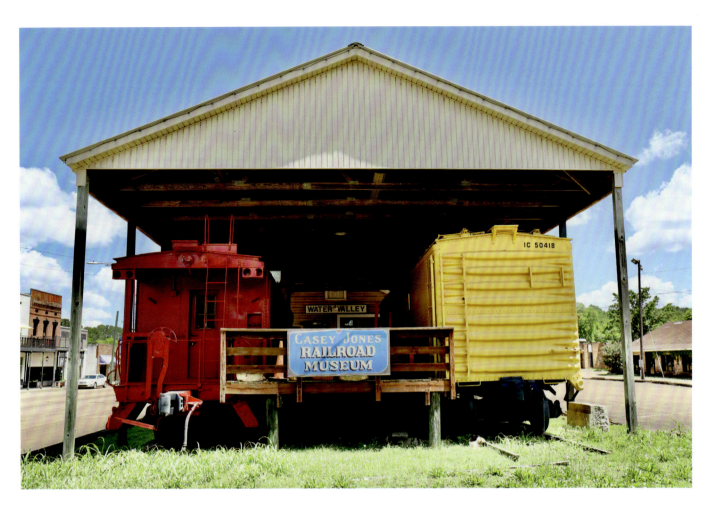

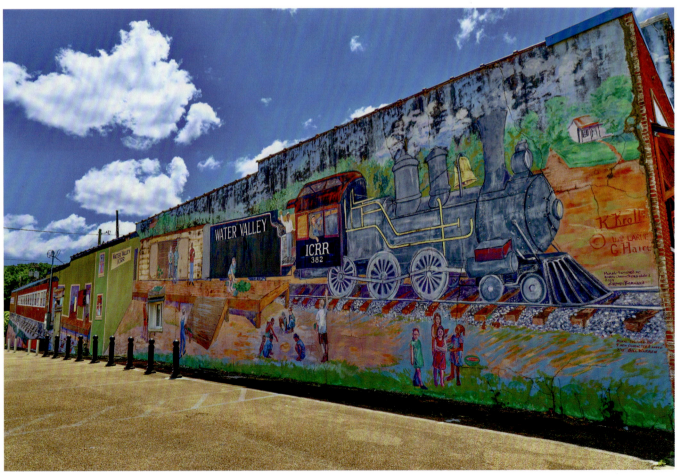

"It's the people... It's the Mississippi people who make all these small towns wonderful, inviting, charming, and fabulous! It's the people! Period!"
—JULIE GRESHAM

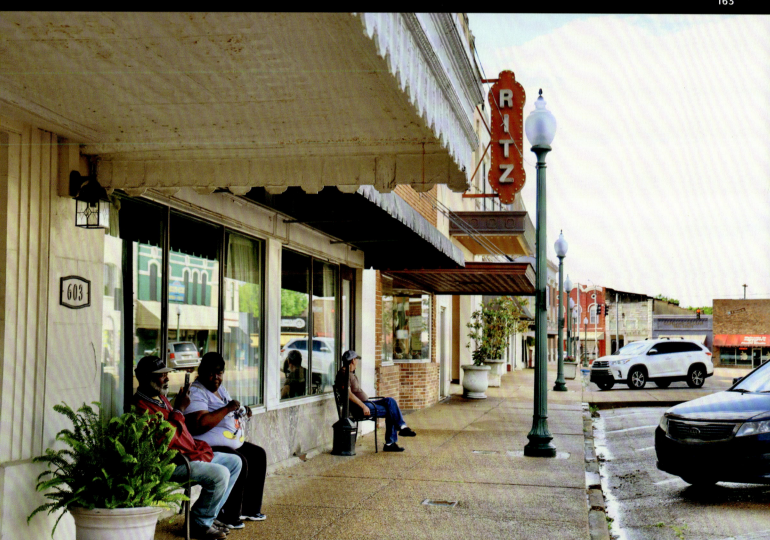

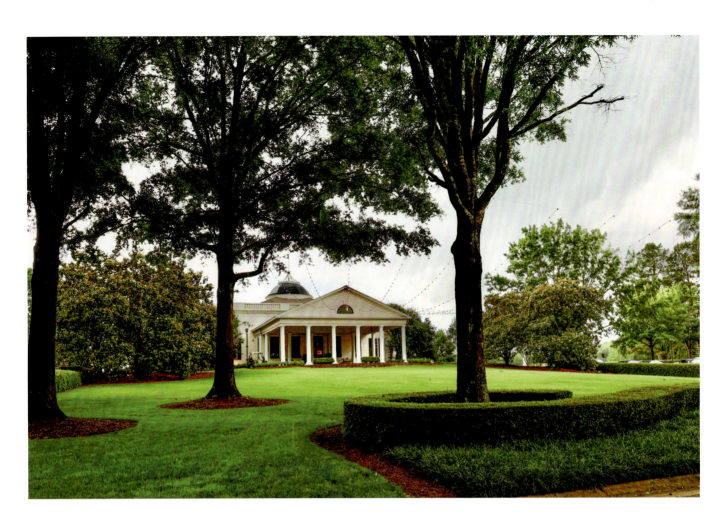

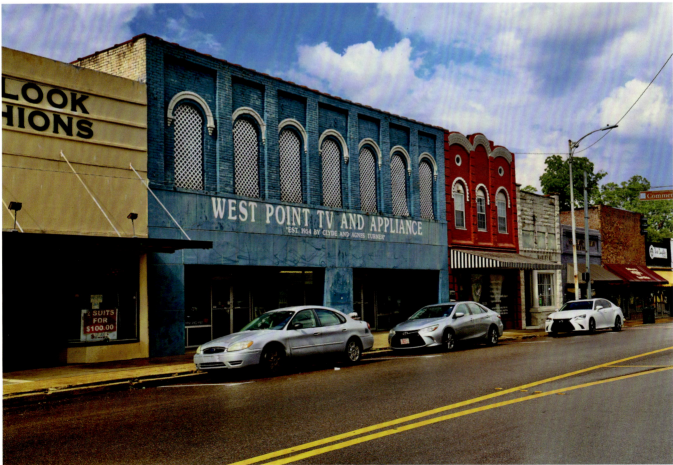

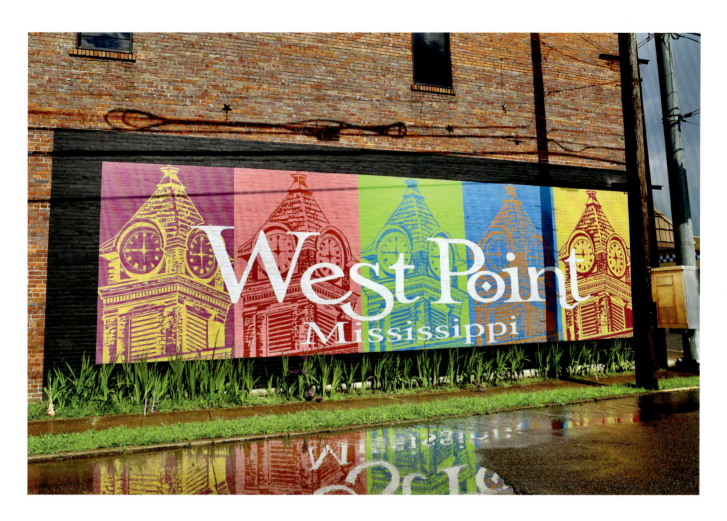
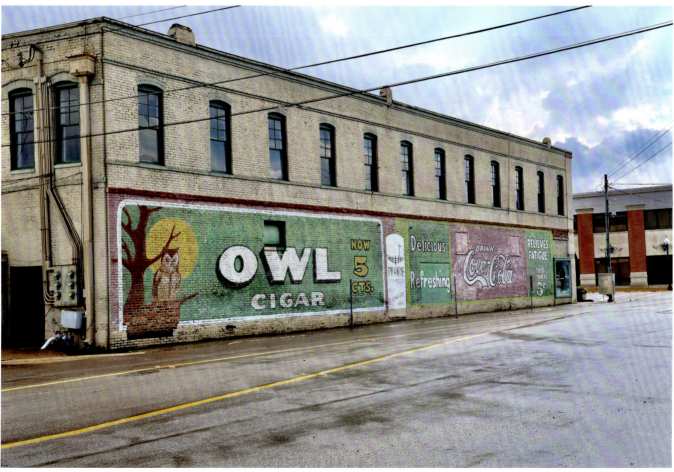

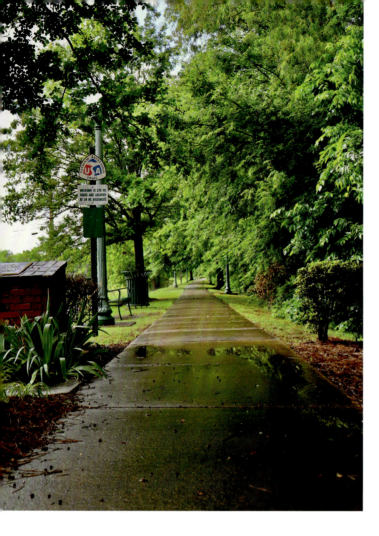

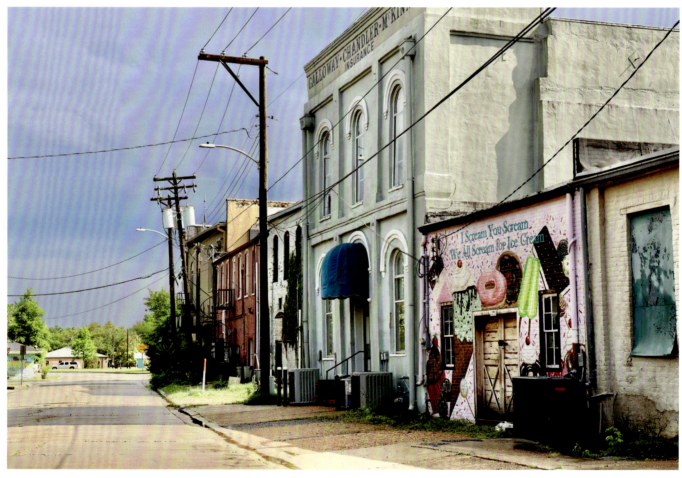

"From the kudzu-covered hills as you approach from the east to the top of Broadway overlooking the flatlands of the Mississippi Delta, you know Yazoo City is truly the 'Gateway to the Delta.'"
—**CLAY MCCONNELL**

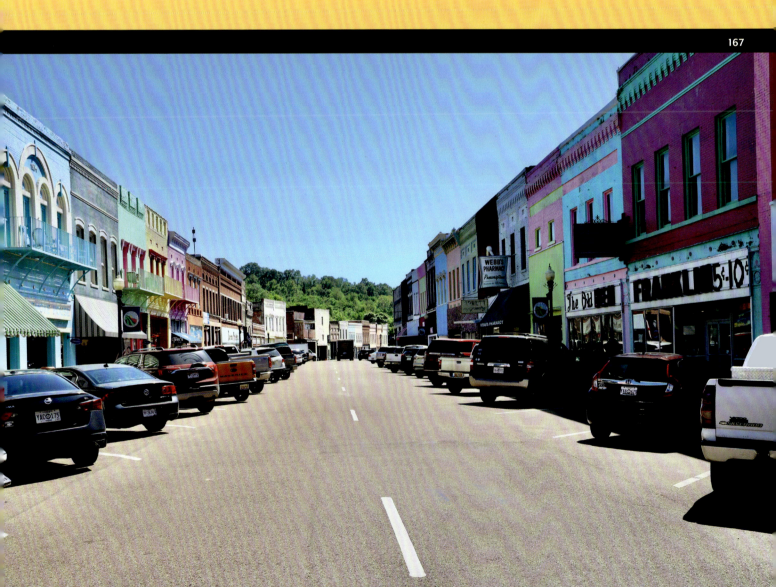

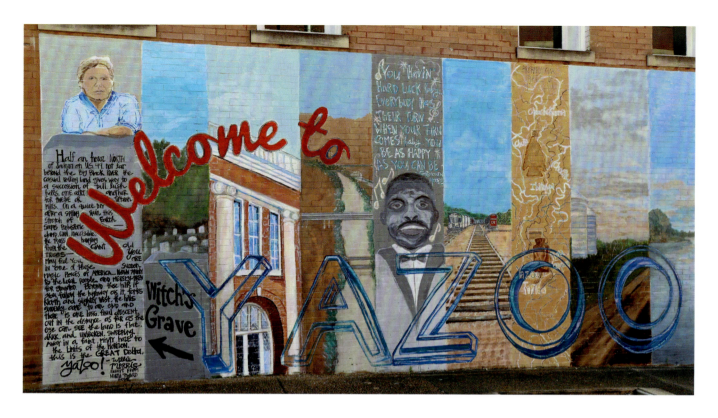

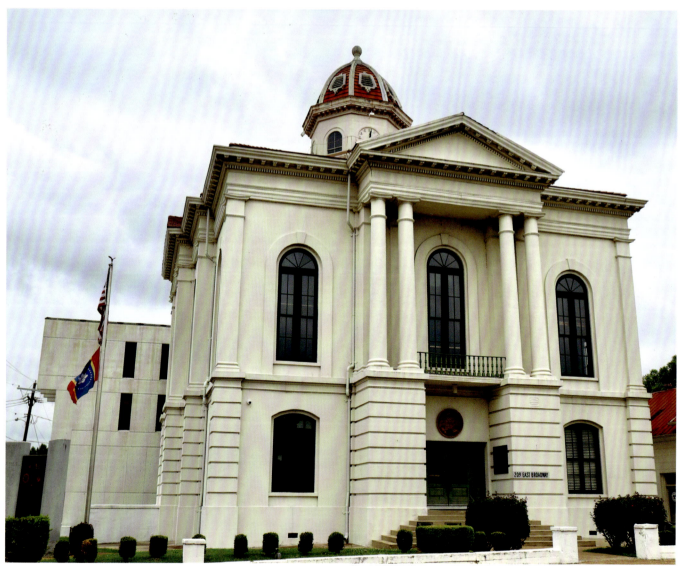

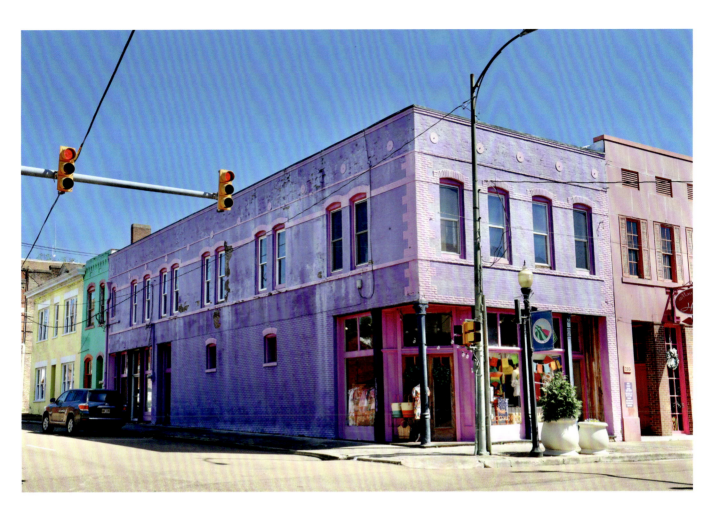

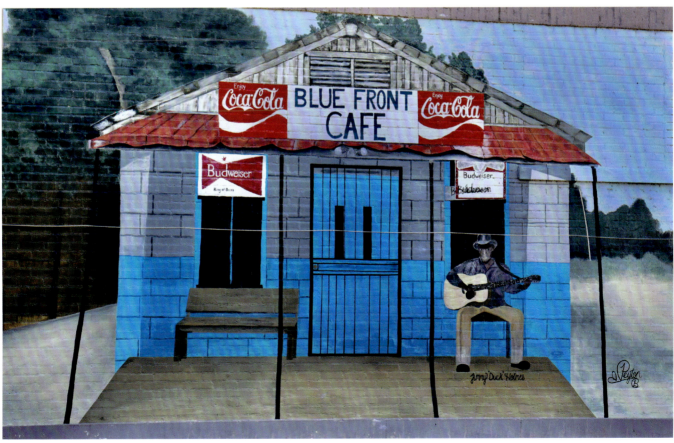

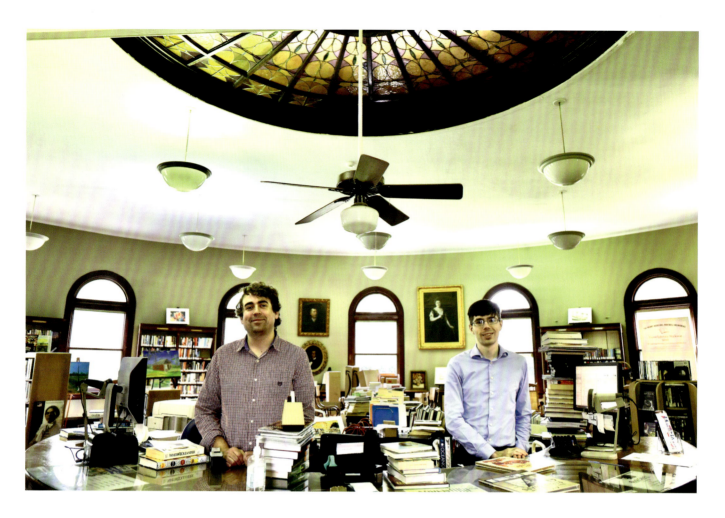

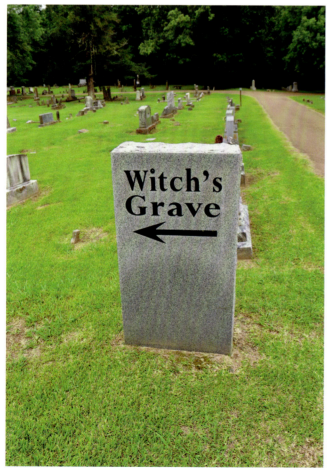

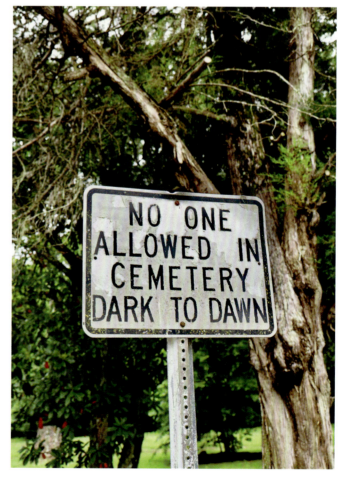

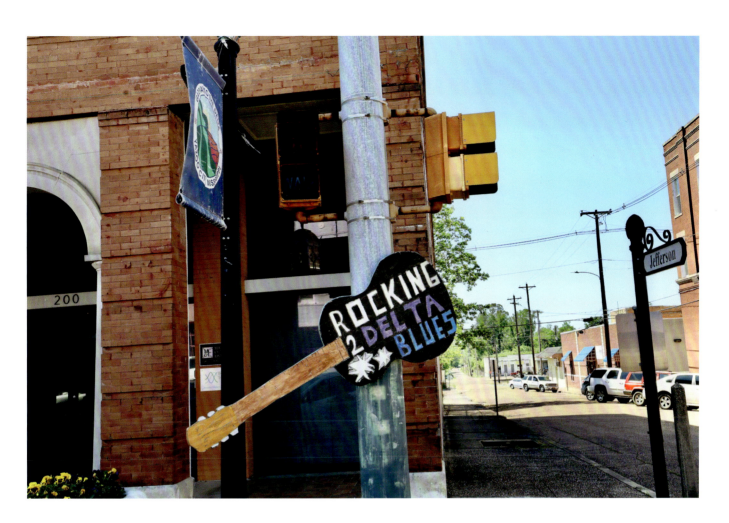

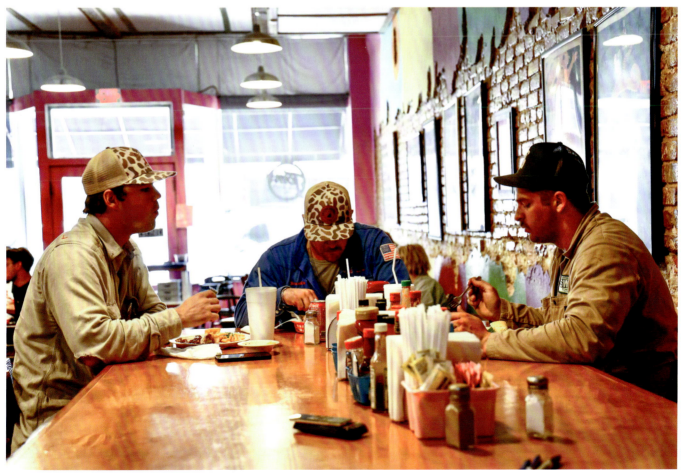

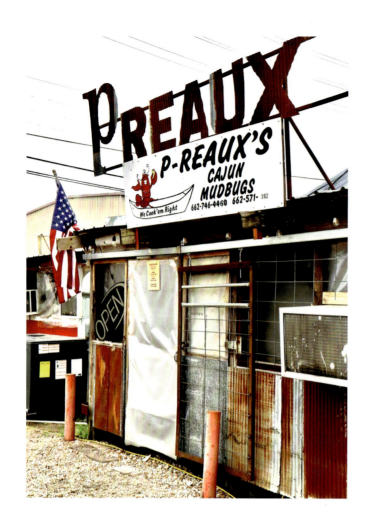
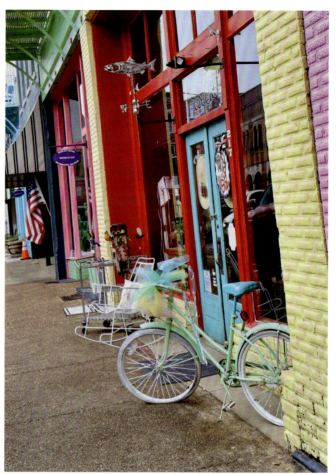
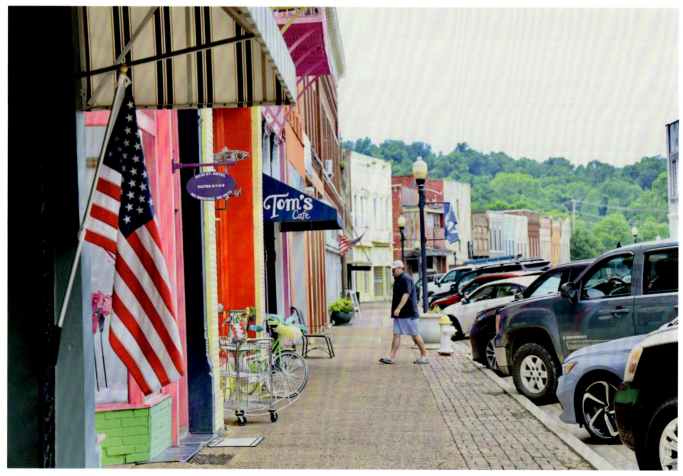

Photo by Melody Golding

ABOUT THE AUTHOR

Melody Golding is an author, a photographer, and an artist. She received a BFA from Mississippi State University. The Smithsonian Institution's National Museum of American History Archives Center acquired her solo documentary exhibit on Hurricane Katrina and her documentary photography and oral history project on wild boar hunting in the Mississippi Delta. Her photographs are on display at the Department of Homeland Security and have been featured in solo exhibitions at the National Museum of Women in the Arts in Washington, DC, and at numerous universities, colleges, and museums. Her Katrina photos will be the subject of a solo exhibition at the Two Mississippi Museums in 2025 in honor of the twentieth anniversary of the storm's impact on Mississippi. She is author of *Katrina: Mississippi Women Remember*; *Panther Tract: Wild Boar Hunting in the Mississippi Delta*; and *Life Between the Levees: America's Riverboat Pilots*, all published by University Press of Mississippi. Learn more about her work at www.melodygolding.com.

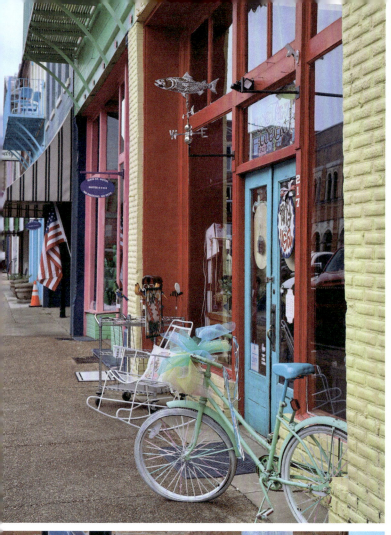
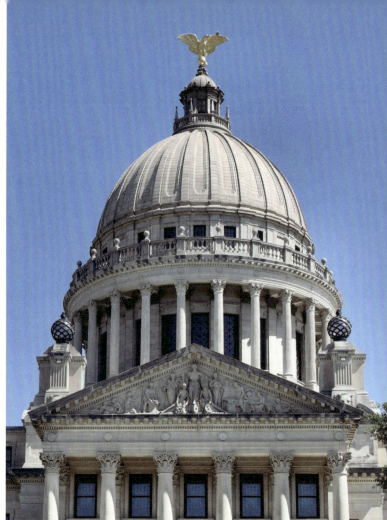
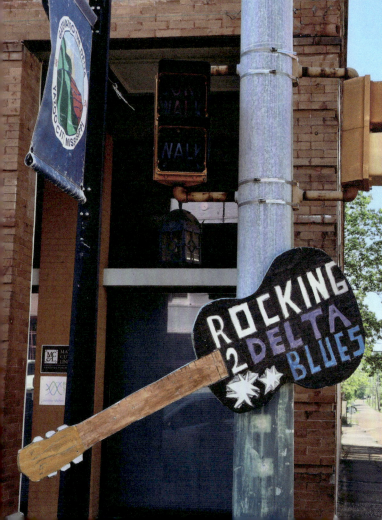